studying
visual
communication

sol worth, 1922–1977
(photograph courtesy of carl fleischhauer)

sol worth

studying
visual
communication

edited, with an introduction, by larry gross

university of pennsylvania press
philadelphia 1981

This work was published with the support of the Haney Foundation

Library of Congress Cataloging in Publication Data

Worth, Sol.
 Studying visual communication.

 (University of Pennsylvania publications in conduct
and communication)
 Bibliography: p. 204
 Includes index.
 1. Communication—Audio-visual aids—Collected works.
2. Anthropology—Audio-visual aids—Collected works.
3. Semiotics—Collected works. I. Gross, Larry P.
1942– . II. Title. III. Series.
P93.5.W6 001.55'3 80–52807
ISBN 0–8122–7791–0 AACR2
ISBN 0–8122–1116–2 (pbk.)

for saul robert hymes

contents

preface ix

introduction:
sol worth and the study of visual communication 1

one
the development of a semiotic of film 36

two
a semiotic of ethnographic film 74

three
toward an anthropological politics of symbolic forms 85

four
the uses of film in education and communication 108

five
symbolic strategies
(with larry gross) 134

six
seeing metaphor as caricature 148

seven
pictures can't say ain't 162

eight
margaret mead and the shift from "visual anthropology" to the "anthropology of visual communication" 185

appendix:
an american community's socialization to pictures: an ethnography of visual communication (a preproposal)
(with jay ruby) 200

bibliography 204

index 210

list of illustrations

figure 1-1
the process of communication—ideal model 45

figures 1-2 and 1-3
the process of film communication—probable results 47

figure 5-1
the context of interpretation 136

figure 5-2
competence to perform in a communications event 139

figure 7-1
impossible figure 177

preface

Sol Worth died in his sleep of a heart attack on 29 August 1977 at the age of fifty-five. In the weeks before his death, Sol had been preparing an application to the Guggenheim Foundation and a pre-proposal for a large-scale research project that he hoped to conduct with Jay Ruby (the preproposal is included as the appendix to this volume). Sol wanted to devote the academic year 1978–79 to writing a book that would weave together the theoretical and empirical strands of his previous work and serve as the conceptual foundation for the ambitious new endeavor that he was charting—the visual ethnography of an entire community.

In the introduction that follows this preface, I have tried to outline the development of Sol's research and writing over the course of his remarkably active, but tragically short, academic career. However, I would like to include here his own version of this story. The Guggenheim application requested a "brief narrative account of your career, describing your previous accomplishments." This request prompted Sol to write an autobiographical sketch that is uncharacteristically lacking in modesty.

My formal education was designed to educate a painter. I attended the founding class of the High School of Music and Art in New York City and then received my Bachelor of Fine Arts degree from the State University of

Iowa in 1943, studying painting with Phillip Guston. At age fifteen, one of my paintings was selected for showing in a group show of young artists at the then new Museum of Modern Art. In 1945, after serving two years in the Navy, designing posters, painting murals in training camp, serving as a helmsman on the *USS Missouri*, and working in Intelligence Headquarters in Hawaii, I decided not to accept a graduate assistantship in painting at Iowa and accepted instead a position as photographer and filmmaker in a commercial studio in New York. I worked there from 1946 to 1962, moving from employee to partner and owner, publishing photographs in most commercial magazines and producing and directing hundreds of films and commercials. By 1956, I had grown increasingly estranged from myself as both a creative and intellectual being, and from the Madison Avenue environment I was in. Therefore, I accepted a Fulbright Professorship to Finland to design their curriculum in Documentary and Educational Film at the University of Helsinki. I taught the first such course there and founded the Finnish Documentary Film Unit. As a teaching example of documentary film, I produced and directed the film *Teatteri*, which won awards at the Berlin and Cannes Film Festivals in 1957 and 1958 and has been chosen for distribution by the Museum of Modern Art.

In 1957, as a result of seeing *Teatteri* and reading a piece of mine in the *American Scholar*, I was asked by Gilbert Seldes, who was then founding the Annenberg School of Communications at the University of Pennsylvania, to consider coming there to help him design and then to teach and head what we both conceived of as a visual communications laboratory program. After trying this for several years as a part-time lecturer, I found that my interests in teaching and research overpowered whatever fears I had about leaving New York and my life there, and in 1964 I sold my business and moved to Philadelphia to devote myself to teaching and research in visual communication.

By 1965, based upon earlier research in New York, I had fully developed the research plan of teaching Navajo Indians—a people with very little exposure to or experience with film or picture-making—to use motion picture cameras and to analyze the relationship between their language and culture and the way they structured their world through film. That work, which I started in 1966—working with the anthropologist John Adair—was supported by the National Science Foundation in a series of grants starting in 1966 and continuing through 1971. This research resulted in six films, conceived, photographed, and edited by the Navajo students, several journal publications, many invited lectures here and abroad, and the book *Through Navajo Eyes*, analyzing the films and the process by which they were made. These films have been shown at Lincoln Center, the Edinburgh Film Festival, the Festival de Popoli in Florence, the Museum of Natural History, several television programs, and are currently being distributed by the Museum of Modern Art in the United States and the British Film Institute in Europe. Susami Hani, one of Japan's leading filmmakers, has called one of these films the American film most influential upon his own work.

During this period, I was promoted from Lecturer to Associate Professor, and in 1973 to full Professor of Communication. In 1977, I was appointed Professor of Communication and Education. In 1976, I was appointed Chairman of the Undergraduate Major in Communications, a program I designed and steered through the approval process of the University Committee on Instruction. I have been elected to the University Council (the governing body of the university), chair numerous departmental and university committees, and am a member of the Editorial Supervisory Board of the University Press. In 1970, in collaboration with Margaret Mead and others, I helped found the Anthropological Film Research Institute and continue to serve on its Board of Directors; the Society for the Anthropology of Visual Communication, of which I was the first president from 1972 to 1974 and continue to serve on their Board of Directors; and *Studies in the Anthropology of Visual Communication,* of which I have been editor since its inception in 1973. I am currently on the founding Board of Directors of the Semiotic Society of America, the Editorial Board of the *Journal of Communication,* and the Board of Advisors of the International Film Seminars. In past years I have served as Chairman of the Research Division of the University Film Association and on the boards of a variety of other film and communication societies.

Beginning in 1970, and stemming from my studies of how peoples of different cultures and groups structured their world through film, I and my students have examined the filming and photographic behavior of such groups as the Navajo, and working- and middle-class teenagers (black, white, male, and female). In 1972, sponsored by the National Science Foundation, I organized and taught (along with Jay Ruby, Carroll Williams, and Karl Heider) a summer institute where we took twenty selected doctoral students and young faculty in the social sciences and helped them to learn how to use the visual media of still cameras, motion pictures, and television for research and communication. The major purpose of the institute was to teach these researchers both how to conceptualize research in visual communication and how to use the visual media themselves to report the results of research in all forms of behavior.

As a result of these researches, publications, and teaching activities over the past decade, I have been developing a theory of visual communication based on the studies described above as well as in the publications listed in the attached bibliography, and on more recent studies concentrating on interpretive strategies as applied to all visual events. I now intend to articulate fully a theory of visual communication and its consequences for future research. This book, which is described in the "Statement of Plans," will be written during a leave that I plan to take in the academic year 1978–79. I need to be able to devote myself fully to a concerted and undivided period of writing, free of teaching, dissertation supervision, committees, other people's research, and general university duties. I need time to grapple with a large-scale articulation of a theory of visual communication.

In preparing this collection, I have tried to include the most important and lasting of Sol's writings, with the exception of the reports on the Navajo Filmmakers' Project, which are available in the book, *Through Navajo Eyes,* written by Sol and John Adair (1972). I have excluded several early papers that were either superseded by later work or seemed to me to be of lesser interest. Also omitted are several later works which were too repetitive of points made in the papers presented here.

Although Sol had a history of serious heart trouble, his death was as unexpected as it was tragic for those who knew him. Sol was an unusually vital and charismatic figure, who combined genuine intellectual passion with warm personal feeling. To be with Sol was always exciting and stimulating; to be without him is still, after three years, a painful deprivation.

After Lytton Strachey's death, his friend Dora Carrington wrote, "What is the use of 'adventures' now without you to tell them to?" For me, as for many others, some adventures will never be the same without Sol to share them with. I am grateful, however, to be able to share the papers in this book with those who knew Sol and with those who will come to know him through his contributions to the study of visual communication.

philadelphia larry gross
june 1980

introduction:
sol worth
and the
study of
visual communication

by larry gross

The central thread that runs through Sol Worth's research and writings is the question of how meaning is communicated through visual images.[1] Coming to academic life after careers in painting, photography, and filmmaking, Worth was imbued with the conviction that visual media were forms of communication that, while fundamentally different from speech, could and must be seriously examined as ways by which human beings create and share meanings. Focusing on film, he began with the question "What does a film communicate, and how does this process work?" (1966:322). The answers he began with grew out of his practice as a teacher of film.

teaching film as communication ●
In Worth's initial experience in teaching film, as Fulbright Professor in Finland (1956–57), he had utilized a method that he later described as follows: "The teacher would make a film; the students would work along with him, learning and doing at the same time. Class discussions would be held in which the various aspects of the film were developed and demonstrated" (1963:54). The film that he made during this process of teaching was *Teatteri,* now in the permanent collec-

1. In the preparation of this introduction, I benefited from comments and suggestions by George Custen, Paul Messaris, Jay Ruby, and Tobia Worth. I also drew upon Chalfen 1979.

1

tion of the Museum of Modern Art. When he came to the Annenberg School of Communications at the University of Pennsylvania to set up and teach a course in documentary film, however, Worth adopted a different approach: the students would make a film. This choice was decisive in orienting him toward questions and perspectives that influenced all of his subsequent work. It led Worth to consider problems that few film scholars had posed or pursued.

The most immediate consequence of this pedagogical decision was a concern over the inexperience of his students:

The young men and women in my class were bright, but they had never before made a film. They had never used a camera, edited a shot, or written a script. There was not enough time. And I was worried. If I made a film, I could control it; if I let the students make their own films, they could fail. The films might be bad or unfinished, the cameras and equipment might be ruined, film might be wasted. [1963:55]

This concern proved unfounded. The students succeeded in making films, and the workshop technique seemed to engage them in the process that Worth deemed appropriate to a school of communications:

The process of changing back and forth from conception as paramount, to the actual visual document as paramount, seems to me the key learning process in the Documentary Film Workshop. It is the way in which the students learn to see. It is the process by which they train themselves to find a meaningful visual image in relation to a concept which is usually literary or philosophical in nature. The purpose of the workshop is not to produce films (this is our pleasure), but rather to provide an environment in which students learn to see filmically; to provide an environment where they can learn about the techniques and the thinking necessary to communicate ideas through the filmed image. [1963:56f.]

It was the final stage in the workshop, however, that led Worth to the next set of questions. When the films were completed, they were screened before an audience of students, friends, and faculty. "It is in the period after the lights go on, when the comments are made, that the students begin to know how very complex and difficult the art of film communication is" (1963:57). The students were not alone, as Worth himself became increasingly intrigued by a pattern that he found in the responses of diverse audiences to the films made by his students:

The greatest involvement, identification, and understanding seems to come from the young and the untrained. The greatest hostility and incomprehension seems to come from the adult professional in the communication fields. . . . Adolescents find these films easier to understand than do adults. [1965: 12]

the biodocumentary ●

In trying to make sense of this unexpected pattern of responses, Worth first clarified the nature of the films he was screening. He realized that the inexperience of the student filmmakers (their lack of socialization in traditional film codes) and his insistence that "the subject matter evolves from the student's own interests and experiences" (1963:56), led to a particularly subjective kind of film. Worth called this type of film a *biodocumentary* and defined it as

a film that can be made by a person who is not a professional filmmaker, or by someone who has never made a film before. It is a film that can be made by anyone with enough skill, let's say, to drive a car; by a person of a different culture, or a different age group, who has been taught in a specific way to make a film that helps him to communicate to us the world as he sees it, and his concerns as he sees them. [1964:3]

In developing the concept of a biodocumentary, Worth was clearly concerned with an analogy between subjective films and dreams, as forms of visual imagery:

A biodocumentary is a film made by a person to show how he feels about himself and his world. It is a subjective way of showing what the objective world that a person sees is really like. . . . In addition . . . it often captures feelings and reveals values, attitudes, and concerns that lie beyond the conscious control of the maker. [1964:3]

But it was not enough to see the biodocumentary as a subjective, individual statement by a novice filmmaker. That might explain why adults could not "understand" these films, and especially why "hostility seems to be found most frequently among filmmakers, film critics, and communications professionals," typical comments being, "I think you are intellectually irresponsible to teach young people to make films like this. . . . I think the whole thing is a hoax" (1965:7). After all, it is hardly a novel observation that those most engaged with a set of conventions in art are the most outraged at innovations or variations that ignore, challenge, or undermine these conventions.

It still remained to ask why young viewers responded with enjoyment and understanding; after all, even if they were not profes-

sionals, they were used to seeing conventional films. Worth decided that there was something in the subject matter and the structure of the films made in the workshop that was comprehensible to young viewers because it was close to their way of talking and thinking. In particular, he felt that the films used ambiguities and hints in a fashion that adults were no longer comfortable with but which younger viewers find "safer and more comfortable for certain themes than [they] would an outright statement" (1965:18).

Although he probably did not see the implications of his inquiries at this point, Worth was laying some of the foundations for an important analytic shift that gradually became explicit in his thinking. I believe that he was already expressing some uneasiness with the psychological approach noted above, the idea that biodocumentaries are dreamlike revelations of the unconscious. Although much of Worth's research on film during the rest of the 1960s is clearly dominated by the psychological model of film as individual expression, he increasingly focused his attention (often simultaneously, and even contradictorily) on film as cultural communication. Even at this point, then, Worth was beginning to formulate two related sets of questions that he pursued for the rest of his life.

First, he began to explore the question of how meaning can be communicated in various modes and media: are visual images in general, and film in particular, better understood in light of a general theory of communication as symbolic behavior; and what would this theory look like?

Second, he understood that his experience with novice filmmakers suggested a radical innovation in the way the film medium could be used as a research tool. If anyone could be taught to make a film that reflected their own world view and the values and concerns of their group, then the usual direction of the film communication process could be reversed. This meant using the medium "to see whether the visual world offers a way of communication that can be used not only for us to communicate to them, but so that we might make it easier for them to talk to us" (1965:19).

Although these two sets of questions were pursued in tandem and their interconnections formed the basis of much of Worth's intellectual development, it will be necessary for the purpose of exposition to discuss them separately.

the navajo project ●
The first fruits of the biodocumentary approach and Worth's realization of the potential it offered for "them to talk to us" were not long in coming. In his first exposition of the concept of the biodocumentary film, at the 1964 meeting of the Society for Applied Anthropol-

ogy, Worth already saw the possibility of using this method to explore the world view of another culture.

In a documentary film about the Navajo you look for an objective representation of how they live as seen by an outsider. In a Bio-Documentary about the Navajo, the film would be made *by* a Navajo. One would not only look to see how the Navajo live, but one would also look to see how a Navajo sees and structures his own life and the world around him.[2] [1964:5]

In this capsule "proposal" for a research project, Worth later realized he was obeying Malinowski's injunction that "the final goal, of which an Ethnographer should never lose sight . . . is, briefly, to grasp the native's point of view, his relation to life, to realize *his* vision of *his* world" (1922:25). In this context, it is interesting to note Worth's sensitivity to one of the most important, but often neglected, problems in anthropological theory and practice: the influence of the researcher's own values and biases on written or filmed records of research. The proposed use of the biodocumentary approach was, to use a term that achieved currency in later years, *reflexive:*

Of course no view by one man of another is entirely objective. The most objective documentary film or report includes the view and values of the maker. The standard documentary film tries, however, to exclude as much as possible of this personal value system. The Bio-Documentary, on the other hand, encourages and teaches the filmmaker to include and to be concerned with his *own* values. . . . The Bio-Documentary method teaches the maker of the film to search for the meaning he sees in his world, and it encourages the viewer to continue that search by comparing *his* values with the values expressed by the filmmaker in the film. [1964:5]

This interest in what "other people had to say about themselves through film, and how one could teach them to say it" (Worth and Adair 1972:30) led to the Navajo Filmmakers Project, conducted in the summer of 1966 by Worth in collaboration with John Adair, and assisted by Richard Chalfen, then a graduate student working with Worth.

The project addressed a series of research objectives and issues:

(1) "To determine the feasibility of teaching the use of film to people with another culture" (Worth and Adair 1970:11).

(2) "To find out if it was possible to systematize the process of

2. The choice of the Navajo in this example was not accidental. Worth had already been discussing the idea of using biodocumentary film to study a culture with John Adair, a longtime student of the Navajo, who later collaborated with him on the project.

teaching; to observe it with reference to the maker, the film itself, and the viewer; and to collect data about it so as to assist other ongoing research exploring the inference of meaning from film as a communicative 'language' " (ibid.:12).

(3) To test the hypothesis that "motion picture film, conceived, photographed, and sequentially arranged by a people such as the Navajo would reveal something of their cognition and values that may be inhibited, not observable, or not analyzable when investigation is totally dependent on verbal exchange—especially when it must be done in the language of the investigator" (ibid.).

(4) To "create new perspectives on the Whorfian hypothesis, work on which has for the most part been limited to linguistic investigation of cognitive phenomena. Through cross-cultural comparative studies using film as a mode of visual communication, relationships between linguistic, cognitive, cultural, and visual phenomena might eventually be clarified" (Worth and Adair 1972: 28).

(5) To see whether "the images, subjects, and themes selected and the organizing methods used by the Navajo filmmakers would reveal much about their mythic and value systems. [It was] felt that a person's values and closely held beliefs about the nature of the world would be reflected in the way he edited his previously photographed materials" (ibid.).

(6) To study the process of "guided" technological innovation and observe "how a new mode of communication would be patterned by the culture to which it is introduced" (Worth and Adair 1970:12).

The Navajo project was enormously successful. The films made by the Navajo filmmakers were widely screened and discussed as "a breakthrough in cross-cultural communications" (Mead 1977:67). Worth's involvement with anthropology deepened after the completion of the project and the publication of its results (Adair and Worth 1967; Worth and Adair 1970, 1972). He became increasingly identified with the revitalization of a subfield, the *anthropology of visual communications,* a term he proposed as an alternative to the earlier term *visual anthropology.*

Worth felt that most anthropologists viewed film and photography only as ways to make records *about* culture (usually other cultures) and failed to see that they could be studied as phenomena *of* culture in their own right, reflecting the value systems, coding patterns, and cognitive processes of their maker. His experience with biodocumentary films had clarified this distinction for him, and he saw it as crucial to the understanding of visual communications.

Pursuing this distinction leads to three other issues which concerned Worth:

(1) The denial of the possibility of an objective, value-free film record and the assertion that every filmmaker has an inherent cultural bias raise serious questions about the way in which we all view photographic images, especially our tendency to accept them as evidence about the external world. In particular, Worth was disturbed by the lack of understanding and sophistication of anthropologists regarding their own use of visual image technologies.

(2) The use of these technologies to record the lives of others for our purposes and the purveying to others of our own cultural products and technologies (again, usually for our own profit), raise serious ethical issues about the power and the use of media which we ourselves do not adequately understand.

(3) The need to understand the nature of film as a medium of communication: Is there a peculiarly filmic code, and what are its properties?

I will begin with the last of these, which takes us back to the question of how meaning is communicated through film.

film as communication ●

In the process of analyzing the early biodocumentary films made by his students, Worth had realized that although they were subjective, they were not, taken individually, completely idiosyncratic. In his discussion of these films, he noted that they "all employ similar grammars (in the sense of editing devices and filmic continuities) . . . grammars of argot rather than of conventional speech" (1965:18). As I have noted, the decision to view these films as social, rather than merely individual, expressions led to the question of whether there were underlying rules for the shaping and sharing of meanings in film.

Worth began by employing a communications theory model in which film is seen as "a *signal* received primarily through visual receptors, *which we treat as a message by inferring meaning from it*" (ibid.:323, emphasis in original). The implications of this last point were to become increasingly central in Worth's work, but he already was insisting that "there is *no* meaning in the film itself . . . the meaning of a film is a relationship between the implication of the maker and the inference of the audience" (ibid.). But how did this process of implying and inferring meanings actually occur? In two of his early papers (1966, 1968) Worth laid out an initial model, some of which was retained and developed in future work, some of which was modified or discarded as his thinking progressed.

Because many key points in the model of film communication presented in these papers are repeated in the paper "The Development of a Semiotic of Film" (1969), included in this volume as chapter 1, I will briefly discuss some aspects of the earlier papers which were less prominent but still useful in the later effort. In addition, I will focus on what I feel are weaknesses, as well as the strengths of Worth's approach, as represented by all three of these papers.

In these initial papers, Worth drew heavily upon psychology as a framework for understanding film, again making an analogy to the dream, which he described as an "intrapersonal mode of communication through image events in sequence." The film, he asserted, "is a similar mode of communication but most often extended to the interpersonal domain" (1968:3). He proceeded to outline "an intuitive experiential model" of film as a process which begins with a "Feeling Concern . . . to communicate something," a concern "which many psychologists feel is almost a basic human drive" (1966:327). This "feeling-concern" should not be seen as an explicit message that one wants to communicate; it "is most often imprecise, amorphous, and internalized. It cannot be sent or received as a film in this internalized, 'feeling' state" (1968:4).

Here Worth makes a further point which he did not pursue at the time, but which can be seen as an early indicator of what later became an important emphasis in his view of communicative phenomena:

Obviously, inferences can be made about internal feeling states by observing a subject's gestures, body movements, and so forth. . . . [However,] there is an important distinction which must be made between the inferences we make from a person's own behavior, which can have a great variety of reasons explaining and motivating them, and the inferences we make from a coded expression in linguistic or paralinguistic form whose purpose is primarily communicative. [1968:4]

If the filmmaker is to communicate this feeling-concern, then, Worth continued, he "must develop a Story Organism—an organic unit whose basic function is to provide a vehicle that will carry or embody the Feeling Concern" (1966:327). In practice, the "story-organism" may be a story in the usual sense of the word, even a shooting script, but Worth was dealing more with the "organization into a system of those beliefs and feelings that a person accepts as true and related to his Feeling Concern" (ibid.:328).

The final stage in the encoding process occurs when, "after recognizing the feeling concern and finding the story organism,

. . . the communicator [begins] to collect the external specific *Image Events* which, when sequenced, will become the visible film communication" (1968:4).

meaning as mirror image ●

Worth then proceeds to define the receiving process "as a kind of mirror image of the sending process" (1966:328). Because I feel that this position contains a fundamental error (one which Worth later recognized), I will quote it in full:

The viewer first sees the Image Event—the sequence of signals that we call a film. Most often he knows nothing of what went on before. He doesn't know the film-maker and his personality, and he usually doesn't know what the film is about, or is meant to communicate. Should our viewer choose to treat these signals as a message, he will first infer the Story Organism from the sequenced Image Events. He will become aware of the belief system of the film-maker from the images he sees on the screen. From this awareness he will, if the communication "works," be able to infer—to invoke in himself —the Feeling Concern.

As you can see from this suggested view of the total process, the meaning of the film for the viewer is closely related to the Feeling Concern of the film-maker. The single Image Events of the film are the signals, these specifically sequenced Image Events are what we treat as messages, and our inference about the Feeling Concern of the maker is what we call the meaning of the film. [1966:328]

This view is explicitly tied by Worth to a psychological model of communication in art enunciated by Ernst Kris in his *Psychoanalytic Explorations in Art* (1952). Worth quotes Kris's statement that communication "lies not so much in the prior intent of the artist as in the consequent recreation by the audience of his work of art. . . . What is required for communication, therefore, is similarity between the audience process and that of the artist" (pp. 254–55).

The primary problem with this argument is that it does not, in fact, represent the experiential realities of film communication.[3] Simply put, it is unreasonable ever to expect the process of viewing a film to mirror the process of making that film. Given Worth's own model of the filmmaking process, it should be clear that the maker interacts with the film in the process of creation in a way which can never be

3. Worth's later repudiation of the mirror-image model was in large part the result of many discussions between the two of us during the period between 1968 and 1972. The arguments summarized in this paragraph represent the position I maintained in opposition to Worth's implication of sender-receiver "isomorphism" in the communications process.

repeated by himself or by anyone else. The very acts of filmmaking are different in time, space, and pace from any act of viewing. Moreover, the model implies a static, unchanging feeling-concern which leads to a fixed story-organism, which in turn is represented by a sequence of image-events. In reality, of course, the process of filmmaking, as Worth's own descriptions show, often involves changes and modifications in what one wishes to say and how one tries to say it. The filmmaker's experience is one of choosing among alternatives, attempting to realize intentions, and assessing achievements as a means of confirming or altering those intentions. The viewer confronts only the arranged, final set of images, and can only deal with them in terms of conventional and specific expectations, and in light of assessments of the filmmaker's control and skill in choosing, sequencing, and implying meanings. This is hardly the same thing as "[reversing] the process by which the encoder made the film" (chapter 1, below).

But, if this position is so patently untenable, why did Worth hold to it for several years and repeat it in a series of papers? I think there may be several reasons. First, I believe that Worth was heavily influenced by his experiences in teaching students in his documentary film workshop. His method of teaching concentrated on forcing the students to clearly articulate their intentions and their decisions in selecting and arranging images in order to convey ideas and feelings. The model of a feeling-concern that leads to a story-organism which is embodied in a sequence of image-events may not capture the experience of all filmmakers, but it does characterize the method used in Worth's workshop.

Second, the influence of the student workshop experience may have contributed another flaw of the mirror-image model: the implication that films are typically made by individual filmmaker-communicators. This "mistake" is all the more odd, given Worth's years of experience as a professional filmmaker. There is no doubt that he was aware that film is among the most collective of media and that most films could in no way be described as the embodiments of any one author's feeling-concern. Worth was certainly not a naive auteur theorist; rather, I think we can see here again the influence of the psychologically based, individually oriented communications theory which Worth was using at that time.

In his 1969 paper (chapter 1 of this volume), Worth had already begun to retreat from his claim of isomorphism between the receiver's and the sender's experience of a film. In this paper, he gives several examples of possible viewer interpretations of a film (*Red Desert*, by Antonioni) and concludes that

most film communication is not . . . the perfect correspondence between the feeling-concern, the story-organism, and the image-events they dictate, and their reconstruction by the viewer. Most film situations, depending as they must on the maker and his context (both social and psychological), the viewer and his, and the film itself, are imperfect communicative situations.

Note, however, that perfect communication is still defined as the achievement of isomorphic correspondence; context and other factors are still viewed as "imperfections" which muddy the communicative stream.

film as the language of visual communication ●

Despite their unfortunate devotion to the mirror-image model, these early papers were valuable for an understanding of film as communication. By using an approach that drew upon linguistics, communications theory, and psychology, Worth was explicitly differentiating himself from the evaluative concerns of film theorists who approached film primarily as an art form. The title of his 1966 paper, "Film as a Non-Art," was meant provocatively to assert this emphasis on looking "at film as a medium of communication, rather than as an art or an art form" (1966:322). He was determined that we understand the "difference between evaluation and meaning" (ibid.: 324):

My concern is not whether film is art or not, but whether the process by which we get meaning from film can be understood and clarified. . . . While all art might be said to communicate, all communication is certainly not art. [Ibid.]

Having elaborated a model of the film communication process, he saw as the next step the analysis of the mediating agent—the film itself.

The study of the Image Event . . .—its properties, units, elements, and system of organization and structure that enable us to infer meaning from a film— should be the subject of our inquiry, and of our professional concern. [Ibid.]

In pursuit of this inquiry, Worth followed the analytical paths laid down by linguists in describing and analyzing the structure and functioning of lexical communication. He adopted, in fact, the heuristic strategy "that film can be studied as if it were the 'language' of visual communication, and as if it were possible to determine its elements and to understand the logic of its structure" (ibid.:331). Worth called this visual analogue to linguistics *vidistics,* and pro-

ceeded to elaborate a model of filmic elements and principles of organization based on those of structural linguistics.

Vidistics in this early stage is concerned, first, with the determination and description of those visual elements relevant to the process of communication. Second, it is concerned with the determination of the rules, laws and logic of visual relationship that help a viewer to infer meaning from an Image Event, and the interaction of Image Events in sequence. Film as if it were language, as studied vidistically, is thus thought of as the study of specified elements, elements in sequence, operations on these elements, and cognitive representations of them that act as a mediating agent in a communication process between human beings—between a filmmaker and a viewer—between a creator and a re-creator. [Ibid.:331]

Worth presented his solution to the first of these questions—the identification of the basic filmic unit, or visual element—through an account of the development of the film medium and of the theories that accompanied its growth. This account, given first in his 1968 paper "Cognitive Aspects of Sequence in Visual Communication," was elaborated in the 1969 paper (chapter 1). After presenting various theorists' positions, Worth casts his vote with Eisenstein (1949), who isolated the "shot" as the basic element, or, in Worth's words, "the smallest unit of film that a filmmaker uses." This seemed "the most reasonable" choice, "not only because it is the way most filmmakers construct films, but because it is also possible to describe it fairly precisely and to manipulate it in a great variety of controlled ways."

Moreover, the Navajo filmmakers "who were taught only the technology of filmmaking without any rules for combining units seemed 'intuitively' to discover the shot as the basic sign for the construction of their films." However, as Worth himself noted in his historical account, the first filmmakers saw the "dramatic scene" as the basic film unit. This was essentially a theatrical concept: "the first filmmakers pointed the camera at some unit of action and recorded it in its entirety." It took several years before Porter, in 1902, discovered that "isolated bits of behavior could be photographed and glued together to make a scene." In retrospect, we might wonder how naive the Navajo actually were (most had seen at least some commercial films) or whether Worth had been able to limit his instruction, as intended, to "the technology of filmmaking without any rules for combining units."

Worth used the term *videme* for Eisenstein's basic unit of film communication (the shot), previously called by Worth an image-event, "that is accepted by viewers as something that represents the

world" (1968:13). However, in 1969 Worth argued that a finer distinction was required "if we are to attempt further scientific analysis. . . . The shot is actually a generic term for two kinds of shots: the 'camera shot' and the 'editing shot.' " The camera shot, which Worth called the *cademe,* is "that unit of film which results from the continuous action of the movie camera . . . from the moment we press the start button to when we release it." The editing shot, called the *edeme,* is "formed from the cademe by actually cutting the cademe apart and removing those segments one does not wish to use" (1968:14). The process of filmmaking, then, involves the shooting of cademes and their transformation (in whole or part) into edemes.

It is then possible to sequence these resultant edemes in ways that are determined by the individual filmmaker, his communication needs, his particular culture, and his knowledge of the "language" of film.

The edeme thus becomes the hypothesized basic element and building block of the language of film upon which all language operations are performed, and a basic image-event from which all meaning is inferred (1968:14). Much of the balance of the 1968 paper was devoted to a discussion of parameters along which this basic element can vary. This discussion has much in common with the work of other writers on film (for example, Spottiswoode 1935), who used the "film language" concept. However, Worth felt that "none of these authors developed a theory of grammar embodying 'linguistic' elements or rulelike organization capable of syntactic structures" (1968:12).

In Worth's linguistic analogy, the parameters of motion, space, and internal time in the film are thought of as semantic elements. Sequence, however, including the manipulation of apparent time, belongs to the syntactic aspects of film "language" because it deals with more than one edeme at a time. "Sequencing edemes can be thought of as applying syntactic operations to edemes. This does not in itself imply a code, a set of rules, or a grammar—but it does make it possible to test visual communication phenomena along these lines" (1968:17f.). Sequence becomes the fulcrum upon which Worth supported his analysis of filmic communication:

Sequence is a strategy employed by man to give meaning to the relationship of sets of information, and is different from series and pattern. As I will use the word here, *sequence* is a deliberately employed series used for the purpose of giving *meaning rather than order* to more than one image-event and having the property of conveying *meaning through* the sequence itself as well as through the elements in the sequence.

Man imposes a sequence upon a set of images to imply meaning. [1968: 18. Emphasis in original.][4]

However, at this stage, Worth was still preoccupied with the quest for a universal vidistic syntax analogous to those identified by linguists and psycholinguists in the analysis of lexical communication. Following Chomsky (1957), he saw the goal of vidistics as the development of a grammar of film syntax, "whose rules we can describe in such a way that we can distinguish between what is a grammatical sequence and what is an ungrammatical sequence" (1966:334). Unfortunately for this enterprise, Worth admitted that he found "it almost impossible at this point to construct a sequence of shots that an audience will say is ungrammatical" (ibid.). Not willing to discard the concept of grammaticality in film, Worth hoped to utilize the notion of a semantic space having dimensions of meaning such as that developed by Charles Osgood to arrive at "a grammar of probability, a system of possible, of more or less meaningful, sequences based on a concept of dimensions of syntax" (ibid.).

This prospect was explored in a series of studies that Worth conducted along with Shel Feldman, a psychologist then at the Annenberg School. Some of this work was sketched in his 1968 paper and further publications were promised, but events led him to other approaches and this line of investigation was dropped.

the semiotic model ●

Two factors played a role in shifting Worth away from the attempt to formulate a psychological and linguistic model of film communication. First, the Navajo project, which might have served to intensify his search for a universal "psycho-logic" of visual syntax, "determined by cognitive processes that all human beings share" (1966: 339), demonstrated instead that members of a culture developed film "syntax rules" which could be related to their lexical syntax, and to their patterns of storytelling and their systems of value and belief.

Second, as he read more widely in linguistics and, increasingly, in the literature of semiotics—de Saussure, Peirce, and Morris— Worth found his central concern shifting to the role of social and

4. Later, in our joint paper, "Symbolic Strategies" (1974, chapter 5 in this volume), this terminology was significantly altered. As the general term for intentionally articulated arrangements of elements, Worth and I used the term *order*; we used *sequence* to designate temporal orderings of sign elements, and *pattern* to designate spatial orderings. In contrast to *order*, we used the term *contiguity* to designate the "juxtaposition of units or events over time, space, or position," where the perceiver does not assume that this arrangement was *intended* to imply meaning(s).

cultural influences, and away from the psychological and psycho-
linguistic models that he had earlier employed.[5] Rather than a gram-
mar of film as the language of visual communication, he now looked
to the broader scope of semiotics for an understanding of the rules
by which we make inferences from sequences of signs:

The development of a semiotic of film depends not on answering linguistic
questions of grammar, but on a determination of the capabilities of human
beings to make inferences from the edemes presented in certain specified
ways. [Chapter 1]

This shift permitted Worth to place the linguistic model in a
perspective which had previously eluded not only him but many
other film scholars. As he noted, "most theoreticians from Eisenstein
to Bazin have at one time or another used phrases such as 'the
language of film,' 'film grammar,' and 'the syntax of film' " (chapter
1). More insidiously, these metaphoric uses often served more as a
hindrance than as an aid to the understanding of film communica-
tion. Film was all too often stretched on a Procrustean bed of linguis-
tic models and its contours destroyed in the attempt to fit it to an
uncongenial frame. Worth came to the realization that tremendous
care must be taken if one is to use "that most scientific of sign
disciplines" for the study of film. He returned to his initial concep-
tion of the linguistic approach as a heuristic strategy with a far more
modest estimate of its utility. The strategy had, however, led him to
a better understanding of how film might be scientifically analyzed.

I am suggesting, then, that linguistics offers us some fruitful jumping-off
places for the development of a semiotic of film, but not a ready-made body
of applicable theory leading to viable research in film. If we accept
Chomsky's definition of language, we must be forced to conclude that film
is not a language, does not have native speakers, and does not have units to
which the same taxonomy of common significance can be applied as it can
to verbal language. At this point, our aim should not be to change the
definition of language so as to include the possible rules of film, although this
may well be a result of further research in film, but rather to develop a
methodology and a body of theory that will enable us to say with some
certainty just how it is, and with what rules, that we make implications using
film signs with some hope of similar inferences. [Chapter 1]

5. A major influence on Worth's thinking at this time was the emerging field of
sociolinguistics. In particular, he was impressed with the work of Dell Hymes, who
had come to the University of Pennsylvania in 1965.

In most of his work after 1969, Worth followed this prescription, but his focus shifted from film in particular to the larger class of visual images in general, and, although the two sides of the communications process were always taken into account, increasingly his primary objective was to understand better how meaning is interpreted by viewers, rather than how it is articulated by the imagemaker. Before discussing these investigations, however, I want to turn to some important papers in which Worth applied the lessons of his theoretical research to the practice of those engaged in the use of visual media in anthropology and education.

the politics of anthropology ●
The most immediate application of Worth's emerging semiotic approach to film communication was in the field of anthropology. I have already mentioned his involvement with the subdiscipline of visual anthropology. With the completion of the Navajo project, Worth found himself near the center of a growing "invisible college" of anthropologists interested in going beyond the limited uses of visual media characteristic of most work in the field. Visual anthropology, despite the important early contributions of Bateson and Mead, had come, for the most part, to mean the taking of photographic or film records in the field and the use of these materials as illustrations to accompany verbal accounts or as "evidence" uncritically accepted as objective records of objects and events.

In a paper presented to the American Anthropological Association in 1968, entitled "Why Anthropology Needs the Filmmaker,"[6] Worth took strong exception to these assumptions and to the biases and limitations that they entailed. In the first place, he maintained that we could not simply accept photographic or film images as "evidence," because they always reflect human decisions (conscious and unconscious) and technological constraints.

Further, he argued that by defining film exclusively—and naively—as a record *about* culture, anthropologists tended to ignore the study of film as a record *of* culture, "reflecting the value systems, coding patterns, and cognitive processes *of the maker*" (chapter 3, below). Here, in addition to the obvious echoes of the Navajo project, Worth is explicitly drawing upon Hymes's concept of the "ethnography of communication," in which one is interested in what things are said (or not said), why, to whom, and in what form.

As a corollary of this position, Worth was led to the view that

6. A revised version, published in 1972, is included as chapter 2 of this volume.

any film can be used for ethnographic analyses—of the culture of the film's subjects, or of the filmmaker, or both: consequently

there can . . . be no way of describing a class of films as "ethnographic" by describing a film in and of itself. One can only describe this class of films by describing how they are used and assigning the term *ethnographic* to one class of descriptions.

Worth's argument was controversial, for it implicitly denied the inherent ethnographic validity of much "anthropological film"; a film was not ethnographic just because an anthropologist made it. In fact, he went much further and attacked the "visual anthropologists" for their lack of sophistication in the use of film, a condition that contributed in part to their naive view of film as "objective record":

The only group of professionals involved in the making and use of anthropological films who have no training at all in the making, analysis, or use of film are anthropologists. One can count on the fingers of both hands the anthropologists who are trained to study films, not as a record of some datum of culture, but as a datum of culture in its own right. [Chapter 3]

By the late 1960s, Worth was actively engaged in efforts to change this state of affairs. He was involved with the American Anthropological Association's Program in Ethnographic Film (PIEF), and, in 1970, in collaboration with Margaret Mead and others, he helped to found the Anthropological Film Research Institute at the Smithsonian Institution. In the summer of 1972, he organized and taught, along with Jay Ruby, Carroll Williams, and Karl Heider, a summer institute in visual anthropology funded by the National Science Foundation. That fall, at the annual meeting of the American Anthropological Association, Worth was instrumental in the transformation of PIEF into the Society for the Anthropology of Visual Communication. He served a term as president of the society and was the founding editor of its journal, *Studies in the Anthropology of Visual Communication.*[7] The society and the journal provided a continuing forum and context in which Worth and others could advocate and demonstrate the rich potential of the approach that they represented.

the ethics of anthropology ●
The issues that Worth was raising in the late 1960s and early 1970s did not exist in a vacuum; they were very much in the air of the times.

7. As of the spring 1980 issue (6:1), the name of the journal was changed to *Studies in Visual Communication.*

Anthropologists, along with the rest of academia, were facing political and social realities that called into question many of the untested assumptions of their discipline. In 1972 Dell Hymes edited a volume of essays (entitled *Reinventing Anthropology*) in which sixteen authors discussed the field as a product of "a certain period in the discovery, then domination, of the rest of the world by European and North American societies" (Hymes 1972:5). The essays in the book addressed many assumptions, biases, and limitations of anthropological theory and practice, exposing flaws and ethical problems, and questioning whether it was possible to "reinvent" a more responsible and self-conscious discipline.

Worth contributed a chapter to this book, entitled "Toward an Anthropological Politics of Symbolic Forms" (included as chapter 3 in the present volume), in which he explicated many of his concerns about the way anthropologists have used and misused, understood and misunderstood, the visual media in studying and reporting about various groups around the world. He identified a series of intellectual and ethical problems that have resulted from the development and diffusion of visual communication technologies.

For the field of anthropology, Worth argued that "an ethnography of communication developed on the basis of verbal language alone cannot cope with man in an age of visual communication." He maintained, as I have already noted, that the naive belief in film as objective record must give way to a more sophisticated understanding and use of visual media as research tools and of visual images as research data.

Worth also criticized the inertia of academic disciplines which leads us to "continue examining and thinking about only inherited problems, rather than those problems and modes our children, our students, and even ourselves pay most attention to." We must, he felt, begin to recognize the growing centrality of the visual media in all cultures, not only in Western industrial society. He spelt out in this paper some of the ways in which social scientists can become more sensitive students of contemporary "visual culture."

The ethical problems that he articulated are more difficult to resolve. When Worth first began to develop the biodocumentary method, he saw it as a way to learn "how others see their world," to "make it easier for them to talk to *us*" (1965:19). The Navajo project was an expression of his belief in the potential of film to reverse the one-way flow of most anthropological communication. But in this paper, he reveals a considerably less sanguine view of the role of visual media in the lives of "others" in the modern world.

The Navajo project, carried out in 1966, had as one of its aims

the study of the "guided" introduction of a communications technol-
ogy into a new cultural context. By 1972, however, Worth was all
too aware of the realities of technological diffusion in the modern
world. For most cultures and societies, the question is not whether
they will encounter and come to live with these new visual media,
but when and how: "In teaching people to read, we implicitly teach
them what to read. . . . The use of a mode of communication is not
easily separable from the specific codes and rules about the content
of that mode." One central problem, therefore, is that our technolo-
gies may carry with them "our conceptions, our codes, our mythic
and narrative forms," unless we also make clear to other cultures that
these new media *need not* be used only in the ways of the . . . societies
that introduce them."

Another ethical question raised in this paper focused on the
importance of control over information as an instrument of power.
Worth noted that "anthropologists . . . are notorious for studying
everyone but themselves." Is it appropriate for us to encourage others
to reveal themselves, when we do not? As visual technologies spread
to groups in our society and to other cultures unused to manipulating
these media,

what is our responsibility to help them to understand a world in which their
every act of living can be televised and viewed by a watching world? . . .
Should we teach them not only to make their own films but to censor ours
as well? The problem as I see it is: What reasons do we have *not* to insist that
others have the right to control how we show them to the world?

film in education ●
Although I have concentrated on Worth's extensive involvement
with anthropology, some of his earliest academic endeavors were in
the field of education. His interest in this area was revived in 1971
when he was invited to contribute to a yearbook of the National
Society for the Study of Education that was to focus on communica-
tion and education. He agreed to write a paper on the use of film in
education, and he took the opportunity to draw together and to
clarify several strands in his previous and current thinking (the paper
is included as chapter 4 of the present volume, "The Uses of Film in
Education and Communication").

Worth began by examining three perspectives that he saw as
exercising major—and pernicious—influence on "the educational
and film communities" but which had "very little research evidence
in their support." First, and most intensely, he takes issue with Ru-
dolf Arnheim's position, which he characterized as "visual primacy."

Worth argued that Arnheim's theory of "visual thinking" carries to an unreasonable extreme the "reasonable assertion that visual perception contains, or is part of, what we normally call 'thinking.'" This is, I believe, a fair characterization of Arnheim's work, and Worth goes on to pinpoint some of its major flaws. Rejecting in Arnheim an extreme version of the psychological, perceptual-cognitive bias that he himself had earlier manifested (although he had never espoused such an extreme "Gestalt" position), Worth concluded that Arnheim "underestimates or denies the extent to which symbolic systems or conventions mediate our knowledge of the world."

Arnheim's theory of visual primacy, Worth felt, led him to deny the crucial role of culture in determining what and how we "see": "True visual education presupposes that the world can present its inherent order to the eye and that seeing consists in understanding this order" (Arnheim 1966:148). In contrast to this position, Worth aligned himself with most contemporary thinkers in saying that "what we see and what we think about is determined at the least as much by our symbolic systems and conventions for representing that universe as by the universe itself."

Worth went on to outline two other perspectives—those of certain film theorists (represented by Gene Youngblood) and film educators—which he felt were as inadequate and misleading in their own areas as Arnheim was in his. What these criticisms have in common is Worth's dismay at the failure of so many researchers and educators properly to understand or utilize film as a process of communication.

In the remaining sections of the paper, Worth presented his own current view of how film could be understood as communication and how knowledge of this process enables us to use film in the process of education.

He restates an abbreviated version of the feeling-concern/story-organism/image-event model (these terms are not always used), but with several significant modifications. In this account, the complexity and nonlinearity of the filmmaking process is now emphasized, moving the model away from the misleading implication that the filmmaker moves in strict, irreversible steps from feeling to story to image sequence. However, the model is still conceived in "single author" terms. This is shown explicitly when Worth describes the completion of filmmaking: "At some point, [the filmmaker] decides to 'release' his film. It is now no longer a personal act but a public and social one; it is a symbolic form, available for participation in a communication process."

Worth was ready, however, to abandon the mirror-image model of viewer reception, if somewhat reluctantly:

When another person sees this film, he must (depending on how one talks about such acts) receive it, decode it, or recreate it. Since meaning or content does not exist within the reel of acetate, the viewer must recreate it from the forms, codes, and symbolic events in the film. . . . For communication to occur, meaning must be implied by the creator and inferred by the viewer or recreator.

Note that while perfect communication is no longer defined in terms of the viewer's ability to trace the filmmaking process in reverse and reach the author's feeling-concern, the terminology suggests an ambivalence that probably reflects a genuine state of intellectual transition. Worth shifts among "receive," "decode," and "recreate" to describe the viewer's role in the process of communication, still echoing the isomorphic implications of "recreation" as he had used the term in earlier papers. Yet he also makes explicit the role of "conventions through which meaning is transmitted between people by a process of implication and inference."

Worth was now coming to focus more and more on the process of interpretation—how meaning is created by viewers—rather than on the process of articulation by imagemakers, his primary concern in the biodocumentary and Navajo projects. In order to clarify the importance of this shift, I have to backtrack to an earlier stage in Worth's work.

ignoring interpretation ●
In one of his earliest papers, Worth had introduced a discussion of audience reactions to his students' films with the comment that "perhaps, in an attempt to understand a particular act of communication, we can approach understanding by examining the reaction to the act, rather than the act itself" (1965:3).

In most of his work over the next six years, however, Worth focused more on the act of making than on that of interpreting meaning from images. In the study of biodocumentaries made by various groups in our society (reported in Worth and Adair 1972, chapter 15), and in the Navajo project, it was the films and the activity of the filmmakers, not the viewers, that Worth was interested in.

In his 1966 paper, "Film as a Non-Art," Worth appeared willing to forgo the investigation of the interpretive side of the communication process:

This particular area of study—the interaction between persons and groups and the stimuli they relate to—has been undertaken by the social and behavior scientists. Although relevant to our interests, the specific study of the

relationships between people and events cannot be the professional concern of those interested in visual communication. [1966:330]

Although I believe that in this remark he was primarily attempting to distance himself from an overly subjective approach which centers on individual viewers' reactions, Worth also was clearly advocating the priority of the "study of the image-event" itself.

The extent of this bias is shown by the perfunctory way in which Worth and Adair assessed the reactions of other Navajo to the films made by their fellows. The account which they give of the films' world premiere on the reservation (attended by sixty Navajo) is the shortest chapter in their book, but it is most revealing (1972:128–31).

They make clear the fact that the idea of holding the screening at all originated with the filmmakers, not the researchers. More important, the account reveals how unprepared they were for this crucial opportunity to investigate the interpretations and responses of the Navajo viewers. Only nine viewers were questioned, and the questions failed fully to explore their reactions.

Two of the Navajo reported that they did not understand certain of the films. These were films judged by Worth and Adair to be "somewhat outside the framework of Navajo cognition," in either form or subject matter (ibid.:130). The way in which these viewers expressed their lack of understanding was to say that they could not grasp the meaning because the films "were in English." This is a most intriguing response, considering that none of the films had any sound at all. However, Worth and Adair continue, "since these interviews were conducted in Navajo, we didn't see the translated tapes until we left the reservation and have not been able to question our informants further along these lines" (ibid.:131).

By the early 1970s, in contrast, Worth was clearly insisting on the need to include the perspectives of both the interpreter and the imagemaker within the scope of investigation. In part, as I have indicated, this insistence was influenced by Hymes's advocacy of an "ethnography of communication."[8] However, in order to fully describe the development of Worth's work at this time, I have to discuss my own involvement with it.

8. Richard Chalfen, who had assisted on the Navajo project, was at that time conducting dissertation research that combined the approaches of Worth and Hymes. Chalfen used the term *sociovidistics* to designate an "ethnography of film communication" (Chalfen 1974, 1975).

personal interlude ●

I met Sol Worth in the spring of 1968 when I visited the Annenberg School for the first time. My decision to join the faculty of the school (as opposed to taking a job in the field—social psychology—in which I had just received a Ph.D.) was motivated in large part by Worth's presence. It was immediately clear that we shared a strikingly similar set of interests and intellectual inclinations, and it was Worth who convinced me that my interests in the study of art and culture could be pursued far more readily in a communications program, where they were seen as central, than in a psychology department, where (as I already knew) they would be seen as peripheral. Certainly my experience with the subfield of the psychology of art had been disappointing: those who seemed to have a feeling for art used poor psychology (for example, Arnheim), while those who were psychologically rigorous did not seem to understand art (for example, Berlyne). The field of communications, at least as it was represented at the Annenberg School, appeared to offer a framework in which the varieties of symbolic behavior (especially the kinds that we call art) could be studied with a sensitivity to the role of psychological, social, and cultural determinants.

From the outset, Worth and I engaged in discussions and arguments which helped both of us to clarify and, I hope, to improve our understanding of communications phenomena. In these discussions, I made clear my belief that the interpreter's role was at the center of the communicative process. Put most simply, I argued that before one could become a "sender," one had to become a "receiver." The competence needed for articulation derived in large part from one's prior experience in interpretation. Specifically, in the realm of art, I maintained that "the process of artistic creation itself presupposes and arises out of the process of appreciation" (Gross 1973:115).

This position reflected two basic considerations. The first was the simple fact of ontological sequence: we all encounter symbolic events first as consumers and only later, if at all, as producers. "Only upon the basis of the competence to appreciate meaning presented in a symbolic mode can one hope to achieve the realization of creative potential in that mode" (Gross 1974:71).

Second, I was arguing that symbolic behavior occurs in a variety of distinct modes, and that meaning can be understood or purposely communicated only within these modes. "These modes are partially but not totally susceptible to translation into other modes. Thus they are basically learned only through actions appropriate to the particular mode" (ibid.:57).

Two papers which I wrote in 1971–72 presented the outlines of

a theory of "symbolic competence" and aesthetic communication that incorporated this position (1973, 1974). These papers and the theory which they presented owed much to Worth's influence. At the same time, my views and emerging theoretical formulations helped to shape his views on a number of issues. Worth's paper on film and education (chapter 4) reflects our discussions. By the fall of 1971, these discussions had led, by way of an informal research seminar that we conducted, to collaborative projects carried out by several of our students and, eventually, to a joint paper (chapter 5 in this volume).

This paper, "Symbolic Strategies," written in 1972–73 and published in 1974, presents the outlines of a theory of interpretation—the assignment of meaning to objects and events. The model introduced in this paper figures importantly in Worth's subsequent writing, and, because our discussion of it was sometimes unclear or incomplete, I will risk the appearance of immodesty by discussing its contents in somewhat greater detail than I have devoted to the other papers in this volume.

interpretive strategies ●
The questions that we focused on in our discussions and research centered on the peculiar properties of visual images. Although our paper addressed the general issue of how people assign meaning to objects and events, in retrospect it seems clear that we were primarily concerned with the visual mode in general, and film or photographic images in particular. The basic question that we were asking might be put in this way: What can we "know" from these images, and how can we know it? We felt that the first step toward an answer was to draw two basic distinctions in describing interpretive processes.

We first made a distinction between those objects and events that do, and those that do not, "evoke the use of any strategy to determine their meaning." Most of the objects and events that we encounter in life are interpreted "transparently," in the sense that we "know what they mean" without any conscious awareness of any interpretive activity. We generally respond to their presence (or absence) in a way that indicates (analytically) that a process of tacit interpretation has occurred: our behavior has been affected by the presence (or absence) of some object or event in some fashion. We simply have not needed to "think about it." Such tacit interpretations range from our "unthinkingly" extending our hand to open a closed door when we leave a room to our ability to drive a car along a familiar route while absorbed in conversation or reverie.

Worth and I used the term *nonsign-events* to identify the events

that we ignore, or code "transparently." The objects and events that do evoke an interpretive process, we called *sign-events*. However, we continued, these are not predetermined or fixed classes:

It is important to note that the distinction between sign- and nonsign-events must not be taken as a categorical classification of persons, objects, and events. Any event, depending upon its context and the context of the observer, may be assigned sign value. By the same token, any event may be disregarded and not treated as a sign.

The purpose of this first distinction, therefore, was not to isolate two kinds of objects and events in the world, but to distinguish two ways in which we respond to the presence or absence of objects and events. Having made this distinction, we turned our attention to the ways in which sign-events are interpreted. Our second discrimination was between those sign-events which we called *natural* and those which we called *symbolic*.

Natural events, as we used the term, are those which we interpret in terms of our knowledge (or belief) about the conditions that determine their existence. The meaning of these events for us, in fact, can be said to derive precisely from those existential conditions. The events are informative about the stable or transient conditions of the physical, biological, or social forces that determined their occurrence (or nonoccurrence) and configuration. The important point here is that while we assign meanings to such events on the basis of knowledge (or belief) about the forces that caused them to exist, we do not see them as having been caused (to any important degree) in order to convey these meanings to us. Therefore, while they inform us about those factors which we assume (or know) to have caused their occurrence, we do not sense an authorial intent behind them.

Natural events may be produced by either human or nonhuman agency. "However, the signness of a natural event exists only and solely because, within some context, human beings treat the event as a sign." To give a simple example, if I observe a tree bending in the wind, my knowledge of meteorology may lead me to interpret it as a sign of a coming storm. My interpretation is based upon my knowledge of the forces that caused the event to occur.

Similarly, I may decide that a person whom I observe on the street is a former member of the armed forces because I notice that he has a crew cut, a very erect posture, and walks with a slight limp. In this case I would be basing my interpretation upon stereotypic knowledge of the factors that would result in this configuration of characteristics. Needless to say, I could be mistaken. The point, of

course, is that I would be treating the signs that I attended to as informative about stable or transient characteristics of the person whom I observe and of their interactions with the situation in which I observe that person.

In contrast, symbolic events are events that we assume to have been *intended* to communicate something to *us*. Further, we assume that these events are articulated by their "author" in accordance with a shared system of rules of implication and inference. That is, they are determined not by physical or psychological "laws" but by semiotic conventions. To assess a sign-event as symbolic, then, is to see it as a "message" intended by its "author" to imply meaning(s) that can be inferred by those who share the appropriate code.

If I were to observe, for example, that the man whom I saw on the street, in addition to having a crew cut, erect posture, and a slight limp, wore a lapel pin which read "V.F.W.," I could then draw the inference that he was, in fact, a veteran and, moreover, that he was communicating rather than merely manifesting this characteristic (I leave aside the obvious possibility of deception, both communicative and "existential").

Worth and I called the interpretation of natural events *attribution,* and the interpretation of symbolic events *inference.* The former term was adapted from the area of attribution theory within the field of social psychology. Originally developed by Fritz Heider in the 1940s and revived in the late 1960s by Harold Kelley (1967) and others, attribution theory focuses on the process by which individuals interpret events "as being caused by particular parts of the environment" (Heider 1958:297). However, our use of the term *attribution* as a label for the interpretation of natural events is narrower than that used in social psychology, because we limited it to those interpretations that do not assume authorial intention.

On the basis of these distinctions, we proposed a definition of communication that, in effect, is limited to the articulation and interpretation of symbolic events: *"Communication* shall therefore be defined as *a social process, within a context, in which signs are produced and transmitted, perceived, and treated as messages from which meaning can be inferred. "*

Although I have been speaking as though natural and symbolic events could be easily distinguished from one another, we were aware that this is not always the case and were particularly interested in those not obviously and easily defined as natural or as symbolic. We were interested, that is, in what we termed *ambiguous* meaning situations.

Most of the time there is little difficulty in deciding whether an object or event that we notice is natural or symbolic. Most people who observe the wind bending a tree outside their window and

decide to take an umbrella when they go out would not think that the wind was "telling" them that it might rain. Similarly, if we meet someone who speaks English with a distinct accent, we may attribute foreign origin to the person, but we are unlikely to decide that the accent was intended to communicate the speaker's origin; however, if we find out that the speaker migrated to this country many years before, at an early age, we may wonder about that assessment.

When we encounter a symbolic event, on the other hand, we are likely to see it as intentionally communicative. We usually have little difficulty recognizing such events as communications addressed to us as individuals or as members of a group, provided that we know the code. And we usually have little difficulty interpreting them, again providing that we know the code. Traffic lights are rarely mistaken for Christmas decorations.

One further clarification needs to be made. We were focusing on the perspective of the person who observes the sign-event and interprets it. A sign-event is symbolic (that is, communicative) *only* if it is taken as having been formed (to an important degree) with the intent of telling something to the *observer*. That is, if the observer is watching two people converse and knows that they are unaware that they are being observed, their conversation, while it is a communicative event for *them*, is a natural event for the observer. It was not intended to tell the observer anything, so it can only be seen as informative about the speakers' stable or transient characteristics as revealed in that situation. Of course, certain aspects of the observed event, such as the participants' clothing or hairstyle, might be assessed as being "messages" addressed not just to the other participant but to the "public" at large; these aspects might then be assessed as symbolic vis-à-vis our observer.

life versus art ●
With all of these concepts in mind, we turn to events that we encounter not through direct observation but through photographs or film. Here we find the situation to be more complex, and more interesting. The point of the exercise, really, was to develop a way of dealing with the interpretation of those mediated events (although mediation can occur through words and paintings, and so forth, as well, photographic or film mediation is the most ambiguous, and therefore the most interesting case).

In our paper, we make the suggestion (supported by empirical studies) that there is a learning process by which we come to know how to interpret mediated symbolic events such as films.[9] At the

9. This process is summarized in figure 5-2 in chapter 5 of this volume.

simplest level, we merely recognize the existence of persons, objects, and events in the film and make attributions about them based on our stereotypic knowledge of such things in real life. With somewhat more sophistication, we can see relationships between objects and events that are contiguous in time or space: they go together. The crucial step, then, is to see this contiguity as the result of an intention to tell us something—to see it as a sequence or pattern that is ordered "for the purpose of implying meaning rather than contiguity to more than one sign-event and having the property of conveying meaning through the order itself as well as through elements in that order."

The final stage in this hierarchical process occurs when we recognize the structure of a sign-event; that is, we become aware of the relations between noncontiguous elements and their implicative-inferential possibilities: the beginning and end of a story, variations on a theme, prosodic patterns, and so forth.

When we look at a scene recorded on film, we need to decide whether the event was (among other possibilities): (1) "captured candidly" as it unfolded naturally in front of the camera, with the participants seeming not to know they were being filmed; (2) photographed unobtrusively, so that while the participants knew about it, it was done in such a way that they "almost forgot" that they were being filmed; or (3) scripted, staged, and directed by an "author" working with actors.

If we settle on the first alternative, we are likely to feel justified in making attributions about the persons in the film (their characteristics, their feelings, their relationships, and so forth). If we choose the second alternative, we may be somewhat less confident in making such attributions, since we will feel that the behavior we observe was somewhat constrained by the subjects' knowledge that they were being filmed. That is, their behavior may be less informative because we know it is also "messageful."

If we take the third alternative, we are less likely to make attributions of the former sort; here we will interpret the scene in light of our knowledge of dramatic conventions. These conventions may be nearly the same as the attributional stereotypes which we use in the first two instances (and consequently might lead us to similar interpretations), and this is not surprising: naturalistic conventions in drama aim precisely at evoking attributional knowledge in order to convey "lifelikeness" to characters and situations. However, the interpretations need not be the same. We may "know" that the cowboy in the black hat is the bad guy without also believing that anyone we see in real life wearing a black hat is a criminal.

The point is that although events encountered in "life" and in

"art" may look the same, we make different assumptions about the factors that determine their occurrence and configuration. Because the conclusions reached may be the same, in order for a researcher to decide whether an interpretation is attributional (the observer is assessing the event as "life"—a natural event), or inferential (the observer is assessing the event as "art"—a symbolic event), one needs to know the grounds on which the conclusions would be justified. If asked how we know something that we have concluded about an event we have observed, we might say that we have based our conclusions on what we know about the way such things happen (attributional interpretation); or we might say that we know it because we are assuming the event was made to happen that way in order to tell us something (communicational inference).

Worth and I hoped that this model would clarify some issues that Worth had addressed in earlier papers. Most immediately, it allowed us to say that the tendency to see films as objective records of events rather than as a filmmaker's statement about events derived from a confusion of interpretive strategies. Worth had attacked the naiveté of many anthropologists and others who were filmically unsophisticated, who assumed that filmed events could be uncritically interpreted as "natural." What such viewers failed to understand was that all mediated events are to some degree symbolic. The mediating agent always makes decisions—about what to shoot (and consequently, what not to shoot), and how; and having shot, about how to edit the footage (one rarely sees raw footage); and, finally, about when, where, and how to exhibit the edited film.

A sophisticated viewer will recognize that the persons, objects, and events in a film are there, at least in part, because the filmmaker included them intentionally; that the sequence of events in the film has been ordered by the filmmaker's intention to say something by putting them in that order (which may not be the order they actually occurred in); and that the overall structure of the film reflects the filmmaker's intention, and ability, to use implicational conventions in order to communicate to viewers competent to draw the appropriate inferences.

From this perspective, it should be clear why Arnheim's statement that "the world can present its inherent order to the eye" and that "seeing consists in understanding this order" so infuriated Worth. This view, he felt, led to mistaken theories of film such as Youngblood's advocacy of a cinema that was "entirely personal, . . . rests on no identifiable plot and is not probable. The viewer is forced to create along with the film" (Youngblood 1970:64). Worth's response to this was fierce:

Tyros in the arts always forget that creation and originality cannot even be recognized (or perceived) except within a context of convention and rulelike behavior—especially in the arts. It is not within the context of an ordered universe that art exists, but rather within the context of man's conventions for ordering that universe. [Chapter 4]

cracking the code ●

In the period following the initial development of our theory of interpretation, Worth devoted much of his attention to the elaboration and extension of this approach to understanding how people derive meanings from visual images. He was interested in exploring both the properties which were unique to visual communication and those which could be generalized to other symbolic modes. One of his first efforts in the latter direction came in response to a request that he prepare a commentary on a special issue of the periodical *New Literary History* devoted to the subject of metaphor.

Worth began his paper, entitled "Seeing Metaphor as Caricature" (chapter 6 in this volume) with the observation that "every author [in the issue] 'assumes' that metaphor is a verbal event—a verbal 'thing' of some sort." He then posed the question of whether —and how—the concept of metaphor could be applied to events in other modes. The answer he gave was that "metaphor is a structure composed of elements in any mode . . . related in certain ways." The rest of the paper was largely directed toward an analysis of the metaphoric possibilities of visual images and the argument that "visual structures can clarify a general and abstract notion of metaphor."

Worth described several examples of filmic metaphors and said that the problems they raise are those of interpreting "syntactic forms for nonverbal matters about which we have very little social agreement." How do we know what such metaphors mean?

As an example, Worth explains that when Eisenstein used a sequence in his film *Strike* in which a close-up of a factory foreman who has informed the cossacks about a coming strike is followed by a close-up of a jackal, audiences interpret this as "akin to the verbal notion of 'the informer is a jackal.' " Or, to repeat an earlier example, we "know" that the cowboy in the black hat is the bad guy. Worth's point here was that the understanding of metaphor depends upon our ability to apply the correct interpretive strategy to infer the implied meaning: "Metaphor is a communicational code depending upon the recognition of structure and the assumption of intention on the part of the 'articulator' . . . of the form we are to treat as metaphor."

For example, it is our recognition of metaphoric intention that tells us that Eisenstein has sequenced his shots in order to imply that

foreman = jackal and that we should not read these as merely contiguous events. In this case, the brief introduction of the jackal shot as a "break" in the plot signals us that it is a metaphoric comment, rather than a narrative development. "The important point is that every culture provides its 'native speakers' in any mode with a code for interpretation."

Worth devoted the second half of the paper to an analysis of caricature as visual metaphor. Using the theory of a contributor to the volume (Sparshott) that metaphor is "talking about something as it is not," Worth suggests that "metaphor might most fruitfully be understood in comparison with theories and concepts of caricature rather than with theories of representation." Noting that verbal metaphors are statements that are neither literally true nor false, Worth says that a caricature is

a structure that reveals a set of meanings intended to communicate a certain set of relationships within some understood or understandable context and bounds. . . . A caricature is . . . a structure that relates several elements on one level (in shorthand—that of "reality") with elements on another (the symbolic). It puts things together *both* as they are *and* as they are not, and the point of caricature, like that of metaphor, is that neither is only a "portrait."

Metaphor, in Worth's analysis, thus becomes a central component of the structural code which we learn "for the intentional creation of meaning within specific contexts." It is a particularly rich syntactical device for implying and inferring meanings in each mode of symbolic experience.

Knowing about metaphor means knowing how to organize the universe within our minds, knowing systems of myth, of grammar, of behavior, value, and art as they are defined by our group now, and have been in the past.

what pictures can say ●
The larger questions raised by Worth's analysis of metaphor were addressed in his next paper (included as chapter 7 in this volume), in which he set out "to begin an exploration into how, and what kinds of things pictures mean" and also to explore "how the way that pictures mean differs from the way such things as 'words' or 'languages' mean."[10]

10. Many of these questions were also addressed in a later paper, "Man Is Not a Bird" (1978), which is not included in this volume because of its significant overlap with the material in this chapter.

The title of the paper, "Pictures Can't Say Ain't," signals one of its main arguments, namely, that among things pictures cannot imply are negative statements. But before getting to that point, Worth began by discussing the general status of pictures as symbolic events.

Using the model of the opposition between symbolic and natural events first presented in our joint paper, Worth argued that a picture is never a natural event, but always a "created social artifact." He then described the notions of attributional interpretation as contrasted with communicational inference, making the point that an appropriate interpretation of any picture always assumes that it was structured intentionally for the purpose of implying meaning. Worth invokes Grice's classic analysis of intention and meaning, quoting his view that not merely must a symbolic event have been articulated "with the intention of inducing a certain belief but also the utterer must have intended an audience *to recognize the intention behind the utterance"* (Grice 1957:382; Worth's emphasis).

Worth next emphasizes that we must learn to interpret pictures by learning the system of conventions—the code—used by their makers to imply meanings. Pictures cannot be taken as merely "corresponding" to reality, and therefore we do not merely "recognize" what they mean; we infer meanings on the basis of learned conventions.

Worth here is arguing against two groups that have denied that pictures carry intentional meaning: certain logical positivists and linguists who believe that only "the linguistic mode is capable of meaning," and others, including some artists, who feel that pictures can mean anything anyone sees in them. "No artistic implication should . . . become a grab bag for everyone to reach into and 'pull out what he himself has put in.' "

If we take art seriously as communication, we must acknowledge the separate roles and responsibilities of the artist and the audience. Each performs a distinct and complementary task in the communicative process. The audience does not make the work, but interprets it:

The reader . . . does not write any part of the poem, any more than the viewer paints the picture or makes the film. The reader (viewer), if he can participate in a communications event, recognizes the work's structure, assumes an intention to mean on the part of the creator, and proceeds to his extremely complex job of making inferences from the implications he can recognize.

Turning next to the question of what "pictures cannot do that words can do," Worth answers that "pictures cannot deal with what is not"; they can't say ain't. After disposing of several trivial examples of what might be seen as pictorial negation, calling these *"linguis-*

tic uses of visual forms which become sign-events in a special language" (for example, "no smoking" images), he discusses the general concept of what pictorial images affirm or deny.

Although much of "what is pictured is often valued for what it negates by *leaving out,"* pictures cannot specify, out of all the things that are not shown, which ones the painter means to say are not the case. "All that pictures can show is what *is*—on the picture surface."

On the other hand, pictures also should not be taken as necessarily affirming the existence of what they do show. Worth makes a connection between the fact that pictures (particularly photographs, which we tend to believe are the product of a machine that "tells it like it is") seem to show us things and our tendency to see "false" pictures not as negations but as false affirmations.

Pictures in and of themselves are not propositions that make true or false statements; that we can make truth tables about, or that we can paraphrase in the same medium. Pictures, it must be remembered, are not representations or correspondences, with or of, reality. Rather, they constitute a "reality" of their own.

But, if this is the case, how do we make sense of pictures? What do they tell us, and how? Worth gives two answers: first, pictures imply—and we infer—an existential awareness of particular persons, objects, and events that are ordered and structured so as to imply meanings by the use of specific conventions. Second, Worth pointed to "what Larry Gross (1973) has termed the *communication of competence."* Pictures communicate the skill and control with which their structures have been manipulated according to a variety of rules, conventions, and contexts.

Pushing the argument further, Worth reiterates the point that "matching to the real world is insufficient to explain how pictures mean" and goes on to say that

Correspondence, if it makes any sense as a concept, is not correspondence to "reality" but rather correspondence to conventions, rules, forms, and structures for structuring the world around us. What we use as a standard for correspondence is our knowledge of *how people make pictures*—pictorial structures—how they made them in the past, how they make them now, and how they will make them for various purposes in various contexts.

Worth's answer, then, to the question that he had posed at the beginning of the paper is that pictures communicate "the way [in which] picture-makers structure their dialogue with the world."

toward an ethnographic semiotic ●
Worth's theoretical investigations did not draw him away from his concern with developing a discipline that would study visual communications in a fashion compatible with that theory. In 1976, he delivered a paper at a symposium honoring Margaret Mead on her seventy-fifth birthday (1980). That paper, "Margaret Mead and the Shift from 'Visual Anthropology' to the 'Anthropology of Visual Communication' " (included as chapter 8 of this volume), addressed the need for scholars to properly understand the uses and the limitations of visual communications.

He distinguished between the use of visual images and media as research tools and as research material. In the case of the former, he used Margaret Mead's work with Gregory Bateson as an example of how pictures can be used by a researcher to illustrate patterns of culture. He wanted to emphasize once again a point that we all forget too easily: that "the photograph is not the pattern," but something that we use as evidence to illustrate pattern. "Taking photographs, or looking, or taking notes are tools for articulating and stating patterns that we, as anthropologists, wish to show to others" (1980:17).

And there is an important corollary: the value of the photograph lies in the analysis. Researcher-photographers who understand what patterns they wish to present will take photographs which will be capable of showing these patterns to others. Success is not a matter of luck but of training, skill, and intention. Bateson's and Mead's photographs are valuable because they knew what they were photographing and why they were photographing it: "The reason their photographs and films are records is that they were taken in ways which allowed them to be analyzed so as to illustrate patterns observed by scientists who knew what they were looking for."

The second use of photographs and films is as objects and events in themselves which can be studied in the context of the culture within which they were made and used. Here the pattern is in the picture and the context(s) of its making. These images are analyzed as parts of culture in their own right, "just as conversations, novels, plays, and other symbolic behavior have been understood to be."

This latter approach is one Worth was later to call *ethnographic semiotics*, the study of how people actually make and interpret a variety of visual images and events. These images and events range from the personal and private to the collective and public; from painting and sculpture through television, movies, and photographs (including home movies, snapshots, and photograph albums), store window displays, and other forms of everyday presentation of self through visual means.

Here one looks for patterns dealing with, for example, what can be photographed and what cannot, what content can be displayed, was actually displayed, and how that display was organized and structured. Was it arranged according to how these people tell stories? To how they speak, or to the very language and grammar that they use?

In the last two years of his life, Worth gave considerable attention to the formulation of an empirical application of his concept of an ethnographic semiotics. He was determined to demonstrate, rather than merely to advocate, the feasibility and validity of his approach to the study of visual communications. At the time of his death, he was preparing two grant applications. The first was for a fellowship that would give him a year in which to write a book, to be entitled *Fundamentals of Visual Communication,* which would present a theory through which the process and structure that people use to make interpretations of our visual universe might be understood.

The second application was for a grant to support a project that he proposed to conduct with Jay Ruby, an anthropologist and co-founder of the Society for the Anthropology of Visual Communication. That project, to be carried out over a period of three years, was to be a study of the visual symbolic environment of a small American community in central Pennsylvania (a "preproposal" for this grant is included as the appendix to this volume). This was an enormously ambitious and exciting project, proposing to use as the unit of analysis not specific symbolic products but the "context—the community and the community members' interaction with visual symbolic events."

In his paper honoring Margaret Mead, Worth noted, "I am aware that even as we try to develop a history in this field, we also are in many ways that same history." Sol will remain an important part of the history of studying visual communications.

the development
of a semiotic
of film

When writing about that mysterious scientific entity called a *sign,* we may use the word *semiotic* with relative impunity; when writing about that magical phenomenon called *movies,* we use words like *sign, semiotic, science,* and even *analysis* at our own risk.[1] We will have to learn to accept ridicule and even occasional vituperation from those of our fellows who look at films and write about them with and out of love —of their own deep responses to the magic of film and the art they believe film to be.

Signs may be analyzed, for few love them. But films are somehow delicate, like roses, and pulling the petals off a rose in order to study it is often viewed as an act of destruction. Or, conversely, others have taken the position that films, being tough, strong, and structurally indivisible, cannot be pulled apart for study. Such attempts, many feel, are doomed to failure, or worse, are merely fatuous.

And yet a great deal has been written about film in its almost seventy-five–year history. It has been written about as art, as communication, as a new social phenomenon, and, in its newest form of production and distribution—television—as the herald of a new sensory civilization. There has slowly accumulated a small body of ana-

1. This paper originally appeared in *Semiotica* 1 (1969): 282–321. It is reprinted here with the permission of Mouton Publishers—Ed.

lytical and theoretical work, from Eisenstein and Pudovkin through Bazin, Metz, and Pasolini, and an almost equal body of attack on the futility of it all; this last attitude is perhaps best exemplified by some of the work of Pauline Kael (1965). In the process of formulating theories and criticizing them, conceptions from philosophy, psychology, anthropology, and, recently, linguistics have been name-dropped, mentioned briefly, noted, and sometimes forced into juxtaposition with the word *film.* Film has been made a part of our lives—a dominant mode of human expression, relatively little studied and understood at a time when the study of other, perhaps similar modes, such as verbal language, painting, and music, have developed venerable bodies of theory and analytic methods. Those wishing to study film face a confusing and sometimes confounding choice of approaches. Shall one look at a film as art? If so, as what art? Is film like painting, theater, storytelling, or music? Shall one look at film as communication? This presupposes a definition of communication and commits one to a position that as yet has scarcely been adequately clarified, let alone accepted. Recently some attention has been given to the consideration of film as language. Shall it be studied as a subset of linguistics, using verbal language as a paradigm for the analysis of film?

At the present time, the choice of a method or a body of theory to employ in the study of film is determined by the intuition and previous training of the investigator, by the fortuitous circumstance of place of publication, or by the particular public to be addressed. At this stage, we have too much method and no theory which asks questions or sets problems for study. What is it we want to know about film more specifically than "how does it work"? Until we can justify some set of questions as the parameters of our area of study, a semiotic of film is impossible.

This paper rests on two basic and implicit assumptions which should be made clear at this time: (1) that film is amenable to scientific study and (2) that the organization and untangling of the large body of notions, statements, and theories which have been advanced about film and the study of film can be accomplished scientifically. Previous writers on film have attempted to describe, proscribe, predict, and evaluate what happens when a man makes a film and when another looks at it. These writers have proceeded in such a vast variety of ways, ranging from the aesthetic, moral, literary critical, and psychoanalytic to the linguistic, anthropological, and experimental psychological, that a common language for research in film has yet to be developed. When I make the assumption that film is amenable to scientific study, I am assuming that a common language

for talking about film is possible and that a common set of standards or criteria for the acceptability of evidence about statements as to the nature of film is possible.

Most of these problems can be subsumed under the heading of semiotics, which covers the broadest range of phenomena under which film might be examined. A semiotic "attempts to develop a language in which to talk about signs . . . whether or not they themselves constitute a language; whether they are signs in science or signs in art, technology, religion, or philosophy; whether they are healthy or pathic, adequate or inadequate for the purposes for which they are used" (Morris 1946). In the development of a semiotic of film, we will, then, have to develop a language to use in talking about film signs, which presupposes the development of a methodology for describing and determining them. We will have to consider whether these signs constitute a language, with all that the word *language* implies. We will have to consider whether art, technology, science, or any other discipline offers insights into the structure of film and human responses to it, and whether these disciplines offer a methodology fruitful for research into film. We will be required to examine whether film can be studied the most fruitfully as a semiotic of communication, and will have to inquire into the purposes for which these signs may be used and are used, and whether they are adequate to specified purposes within specified contexts.

This paper will attempt to do four things: (1) To describe film as a process involving the filmmaker, the film itself, and the film viewer. This description will draw heavily on concepts of communication and aesthetics. (2) To define film communication, accordingly, so that it relates this process to some of the current research in psychology, anthropology, aesthetics, and linguistics. (3) To discuss the signs or units involved in film communication. (4) To broach the question of film as language and to attempt an integration of some relevant linguistic concepts with what we know about film. Here the relationship between theories of verbal language development and the development of film, both as a historical process and as the development of individual skill in performance, will be described. From the discussion of these four areas, it is hoped that the beginnings of a language and a set of concepts and questions for the study of film will emerge. The consideration of these terms and problems, and a final section on method, is meant as a prolegomenon for the development of a semiotic of film.

the process of film communication ●

I do not intend in this paper to cite extensively or review all the directions of research previously alluded to. This article is organized on principles other than inclusion. The major criterion for including specific studies is that they may contribute in some way to the clarification, definition, or resolution of theoretical considerations raised by the attempt to develop a semiotic of film. In the area of specific film studies, a small body of literature exists, and several recent bibliographies have been compiled (Gessner 1968; Bouman n.d.). Research and theory drawn from other disciplines cover too wide an area in aesthetics and the social sciences for a short review to be anything but superficial.

Research, analysis, and theoretical discussion of film can be seen as following three separate directions. One group, favoring an essentially evaluative aesthetic direction, concerns itself with classifying films, filmmakers, and viewers in a hierarchical dimension on a good-bad continuum. This group uses essentially the methods of art and literary criticism for either textual explication or aesthetic judgment, placing films and filmmakers into systems consistent with the older art forms such as theater, painting, writing, or music.

The second group concerns itself with the social-psychological effects of film on makers and viewers, either individually or collectively. Such studies include the well-known studies of the effects of violence in films, the effect of propaganda in films, and, even more globally, the effect of this particular mode of expression on human beings in general (Tannenbaum and Greenberg 1968). Essentially, this group is attempting to predict the person or the society from the artifact.

The third group concentrates on describing the medium, concerning itself (according to individual disciplinary ties) with "structure," "language," "technique," and "style."

In almost all cases, previous research has dealt with a fragment of the total process without placing that part of the process within a framework or model of the whole. It would be as if one dealt with phonetics in verbal language without having a model of the speaking and hearing behavior of the speakers of a language.

In conceptualizing film from a semiotic standpoint, it becomes quite clear that one of the basic suppositions employed by de Saussure, Morris, Sebeok, and others is the notion of a relationship between signs themselves and between signs and their users and context. A sign is not a phenomenon in and of itself; a "thing" becomes a sign only because it has a specific relationship to other "things."

Research that deals solely with the effects of a film on its environment, without relating this to the filmmaker who made it, is ignoring a necessary relationship defining the film process; that is, the relationship between the sender, the message, and the receiver. Research that goes in the other direction, from film to maker, rather than from film to audience (the so-called psychoanalytic approach, for example, which tries to determine the man or the society from the artifact), falls into the same trap of dealing with a partial process without a model of the whole into which it fits. One can take either approach: given the artifact, try to predict the society, or given the society, try to predict the artifact. In either case, one cannot proceed gainfully without a model of the whole.

Similarly, those researchers working only with the film itself, its structure, style, or syntax, can do so fruitfully only within a total framework. Without this, verification of statements about structure and pattern becomes methodologically impossible. The problem of verification is indeed one of the major problems for a semiotic of film. One can, as Margaret Mead[2] has pointed out, start with an intuition about film structure—indeed, one almost has to—but one cannot build a scientific case for a semiotic of film by intuition alone.

Some method of verification of a hypothesized structure must be made explicit, and, in order for this to occur, some model of the process and context by which a filmmaker, a film, and a film viewer are related must be developed. Such a model, at this formative stage in the development of research in film, must correspond to what most makers and viewers intuitively feel happens. It must have face validity. It must further have enough heuristic value to indicate possible methods of verification for a semiotic, and must offer viable research avenues for answering the questions and solving the problems that the development of a semiotic of film inevitably poses.

This model should allow us to describe within one framework and with a common language the entire system within which filmic expression (I am deliberately avoiding the use of the word *communication* at this point) takes place, and also to place previous research within that framework for verification and analysis.

The process of film communication can be thought of as beginning with what I have called a *feeling-concern*. A person has a "feeling," the recognition of which under certain circumstances arouses enough "concern" so that he is motivated to communicate that feeling to others. I have purposely chosen the words *feeling* and *concern* because

2. Personal communication.

they are imprecise. After consideration of the entire model, it might prove valuable to try to fit the concepts that these words identify into tighter conceptual frameworks, but for the moment let us use the word *feeling* in the loose sense, by which we mean "I feel that. . . ."

I use the word *concern* in the sense that Paul Tillich used it: "Each man has his own concern, the ultimate concern is left for man to determine."

This feeling-concern, then, this concern to communicate something, which many psychologists feel is almost a basic human drive, is most often vague, amorphous, and internalized. It cannot be transmitted to another or even to ourselves in this "feeling" state. With the decision to communicate, a sender must develop a *story-organism,* an organic unit whose basic function is to provide a vehicle that will carry or embody the feeling-concern.

The story-organism need not be a story in the usual sense of the word, but it may be. It is a set or cluster of "things" developed from the feeling-concern. I chose the word *organism* rather than such words as *element, structure, style,* or *system* because I want first to suggest the living quality and nature of the process that story-organism names and to suggest the quality of growth and development as it occurs in a human personality in the act of communication. Second, the use of the word *organism* suggests the biological concept of function by which most organisms are understood and by which we can examine the story-organism; and third, it is meant to call to mind the concept of organization. All of these qualities—developmental, functional, and structural—are meant to be implied at the story-organism stage of the process.

The story-organism mediates between the feeling-concern and the next stage of the process of film communication, the *image-event.* Before describing the image-event, it might be helpful to look at the feeling-concern and the story-organism in another light. Suppose we think of the feeling-concern as a belief that we want to communicate. We can think of a belief in terms developed by Rokeach (1960) as a "proposition we hold to be true which influences what we say or do. Any expectancy or implicit set is also a belief; therefore we can say that a belief is a predisposition to action." In this sense, a feeling-concern is a belief on which we are predisposed to act. The story-organism can be thought of as the next step in that chain of actions. We do not always know, continues Rokeach, "what a person believes by any single statement or action. We have to infer what a person really believes from all the things he says and does. The organization of all verbal, explicit and implicit beliefs, sets or tendencies would be the total belief-disbelief system." In this sense, what I call the story-

organism can be thought of as similar to the belief-disbelief system developed by Rokeach.

The feeling-concern, then, is a feeling—a vague, amorphous, internalized belief—that a given person, at a given time, within a given context, is concerned or predisposed to act on—in our case, to act on specifically by expressing or (to use again the term undefined as yet) by *communicating* it. The story-organism is the organization into a system of those beliefs and feelings that a person accepts as true and related to his feeling-concern. It is the structuring of the main constituent units through which and within which his feeling-concern is clarified, organized, and brought to life so that it can be externalized and communicated.

It is at this point only, after awareness of the feeling-concern and development of the story-organism (either consciously or unconsciously), that a given person, a filmmaker, can begin to collect the specific external image-events that, when stored on film and sequenced, will become the film. For the moment, let us define an image-event as a unit of film.

So far, we have talked only about the first half of the process. Sending has been started; a film has been made. I would like to suggest that the receiving process occurs in reverse order, as a mirror image of the sending process. The viewer first sees the image-events that we call a film. Most often he knows nothing of what went on before. He does not know the filmmaker and his personality, and he usually does not know what the film is about, whether it is meant to communicate, or, if it is, what it is meant to communicate.

Before I can describe the manner in which the viewer interacts with the image-events on the screen, I must introduce some basic terminology for a semiotic of film. In order to describe the process I must assign more precise meanings to the vague terms I have used so far. A useful term for image-event might be *sign.* By *sign,* I mean the behaviorally oriented set of definitions developed by Morris and his followers. In general, and for introductory purposes, we may think of a sign as a part of a film that stands for something, that signifies. The signs in film that I will be discussing (either to show that film is composed of them or that it is not) are those that Morris designates as "com-signs" (communications signs): "A sign which has the same signification to the organism which produces it that it has to other organisms stimulated by it." The notion of communication signs contains the basic problem of a film semiotic, for it challenges us to determine whether in fact the process of sign manipulation which we call film is actually communicative, and, if so, how this common signification between filmmaker and viewer occurs.

When I use the term *film communication,* I shall mean: the *transmission* of a *signal, received* primarily through *visual receptors, coded* as *signs,* which we treat as *messages* by *inferring meaning* or *content* from them. The film will be said to communicate to the extent to which the viewer infers what the maker implies.

If a film is a specific set of image-events that we call signals, which we organize into signs and messages and from which we infer content, we can ask several basic questions. What is there in us, or in the sign system, that tells us when to treat signals as messages— further, that allows the transfer of common signification that makes for film communication? The definition I am proposing implies clearly that there is no meaning in a film itself. By common signification, or meaning, as used in film, I mean the relationship between the implication of the maker and the inference of a viewer. Although the meaning of a film is inferred in large part from the images and sounds in sequence in a film, meaning is also clearly that which the filmmaker implies in his arrangement of the elements, units, and parts of the film.

It may be postulated as a first statement of film semiotic that film communication is the transfer of an inferable meaning through the range of materials that a film offers, or does not offer, as signs, and through the elements it allows or does not allow. These materials and elements impose their own restraints and constraints upon the signs and signals we receive and choose to treat as messages. It is these filmic materials, elements, and constraints, and their relationships to the meaning we infer from them, their relationship to themselves, and their relationship to the world of shared significance that we must study in order to develop a semiotic of film.

Let us return now to the model of the film process. We have hypothesized a process that starts with an internalized feeling-concern and develops into a more coherent and organized (but sometimes, as in the case of a scriptless film, still internal) story-organism, which then controls the choice and organization of the specific image-events that are always the external, available film. We have suggested that viewing the film is a mirror image of the making process, that is, that the decoder reverses the process by which the encoder made the film. Should our viewer choose to treat these signs and signals as a message, he will first infer the story-organism from the sequenced image-events. He will become aware of the belief system of the filmmaker from the images he sees on the screen. From this awareness of the message he will, if the communication "works," be able to infer—to evoke in himself—the feeling-concern.

As you can see from this suggested view of the total process, the

meaning of the film for the viewer is closely related to the feeling-concern of the filmmaker. The image-events of the film are the signals; sequenced image-events become coded into signs which we treat as messages; and our inference about the feeling-concern of the maker is what we call the meaning of the film.

Ernst Kris, in *Psychoanalytic Explorations in Art* (1952), takes a somewhat similar view of the process. Writing within a psychological-aesthetic framework, he conceives of art "as a process of communication and re-creation." "Communication," he continues, "lies not so much in the prior intent of the artist as in the consequent re-creation by the audience of his work of art. . . . What is required for communication, therefore, is similarity between the audience process and that of the artist" (1952:254–55). He deals at great length with the psychic processes that occur when the process of creation is reversed within the viewer. Kris suggests that this process proceeds from perception of the work on a conscious level, to the understanding of the work on a preconscious level, to a re-creation of the original intent on an unconscious level, thus reversing the sequence that takes place within the artist.

The model that I have suggested describes the process of film communication which can be used as a base for a semiotic. It does not explain it. How is the common significance of signs achieved?

Let us examine in figure 1-1 the relationship between the sign system and the participants in its use. The first notion that emerges quite clearly is the difference between the image-event and both the feeling-concern and story-organism.

The three terms on the left of the drawing can be thought to belong to the realm of the filmmaker. The three on the right belong to the realm of the viewer. The image-event is the nodal point of the process. It is common to both filmmaker and viewer—to both sender and receiver, creator and re-creator. The image-event is different from the other two terms in that it is part of the process both for the filmmaker and for the viewer. It is also the only unit of this process that is directly observable.

The parts of the process that lead to the image-event and those that lead away from it to the inference of meaning on the part of the viewer are internal processes. The strip running down the page (like a strip of film) is our external, objective image-event. The series of concepts across the top of the model describing the process represent our internal world.

In our original definition of film communication, we implied that the inference of meaning from a film was a function—a relationship —of something in the message and something in us. We can look at

this model and see that it suggests two separate fields of study, two kinds of questions. The first revolves around the explanation of the human beings involved in the process, and the second around the explanation of the objective image-event that is the focus, the mediating agent, of the process. In order to explain the process of film communication, we want to know what there is in the image-event that allows an individual to infer meaning from it. This particular area of study—the interaction between persons and groups and the stimuli they relate to—has been undertaken by the social and behavioral scientists. Although relevant to our interests, the specific study of the relationships between people and events cannot be the professional concern of those interested in visual communication.

The study of the image-event, however—its properties, units, elements, and system of organization and structure that enable us to infer meaning from a film—should be the subject of our inquiry and of our professional concern.

Let us assume that this process of communication works sometimes. That is, a human organism constructs a sequence of signs meant as an implication, and another organism looks, or looks and listens, to these signs and infers something from them. It is, of course, possible, as with speech, for a listener or a decoder or receiver to say, or even mutter inwardly, "I don't get it." Or he may "get it." A speaker may say, "Do you think it will rain today?" and a listener

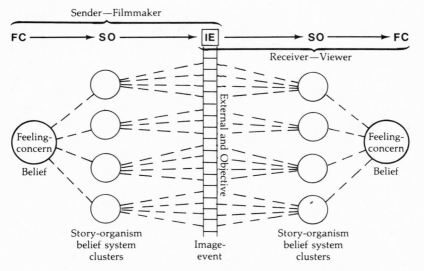

figure 1-1. the process of communication—ideal model

may reply, "My name is John Jones." We can frequently check this kind of verbal response by asking, "What did I just say?" and if the listener replies, "You asked me who I am," we know something is very wrong.

We have in the past learned a great deal about the specific interactions between the speaker and listener. For one thing, both are usually capable of production and consumption of verbal messages. As a matter of fact, we assume some form of psychic or biological pathology if this is not the case. We normally call listeners and speakers "sick" if they do not, as adults, know or respond appropriately to the common speech code of their community.

In the case of film, such methodologies as inviting the listener to repeat utterances have, up to now, not been available to us. For one thing, we don't "converse" in film. It is not a substitute for "talk" as is, for example, the sign language of the deaf and the mute. In film communication, we are more in the position of listeners to a lecturer to whom we can never reply than participants in a conversation. The situation is closer to the viewing of painting than it is to a conversation between speakers.

And yet sometimes we understand a film. Sometimes we are able to recognize the signals, code them into signs, reorganize them into their component units of story-organism and infer a feeling-concern very similar to that implied by the maker. Figure 1-1 suggests a perfect correspondence between encoder and decoder. Figures 1-2 and 1-3 suggest more probable results. Here the filmmaker might be concerned with the problem of men and women living in a highly industrialized society. The filmmaker (think of a movie such as *Red Desert*, by Antonioni, for example) may be saying that the relationship between men and women, in terms of the control of their relationships with themselves and one another, can best be described in terms of the constructive and destructive effects of machines and industrialization on an environment and on a specific society. He may be relating the yellow gas released by a refinery that kills those birds that fly through it to the yellow hair of the man who accepts and uses a woman's inability to handle her emotional life.

A viewer may respond as in either figure 1-2 or 1-3. Let us start with the most difficult situation, but one which, because of film's newness as a mode of expression, is still possible. The viewer does not know what a film is. He sees images on a screen but does not know that he has to code them and make inferences from these images. He does not know that he is dealing with a sign system or even that he is seeing a "representation." He sees first a yellow flower on a background of fuzzy and unclear lawn, then a spurt of yellow

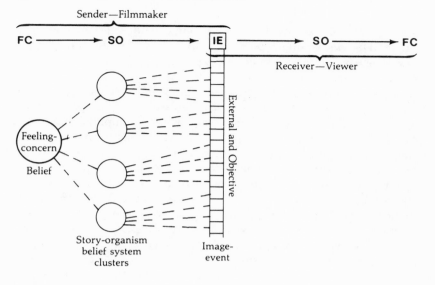

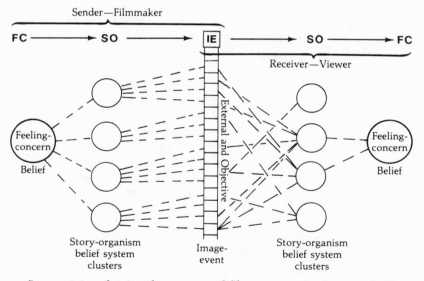

figures 1-2 and 1-3. the process of film communication—probable results

gas from a smokestack, and then a blond man walking down the street. The viewer might possibly walk away. He might intuitively think he was having a dream and expect an oracle to interpret it for him, or he might merely allow the bright colors and motion to be presented to him while he thinks of other things. He would respond similarly to figure 1-2. There would be no attempt on his part to code signs from signals, to treat them as messages or communication signs so as to infer anything from them. The shared significance might be almost zero, to the extent that he does not even assume a set of iconic signs. Such a situation is testable, and one could determine whether this takes place with humans or not. The evidence at present is very unclear but seems to indicate that it is possible to find people who, at first viewing a motion picture, cannot even accept the images as iconic representations. One would want to investigate this developmentally as well as culturally, finding out at what point, for example, a baby, within specific cultural contexts, makes such distinctions.

Let us consider figure 1-3. Here the viewer knows about films and has seen many of them. He assumes an implication on the part of the maker and knows that he must infer meaning from the film. There may be a wide range of inference open to him. He may look for aesthetic meaning only, or cognitive meaning only, or a combination of the two. He looks at the same film, sees the same images, and infers that it is about a crazy woman, a nice husband, and a mysterious stranger who loves her. He is quite clear about the fact that she is crazy, because she leaves both men and she tries to commit suicide, and concludes that the film is tragic, in that a woman who has everything—a nice home, a nice child, and a wonderful lover to boot —wants to throw it all away.

Or another viewer may infer with equal certainty that the film shows quite clearly what happens when ungrateful workers go on strike. The nice manager of the plant is so busy running his factory, working day and night, that he has no time—at the moment—for his wife. This deluded woman falls into the clutches of a rich wastrel and deservedly has a miserable affair with him, as a result of which her child gets sick, and she tries to commit suicide.

Or, again, another inference can be made, but one which is tentative, and the viewer will say, "I'm not sure what it was about. Maybe it was about . . ."

Still another possibility is that the viewer, quite convinced that he understands movies and the signs with which they are composed, may say, halfway through the film, "The filmmaker is crazy. This is a mess of random images from his subconscious. It has no meaning. I'm going home."

I have gone into specific examples of the responses to one film at such length because it is this type of behavior that a semiotic must, in the last analysis, attempt to explain. It is also the kind of response to a potentially communicative situation (in which communication is impossible, broken, uncertain, or misinterpreted) which is the rule, rather than the exception. Most film communication is not, as pictured in figure 1-1, the perfect correspondence between the feeling-concern, the story-organism, and the image-events they dictate, and their reconstruction by the viewer. Most film situations, depending as they must on the maker and his context (both social and psychological), the viewer and his, and the film itself, are imperfect communicative situations.

The only satisfactory end result of a semiotic of film would be the situation in which we could attempt to explain the failure (if that is the proper word) of complete communication that occurs in viewing a film. Such an understanding *might* make it possible for more perfect communication to take place, but this, it seems to me, is not the reason for wanting a semiotic of film. Such understanding is not designed to help us create better movies (on whatever level), although it might have such an effect; it is rather designed to help us understand the infinitely complex processes by which humans interact and transmit information in an always imperfect manner. It is designed to allow us to enjoy those very elements of ambiguity and imperfection by finding out where the uncertainties of human communicative interaction lie.

Understanding such a complex process is at present extremely difficult, but that is where we must begin. There are several avenues from which we could start. We could examine in detail the relationship between the maker and the product he produces, between the sender-encoder and the signs he generates. Or conversely, we could examine the relationship between a set of signs generated by a known or unknown object and its effect on a receiver or decoder. Third, we could examine the sign system itself, determining methods of description and manipulation.

The empirical determination of relationships between signs and their senders or receivers is primarily a sociological-psychological problem at present and *depends* on an accurate description of the signs under consideration and the manipulations actually used, as well as those which are possible, in that particular mode. Those involved in research dealing with the creation of film or with its consequences use film as a stimulus object, mainly to develop and confirm theories about sociological and psychological principles. There does not exist for these researchers an adequate body of basic material

about the sign system which is film itself from which they can draw.

Of course the questions of sign description can never be totally separated from their relationship to encoders and decoders, but at this beginning stage, an effort must be made to concentrate on small areas, keeping in mind their application to the model needed for verification.

It is for these reasons that I am proposing as the first task for a semiotic of film research into the sign system of film itself.

the units of film ●

If we assume the general accuracy of the feeling-concern model developed above, a study of the sign system for film communication must begin with a notion of the development of a set, a configuration of dimensions,[3] or some grouping of individual units representing, or standing for, a previous set of thoughts, concepts, or, in Rokeach's terms, system of beliefs and disbeliefs. The image-events in a film are organized to convey or imply this system which they stand for, and the viewer in turn reorganizes them to infer it. All of this is done by reducing a complex set of internal mental processes into a set of external signs, which are the units encoded and decoded.

The first question to be tackled, then, concerns the nature and description of what might be called the basic film sign. In the early days of movies, the basic film unit was thought of as the dramatic scene. This was essentially a theatrical concept; the first filmmakers pointed the camera at some unit of action and event and recorded it in its entirety. The limitations of the scenic unit were technological and dramatic: how much film the camera could hold, how much time the dramatic scene would take to unfold.

The earliest films were thus single scenes of what seemed to be a single unit of behavior. At that time, few filmmakers wondered about units of perception and cognition in moving images. It soon became apparent that these single-behavior units could be glued together end-to-end to form a many-scened dramatic photoplay in the manner of live theater.

In 1902, Porter stumbled onto the fact that the scene was not the smallest unit of film. The scene itself was divisible. He found that isolated "bits" of image-events could be photographed and glued together to make a scene. Most people making films at that time

3. For a fuller discussion of the notion of inferred and implied meaning in film as a set of dimensions, see "Cognitive Aspects of Sequence in Visual Communication" (1968).

insisted that viewers could not "know" what was on the screen unless they saw the entire scene in an unbroken flow of event. It became apparent, however, that the film unit could be broken down from complete views of the actors and actions to "bits" of views of actors and their actions without any loss of comprehension. This meant a breakdown not only of the perceptual field of, let us say, a man, by showing us a sequence of a head and an eye or hands, but also a breakdown of the cognitive field by forcing us to put together separate ideas, or bits of ideas, across time. Just as we put together separate image-events in film in the way we do tachistoscope images, so also are we able to put together idea bits such as an image of a man followed by an image of a snake, which might under some conditions compel us to infer, "That man is a snake."

In 1923, Sergei Eisenstein (1949, 1933) isolated a "basic" unit of film and called it the "shot." He made no attempt to define it systematically, but described it merely as the smallest unit of film that a filmmaker uses. In constructing his theory of film, he formulated a concept, "the collision of ideas," which he called central to film and set down for the first time what one can see now to be a special theory of cognitive interaction. Using an essentially Hegelian framework of thesis, antithesis, and synthesis, he proposed that a shot equals an "idea," and that from one idea colliding with another there emerges a third idea. It is interesting to note that the Russian word used by Eisenstein and translated into English as "collision" is the same word that Pavlov used, which was translated into English by psychologists as "conflict." If one reads the early literature on film and substitutes "collision" for "conflict," some interesting developments in the psychological literature (e.g., Berlyne 1960) become relevant to understanding film communication processes.

Arnheim, in 1933, working with the ideas of the early Gestalt psychologists, added some insights about perception and persistence of vision to the general body of film knowledge, but his major effort was devoted to proving that film is art, rather than a mere recording of the world as it is (1957). His basic argument was that film is art so long as it is "imperfect." Color and sound decrease its artistic properties because they are devices to make film "more perfect." Like Pudovkin (1949), who in 1927 suggested such undefined elements as "contrast," "similarity," "synchronism," "recurrence of theme," and "parallel structure," Arnheim attempted to formulate operational units which were elements. He tried to define such laws or rules as "constancy of viewpoint," "perspective," "apparent size," "arrangement of light and shade," "absence of color," "acceleration," "interpolation of still photographs," and "manipulation of focus." In all,

he formed twenty such units and was forced to conclude that there could be hundreds more.

In 1960, Kracauer also attempted to formulate some structural and rule-governed units, and although his units differed from Arnheim's, they took a similar shape (1960). He listed numerous subunits merging into five distinct units: "the unstaged," "the fortuitous," "endlessness," "the indeterminate," and "flow of life." Slavko Vorkapitch, in a series of unpublished lectures on film held at the Museum of Modern Art in 1965, defined the film elements (although he did not call them elements) by saying that "film can be understood to be an art composed of kinesthetic, ineffable, and transcendental" units. He meant (I think) an art composed of moving, transcending, and verbally inexpressible entities.

The aforementioned theoretical formulations about film contain several major flaws. The early writers were intent on proving that film was "art" or could be "art." Although they have helped us to recognize some of the parameters of film, their thought was concerned with descriptions of effects, such as Pudovkin's "contrast," "similarity," and "parallelism," and Kracauer's "the unstaged," "the indeterminate," and so forth, and was limited to discussion rather than scientific analysis.

The question of the basic sign remains complex and presumably can be solved in a variety of ways, depending on how and *why* one wants to slice the film pie. Clear use of such units as "the scene" or "the indeterminate" or "the narrative" might be relevant to dramatic, philosophical, or literary criticism, but they are, for the moment, too broad to serve as basic in our sense. The unit of "the shot" that Eisenstein proposed seems at this point the most reasonable, not only because it is the unit most filmmakers use in constructing films, but because it is also possible to describe it fairly precisely and to manipulate it in a great variety of controlled ways. Not only do people in our culture and those who have learned our "system" of filmmaking use the shot as a basic construction unit, but recent research by Worth and Adair (1967, 1970) among peoples of other cultures who were taught only the technology of filmmaking without any rules for combining units showed that these people seemed "intuitively" to discover the shot as the basic sign for the construction of their films.

Eisenstein, however, proposed a generalized unit called a shot, overlooking a distinction that must be made if we are to attempt further scientific analysis along the lines I have proposed. The shot is actually a generic term for two kinds of shots: the "camera shot" and the "editing shot." I would like to propose a more jargonized terminology, whose usefulness will become apparent below. Let us

call the generalized shot, which corresponds to what I have called previously the image-event, a *videme* (1966, 1968). It is the basic sign of film. The camera shot can be shortened to *cademe* and shall mean that unit of film which results from the continuous action of the movie camera resulting from the moment we press the start button of the camera to when we release it. The cademe can be one frame long or several miles long, depending on the will of the camera operator and the limitations of the technology involved. The editing shot, or *edeme,* is that part of the cademe which is actually used in the film.

A filmmaker has an almost infinite choice of cademes which he can possibly collect for use in his film, out of which he usually chooses a smaller number for his film, and which he may shorten, rearrange, or manipulate in a variety of ways. As a general analogy, which will be discussed further below, the edeme is to the cademe as the specific words chosen for a particular utterance are to the lexicon available to a particular speaker. No speaker has at his command at all times a complete lexicon, and no filmmaker has for use in his film every possible cademe. A speaker chooses his word signs for a variety of reasons, including his rules of both competence and performance, just as a filmmaker chooses to make from his cademes that combination of edemes which, according to his rules of film competence and performance, he will call his film.

Just as the vocal musculature, brain, and cultural context set limits on the production of sounds and the manipulation we can make of them, so also do the technology of film and the psychology of perception and cognition set limitations on the way we manipulate our film signs.

The single cademe can also be thought of (in an analogy to speech) as the storehouse of usable sounds available to any one speaker for any one image-event. The edeme then becomes those specific sounds that a speaker finally isolates to form words and combines to form sentences, paragraphs, and larger units.

By making the distinctions between a cademe and an edeme, we call attention to some of the methodological problems surrounding research into the use of film signs. First, when we examine the development of film historically and individually in comparison with that of verbal language, we will find that the breakdown from larger to smaller units, as from cademe to edeme, is somewhat analogous to the processes postulated by recent work in developmental linguistics (Smith and Miller 1966). Second, the distinction between cademe and edeme allows us to observe more closely and to compare the processes by which units of film are broken down and organized by

filmmakers in different contexts. Not only, then, does the cademe-edeme distinction fit what we know about film, but it also offers us a fruitful approach to research in how different individuals, groups, or cultures organize image-events.

Of course, the shot—cademe or edeme—is only a hypothesized unit. It may well be the case that it is not the unit that we use when we make inferences from film signs. It may be that the individual frame is a basic unit, or that sequences of edemes are the unit human beings really use. With a definite unit to start with, however, empirical research determining the psychological and physiological truth of our assumptions becomes possible.

Although the *videme* (the generic term for either cademe or edeme —the image-event, as it were) can be postulated as a basic unit, it is clear that this unit is manipulated and acted upon on a variety of parameters and in a variety of ways. There are, for example, different ways of connecting videmes in a sequence. One can use the straight "cut," merely pasting the end of one videme to the beginning of another; or one can use a "fade," in which one end is blended into blackness and fades into the next image. Still another way is a "dissolve," in which the end of one edeme and the beginning of another are gradually merged into one another, making the separation of the two almost impossible to detect.

Apart from connectives, the filmmaker still has a great variety of alternative ways in which he can capture "reality" before his camera. A filmmaker making a film deals with sign units as material objects which he combines, orders, and operates upon in such a way as to impel a viewer to relate them in specific ways, if he chooses to infer meaning from them.[4]

There are five parameters which, when defined, can become a starting point from which to describe the structural elements of a film language. These parameters are an *image* in *motion* over *time* in *space*— with *sequence*—including, as an overlay, a matrix of sound, color, smell, taste, and other as yet unknown technological or sensory stimuli.

By the term *image*, I mean that which I have called a *videme*. In a previous paper (1968), I have described the parameters of time, space, and motion and how they can be used in research related to the inferences drawn from edemes manipulated along those parameters with specified connectives, such as a cut, a fade, or a dissolve.

4. Of course, the social, personal, and cultural context in which making and viewing takes place must be taken into account. My point is that the *specific* signs in a film must be determined before they can be related to a context. A code always exists within a context, and both must be known before their interaction can be known.

The units that I have proposed are basic units and are by no means exhaustive of either the categories or levels of analysis that might prove useful. They shall serve merely as a springboard to the problems that arise if we postulate any series of units in sequence. The parallel between "a sequence of signs conveying a shared significance" and notions of a "language" is too striking to overlook. The moment we reach the point where we can hypothesize that our signs are sequential and that this sequence makes a difference in implied and inferred meaning, we must consider the possibility that we are dealing with a language.

film examined as if it were a language ●
Tremendous care must be taken in the development of a semiotic of film not to prejudge the question. The point, rather, is to use that most scientific of sign disciplines, linguistics, as a yardstick, rather than a model.

In a conference on semiotics held in 1962, Edward Stankiewicz made the following quite helpful comment in regard to proposals that the proper way to develop a semiotic of non- or para-linguistic modes was to deal with networks, total systems, and configurations of communication:

I could question the methodological merits of an approach that does not attempt to define the communication process in terms of its constitutive elements and which fails to provide criteria for their selection. . . . I think it is important to study any communication process and its modalities with reference to language, since language is the most pervasive, versatile, and organizing instrument of communication. [1964:265]

What, then, are some of the problems that arise if we look at film as language, for this notion has occurred to filmmakers before. Most theoreticians from Eisenstein to Bazin have at one time or another used phrases such as "the language of film," "film grammar," and "the syntax of film." We often speak of "the language of dreams," "the language of vision," "the nonverbal languages," and so on. Most of us working in film or studying it seem to share a common compulsion to lend status to film by attaching it to "that most pervasive, versatile, and organizing instrument of communication." But, unfortunately, until relatively recently most of these uses of the term *language* were metaphoric and wish-fulfilling. Rarely has the term been used, in relation to film, in such a way as to provide us with an adequate descriptive theory enabling us to understand more fully the "faculté de langage cinématographique."

Bazin (1967), Metz (1964), and Pasolini (1966) (a superb

filmmaker in his own right), and the members of the British Film Institute Seminars (Wollen and Lovell 1967) have recently begun to look at films through the theoretical frameworks of de Saussure's semiology, Lévi-Strauss's structuralism, and a variety of linguistic models. Most of these authors have contributed to a clarification of the problems I shall be dealing with below, but none of them seems to have tackled the problem of a film semiotic as a language from the point of view of a total communication system.

Definitions of language range from Sapir's "language is a purely human and non-instinctive method of communicating ideas, emotions, and desires by means of a system of voluntarily produced symbols" (1921) to Hockett's fourteen design features (universals) of language. Some linguists specifically limit language to vocal signs; thus, "A language is a system of arbitrary vocal symbols through which members of a social group cooperate and interact" (Sturtevant 1947). Harris (1960) defines a language as the talk which takes place in a language community among a group of speakers, each of whom speaks the language as a native and who may be considered an informant from the point of view of the linguist. He states, "None of these terms can be rigorously defined," and the word *language* itself, in his opinion, cannot be defined.

There is no point to an exhaustive list of definitions, or, in Wittgenstein's sense, to a list of descriptions of how people use the word *language*. It is clear from even a cursory glance at the literature on language and linguistics that these usages change according to the problems under consideration and according to the general sociology of knowledge in linguistics and related fields. In recent years, one definition of language, advanced by Noam Chomsky of M.I.T., has been responsible for a great amount of research and seems to be the one single definition most commonly accepted: language is

a set (finite or infinite) of sentences, each finite in length and constructed out of a finite set of elements. All natural languages in their spoken or written form are languages in this sense, since each natural language has a finite number of phonemes (or letters in its alphabet) and each sentence is representable as a finite sequence of these phonemes (or letters), though there are infinitely many sentences. . . . The fundamental aim in the linguistic analysis of a language L is to separate the *grammatical* sequences which are the sentences of L from the *ungrammatical* sequences which are not sentences of L and to study the structure of the grammatical sequences. The grammar of L will thus be a device that generates all of the grammatical sequences of L and none of the ungrammatical ones. One way to test the adequacy of a grammar

proposed for L is to determine whether or not the sequences that it generates are actually grammatical, *i.e.,* acceptable to a native speaker, *etc.* [1965]

This definition embodies very clear distinctions between the properties of a language and other forms of communication and discourse which would not be called language and, apart from the term *speaker,* could possibly apply to nonverbal modes. It might be fruitful to see if some of his terms and concepts can be applied to the signs of film, the videmes.

According to Chomsky, (1) there must be a set of rules by which (2) a native speaker constructs an utterance which (3) can be grammatical or ungrammatical; and (4) there is such a thing as a native speaker. Therefore, by use of the rules (1), a linguist or a machine can construct utterances which the native speaker (2) can make grammatical judgments about (3). The linguist can also use the rules to judge the grammaticality of the native speaker's utterances.

Thus the system of common significances for a semiotic of film would have to include at the very least such shared units as rules, native speakers, and grammaticality. Although in Chomsky's above-quoted definition there is no mention of a lexicon, there is an implied axiomatic rule that there exists a lexicon for which the rules of usage exist, that is, that native speakers share a *finite* set of signs for which there is common agreement as to some shared significance.

Let us examine some of these concepts in relation to film. First, a lexicon. This is a necessary adjunct to verbal language. Since vocal signs are arbitrary and essentially "made up," there would be no way for a new member of a speech community to know these signs except to learn them, and therefore a lexicon or written dictionary becomes an indispensable aid. Videmes, however, are essentially nonarbitrary and not "made up," but rather are substitutions for, or mechanical reproductions of, something that exists in the real world (cf. Gombrich 1951). They are iconic, as opposed to noniconic, and while the number of words possible is infinite, the problem of developing shared significance as well as the degrees of usefulness of an infinite set of word signs limit the size of any speech community's lexicon. No such severe limitation exists in the development and use of iconic signs. If we think of a cademe as a basic unit, the filmmaker clearly has an infinite set of possibilities at his disposal. Practically, it might be difficult for him to amass cademes taken in widely separated environments, or from difficult-to-reach environments, but even in a closed room the choice of cademes *that could be used* is incredibly enormous.

To a certain extent, the shared significance of cademes is less

accurate on some levels than the commonality of verbal signs, since the very arbitrariness of verbal signs makes accurate definition necessary. On the other hand, the very basic nature of the generalized commonality of iconic representations makes the possibility of universal recognition that much easier. In terms of the developmental process by which humans communicate through signs (although cultural learning and a high degree of biological maturity are needed in order to learn to manipulate a specific set of arbitrary verbal signs comprising language L), representational signs are recognized and coded sooner biologically, hence more universally.

In a sense, the rejected notion of phonemic symbolism which was advanced as an explanation of the development of a verbal lexicon might very well, if transformed into a concept of iconic symbolism, be a valid explanation of our ability to handle image communication with so much less training than it takes for us to manipulate signs in verbal communication.

In *Foundations of a Theory of Signs,* Morris (1946) proposed three aspects of semiotics: pragmatics, syntactics, and semantics. Pragmatics is "that portion of a semiotic which deals with the origin, uses, and effects of signs, within the total behavior of the interpreters of signs"; semantics deals with "the signification of signs, and . . . the interpretant behavior without which there is no significance"; and syntactics deals with "combinations of signs and the ways in which they are combined."

One might, then, say that the lexical quality of videmes is an aspect of both semantics and pragmatics, while the problems involving rules and grammaticality are the province of syntactics. I think these distinctions are less fruitful methodologically than theoretically. They serve to remind us of various aspects of signs but do not offer too much in the way of insight into methods of verification and description. It is at such points that linguistic methodologies might be examined. The method of "same" or "different," for example, in which informants are asked for their judgments about signs, could be applied to compare cademes and edemes, or edemes and edemes, with different operations of time, space, and motion applied to them. It would be interesting to see at what point any videme is declared by an informant to be different from another.

This, of course, deals only with an almost axiomatic aspect of language. Let us look at the further necessary, if not sufficient, attributes of a language: rules, and the conception of grammaticality.

Filmmakers have over time developed what they might call "rules of filmmaking," or "rules of editing." Such rules as "Always

follow a long shot with a close-up" or "Never cut more than 180 degrees" or "Always show an object moving continuously (don't jump-cut)" are not what linguists mean by language rules or what psychologists mean by rule-governed behavior. The previous examples of film rules are more proscriptions or prescriptions addressed to filmmakers than statements about how encoders and decoders share common significances from sequences of videmes. To ascertain whether film has the kind of rule structure that linguists refer to, we would have to ask questions of the following kind. If I perceive videme A, and then also perceive videme B, what happens to make me know A and B or even X? (I will refer to A and B in connection as AB but do not mean to imply multiplication thereby.) In looking at a sequence of different videmes, is there anything in the sequence and in the operations performed on the elements that allows or helps me to infer meaning from them, *regardless* of the semantic content attached to each of the elements by itself? Sequencing videmes can be thought of as applying syntactic operations to edemes. This does not in itself imply a code, a set of rules, or a grammar, but it does make it possible to test visual communication phenomena along these lines.

Sequence is a strategy employed by man to give meaning to the relationship of sets of information, and is different from series and pattern. As I will use the word here, *sequence* is a deliberately employed series used for the purpose of giving *meaning, rather than merely order,* to more than one image-event and having the property of conveying *meaning through* the sequence itself as well as through the elements in the sequence.

A sequence of image-events is a deliberate ordering of edemes used to communicate the feeling-concern embodied in the story-organism.

This concept of sequence as a deliberately arranged temporal continuity of image-events, giving meaning rather than merely order, is not meant to distinguish between dream and film, between conscious or unconscious motivation, but rather to exclude the kind of order that would result if a blind man put a set of edemes together or a seeing person put some edemes together without looking.

For example, we might find some interesting analogies by exploring some of the ways that sequence is dealt with in mathematics. Let us first consider the commutative law, which contains the statement that $AB = BA$. If we think of A and B as representing edemes and do not at this point consider signs such as "times" or "plus," we can ask whether the meaning that the viewer will infer from AB is

commutative. That is, will a viewer infer the same meaning from the sequence AB that he would from the sequence BA?

If we also examine the associative law, which contains the statement that $A + (B + C) = (A + B) + C$, we are again able to find many parallel structures in film "language." Thinking of the letters A, B, and C as representing edemes, and disregarding the plus, we can ask what properties of film language would apply to make a viewer infer connections such as $A + (B + C)$ or $(A + B) + C$.

If the commutative law applies to film language, it cannot then be true that if two edemes in a sequence are reversed, the meaning of the sequence will change. Or, we can ask another kind of question: Is there a way that we can construct a sequence of three edemes, A, B, and C, so that a viewer will put cognitive parentheses around two of them?

Are there cognitive signs in visual "language" that correspond to something like a parenthesis in written language? It is interesting to speculate as to the possibilities of there being signs in visual language that make us infer connections such as plus, against, with, separated, and so on.

Such obvious manipulations as fades and dissolves suggest themselves immediately, and I plan to report at a later date on further studies attempting to describe these cognitive signs, signals, or rules, and to measure their dimensions of meaning in semantic, and perhaps syntactic, space.[5]

To illustrate these questions in terms of images, let us first think of a sequence composed of three edemes—a baby, a mother, a father. Can these three edemes be sequenced in such a way that the viewer will infer cognitive parentheses around two of the edemes? Is there anything in film "language" that would make us think of (a baby and a mother)—(and a father)? Or (a baby)—(and mother and father)?

In this almost oversimplified set of three edemes, we have the nub of the rule problem as it relates to verbal language. A linguist can tell you fairly accurately why "man bites dog" means something different from "dog bites man." To be sure, the linguist is not quite clear why "John plays golf" is grammatical and easily understood, although "golf plays John," while understandable and grammatical, is more difficult, and "John plays privilege" makes no sense at all.[6]

In film, we are still not only uncertain about the relative difference in sign inference from edemes ABC to edemes CBA but do not yet know how to measure these differences. Again, perhaps, methods

5. Such a report was never written. See discussion in introduction—Ed.

6. For a fuller discussion of this point, see Chomsky (1965).

from linguistics and the other social sciences will offer some method-
ological clues, *if* we can pose clearly formulated problems.

The very notion "grammatical" does not exist for the interpreta-
tion of iconic signs. Man, as far as we know, is the only animal who
assigns a truth value to a visual representation. We say, "That's a
man," or "That's a house," or "I don't know what that is." We do
not, however, say that picture, edeme, or film is grammatical. At
present such a distinction is not common to any large community of
film viewers.

One reason for studying film as a system of semiotics is that it
is so young historically and that its rules are as yet relatively un-
formed. It may well be the case that it was so in the early develop-
ment of verbal language. We may develop more clearly defined rules
and a notion of grammar in film over time. If so, and if we can study
this development, it might shed light on processes of human cogni-
tion responsible for linguistic coding behavior.

There is some evidence that children learning a language do not
start out with what might be called the rules of adult grammar (Smith
and Miller 1966). Early researchers (and some current workers) in
language development assumed that children learn a new language
by imitating the adult speech they hear around them in a kind of
complex operant conditioning situation similar to that described by
Morris, and that patterns of speech in infants up to twelve to fifteen
months could not be found. Such patterns as were noted in early
studies were dismissed as bad imitations or mistakes learned from
adults. It seems quite clear now that when children learn to speak,
they may possibly follow a pattern based on some set of rules which,
according to Brown, McNeil (Smith and Miller 1966), and others,
seems to be a built-in, innate, biological function of the human brain.
It has been shown that children learning to speak do not make the
"mistakes" that the adults whose speech they hear the most make.
Instead they make their own "mistakes," following a set of rules that
seems similar for all children regardless of the language they speak.

These researchers have found that in the beginning a child at-
tempts to build up a lexicon by amassing a set of single words which
he utters. This single word, or holophrastic utterance, is the func-
tional equivalent of the sentence in adult grammar. A child may say
"water." He might mean, "That is water," "Give me a glass of water,"
"I have just had a drink of water," "Where is the ocean?" or "I want
to go into the water to swim." This holophrastic sentence is meaning-
ful to the extent that we know the context in which it was uttered.

The next stage in his development occurs when he learns to
differentiate between words and to make progressively more com-

plex categoric distinctions between them. First he divides his words into two classes, which have been called by Brown modifier and noun classes, and by McNeil pivot and open classes. The pivot-open description seems more applicable to film, and so I shall use that. Here the child arbitrarily takes certain words from his learned lexicon and gives them special consideration. For example, out of a store of words consisting of *this, that, arm, baby, dolly's, pretty, yellow, come,* and *doed,* the child will separate out *this* and *that,* and make expressions such as *this arm, that arm, this yellow, that come,* and so forth (McNeil 1966). Or, in another case, he will choose *allgone* as his pivot word and try it out with all his open-class words, getting sentences like "Allgone Mommy," "Allgone boy," "Allgone yellow," and so forth.

It is only after mastering this construction that he begins to successively differentiate what we call nouns, pronouns, modifiers, verb inflections, and so on. It is precisely because at a certain stage a child may say "I doed that" instead of "I did that" that we can infer his instinctive desire to make rules for language. His "mistake" is really not an error, but the lack of knowledge about an exception to the rule that *ed* is a morpheme marking the past tense of a verb.

Let us try to compare this notion to what might be called the developmental pattern of film. The first "films"—the shot of a kiss, of a train coming into the station, of a mother washing a baby—can be considered examples of a holophrastic film. The kiss was an undifferentiated cademe. As Leopold puts it, referring to speech, "The word has at first an ill-defined meaning and an ill-defined value. It refers to a nebulous complex, factually and emotionally; only gradually do its factual and emotional components become clearer, resulting in lexical and syntactic discriminations" (McNeil 1966). McNeil comments on this that "a degree of semantic imprecision is therefore taken for granted."

Note here the similarity to the feeling-concern model I discussed earlier. It is almost as if in early film use the filmmaker attempts to translate his feeling-concern directly into a single image-event—a single cademe—and that becomes a film. It has also been noted that these early holophrastic utterances seemed closely linked with action and carried a vaguely defined emotional overtone. The consensus among developmental linguists seems to be that holophrastic speech has three intertwined functions. It is linked, and often fused, with action, it expresses a child's motivational and emotional condition, and it usually names things. This similarity seems to hold up for the undifferentiated cademe. De Laguna's comment about holophrastic words seems almost like the advice of an experienced filmmaker to a novice: "A child's word [your first cademe] signifies loosely and

vaguely the object together with its interesting properties and the acts with which it is commonly associated in the life of the child [in your life]. Just because the terms of the child's [the novice filmmaker's] language are in themselves so indefinite it is left to the particular setting and context [surrounding edemes in the sequence] to determine the meaning for each occasion" (McNeil 1966).

As the filmmaker making his one-cademe films grew more sophisticated in the use of his signs, and as the technology developed, he realized that he could combine edemes to make longer statements. At first this combinatory power was used only to present actions that could not be photographed in one cademe. Porter, for example, in 1902 made a revolutionary film using three cademes. First a cademe of a group of firemen sliding down the poles of a firehouse and jumping onto the firewagon; a cademe as the horses and firewagon dashed down the street; and finally, a cademe of the fire fighters arriving at the scene of a fire and putting it out.

The developmental process so far might be something like this: the filmmaker has at his command one sign—a cademe—just as it comes out of the camera. He controls the subject matter to the extent that he points the camera, and controls the length by his decision to start or stop the camera (and by his ability to know how much film the camera has available for one exposure). At a later stage, he realizes that he can join cademes by merely pressing the button and allowing his camera to run again, putting the subsequent image on the same roll of film. He does this until his film runs out. He shows this length of several cademes as it comes out of the camera, and that is his film. Perhaps this is what Porter did. It certainly seems to be the case with most amateur filmmakers and their Brownie movie cameras today.

A further stage comes with the realization that not everything one shoots (all cademes, or one's entire lexicon) is needed in a film. Some things can be thrown away as being "no good" or "not needed." They might, in the case of beginners, be overexposed, moved, out of focus, or "unpleasant." At this point, the filmmaker learns the use of the splicer. He can join two lengths of film, leaving out that which he does not *choose* to use.

The next step is that the cademe itself becomes divisible, and the edeme is developed. This might correspond to the establishment of a recognition of units, so that the holophrastic utterance *allgone* becomes *all* and *gone,* or it might be the beginning of the establishment of some simple pivot and open classes of edemes.

The filmmaker realizes that just as not every cademe is necessary, so not *all* of every cademe is necessary. He can use parts of

cademes to tell his story. Until this point, the filmmaker has still not learned to change the original order of cademes. Like a child learning a language, he may be capable of only one thing at a time. He makes edemes out of cademes, but still in the same order as they were shot.

One would expect the next step to be the development of some primitive "syntactic sense." I do not have any evidence to show that any of these next steps must follow each other in some order, but the general notion of sequence contains several distinct concepts. First, possibly, is the notion that cademes themselves can be placed in sequences other than the one in which they were shot; second, that several edemes from any single cademe may be used as modifiers for other edemes. The notion that a cademe close-up of the feet of a man walking can be broken into two or more edemes and inserted before and after an edeme long shot of the same man walking might be the development of a simple syntactic structure signifying the modifier of the object "man walking."

The next steps involve the dimensions along which cademes and edemes attain "meaning"—their length, their time of occurrence, their spatial dimension (long shot, close-up, and so forth), and their semantic content. This may be the place where the undifferentiated cademe acquires a "particular setting and context to determine the meaning for each occasion." Here, too, in terms of semantic usage, there may be a developmental sequence in which one first joins cademes according to some rules of occurrence—causal, representational, iconic, or associational.

Without going into detail about the history of film, it seems possible to explain the history in this developmental light.

The rapidity with which this hypothesized development occurs has been demonstrated in an experiment with Navajo Indians conducted by the author and John Adair (Worth and Adair 1970). Six young Navajo bilinguals (three men and three women), who had previously been differentially exposed to film, and one monolingual (Navajo only), less acculturated Navajo woman of about fifty-five, who had, professedly, never seen a film, were taught to conceive, photograph, and edit 16-mm. silent film.

Analyzing precisely what rules the Navajos followed in this scheme and how far along they could go in the developmental process was precisely the purpose for which much of our data was gathered. That is, at what point did they break cademes into edemes? What edemes served as modifiers for other edemes? Which cademes were extensively used and which were discarded? How complex a structure and how predictable a structure did each Navajo develop individually, and what rules did all of them seem to follow? Did they correspond to "our" rules, or were they different?

At this point, it might be useful to describe some of the first one-minute films made by the Navajos, which were made after three days of instruction in the mechanics of the camera. Mike said that he wanted to make a movie of a piñon tree. He wanted to show "how it grow." He set about finding a piñon seedling, making a shot of it, then a little bigger one, and so on, until he had photographed a series of seven cademes connected in the camera, ending with a full-grown tree. I thought he was finished at that point, but he continued with a dead piñon tree that still had some growth on it, then a tree that had fallen to the ground, then some dead branches, then a piñon nut, and ended with a shot of the same piñon bush he started with.

When the film was returned from the laboratory and shown to the group, we detected some puzzled looks. The "film" consisted of twelve cademes, starting with a shot of the piñon seedling, continuing through the sequence of cademes as described above, and ending with another shot of the same seedling he had used as his first cademe.

Although Mike and the others could not make clear the reasons for their surprise at the result of their first shooting experience, Mike later was able to articulate his difficulty. He had photographed a sequence of trees in a particular order, a cademe sequence. Its sequence and semantic contents, he felt, should imply the meaning "how a piñon tree grows." Instead, because all the images had the same spatial relation to the size of the screen—that is, he shot all the trees, both the small and the tall ones, as close-ups (filling the full frame)—he failed to communicate the process of growth that can be shown when something small becomes big. Because all the images— those that represented "in reality" big things and those that represented small things—were made to appear the same size in relation to the size of the screen, their representative or iconic qualities of "bigness" and "littleness," which were the relevant semantic dimensions of the cademes, were lost. As Mike continued his filming, however, he was able to master the semantic elements of space to achieve a rather simple syntactic arrangement.

In another case, that of Johnny, we have evidence of the independent discovery of what might be called the modifier-object relationship.

Johnny said he wanted to make a "movie" about a horse. After getting permission from the owner of a horse that was tethered near the trading post, Johnny started shooting his "film" about a horse. First he proceeded to examine the horse through the various focal-length viewfinders on the camera. He remained in the same spatial relation to the horse but tried "seeing" the horse from the different "distances" that lenses of various focal lengths allow. He finally told

me that he was going to make pictures of "pieces of the horse," so you would get to know a Navajo horse when "you see my film."

He shot about ten close-ups of the head, the eyes, the tail, the penis, the legs, and so on. Each shot took him perhaps two minutes of thought to determine. He worked quietly, asking few questions, setting exposure and distance with care. After about twenty minutes, he started looking at me frequently, not by turning his head all the way, but with that quick sideways movement of the pupil that the Navajo use. Then he said, "Mr. Worth, if I show pieces of this horse, and then tomorrow take a picture of a complete horse at the squaw dance—or lots of horses, can I paste them together and will people think that I'm showing pieces of all the horses?"

I managed to restrain myself and said merely, "What do you think?" Johnny thought a bit and said, "I'd have to think about it more, but I think this is so with movies." I asked, "What is so?" and Johnny replied, "When you paste pieces of a horse in between pictures of a whole horse, people will think it's part of the same horse."

I mention these incidents for several reasons. First, it is difficult to know how Johnny "learned" this rule. Second, no matter how he learned it, Johnny after two days "knew" that people infer that a close-up acts as a modifier of a long shot in certain circumstances, and Mike (as well as the other students) "intuitively" knew that the way the cademes of the piñon tree were sequenced did not communicate the concept of growth.

In a period of two months, each of these Navajos, including a fifty-five-year-old woman who spoke no English and said she had never seen a film, made films up to twenty minutes long, using structures of edemes (varying from the simple to the complex) in a planned sequence having no necessary relationship to the sequence in which they were shot. We have reported this material in another publication and have detailed many of the "rules" the Navajo used that to me were quite simply "wrong" (Worth and Adair 1970).

This brings me to the last of the concepts of language mentioned earlier in Chomsky's definition, one that seems to have been overlooked by most researchers trying to find similarities between film and verbal language. That is the notion of a "native speaker" or of a "language community." It is only the native speaker, according to linguists, who can be our informant about the rules or grammar of a language, and it is only the native speaker against whom we can check our reconstruction of the rules of *his* language or of Language. Although the linguist and the native speaker may be one and the same person (and in the Chomskian school most often is), the theory still presupposes that the distinction between a shared body of *arbi-*

trary signs and a set of *rules* for their use known by *all* the members of a community is a demonstrable fact. Are there such distinctions for film? Who are the native speakers? If we move in this direction, we are drawn to ask, "Are there different languages of film?" when we have not yet been able to determine whether there is *a* language of film. We could, of course, for the moment avoid the most perplexing parts of the question by *assuming* one universal "language" of film, dependent on the common ability of human beings to recognize and code iconic images. This might be fruitful, for we could then begin to study universals and differences in the implications and inferences related to film signs across a variety of cultures and verbal languages.

There are several concepts coming from linguistics and communication which recent researchers seem to find useful in the analysis of film from a semiotic point of view that bear directly on the question of a language community. The first and most frequently mentioned is the de Saussurian division of *langue, langage,* and *parole.* While it serves quite well to distinguish between what Chomsky calls deep structure or *the* theory of Language, surface structure or the theory of language L, and performance, the division serves merely to raise the same questions we have discussed above. It presupposes a body of rules not only for utterances of one community but also another set of rules for all utterances from which those of any community can be derived, or from which they can be transformed.

The *langue-parole* distinction is a tremendously perceptive one in regard to verbal language. In recent years, transformed into a competence-performance distinction, it has led to two very different methodologies and sets of problems for research. If one, like Chomsky and his followers, sets out to discover rules of competence, one must be concerned with what people *can* say, rather than with what people *do* say and *why* they *do* say it. In discussing competence rules in film, we can at present merely find prescriptive and proscriptive evaluative rules. We can find some viewers and some makers who will say certain things are "wrong" or "ungrammatical." Using this method, we would have to call each group a language community. These groups—the underground filmmakers, the Hollywood filmmakers, the "new wave," the television documentarians, or the *cinéma-vérité* filmmakers—do in fact rarely use the words "ungrammatical" or "wrong." Rather, they will call other films dull, uninteresting, bad aesthetically, old-fashioned, middle-class, "square," and so on. Films up to now have rarely been judged on other than evaluative-moral-aesthetic grounds. The classic test—and one that does not hold up completely, even for verbal language—would be something like two film sequences corresponding to Chomsky's

(1) Colorless green ideas sleep furiously.
(2) Furiously sleep ideas green colorless.
Here we would have to find a film sequence that we could judge meaningless but correct, and one that we could judge meaningless but incorrect. I do not believe that such a distinction, a distinction of grammaticalness and meaningfulness on a yes-no bipolar scale, is an appropriate judgment for film signs at the present time. It might not be the best scale for verbal language either, for that matter, but that is going too far afield for this paper. Without a definite lexicon, which film will never have except in special cases, the binary, digital distinctions we can make with words are not the ones we make with film. Rather, we make probability, analogical distinctions, which depend on personal as well as cultural contexts. The *langue-parole,* competence-performance distinction, at this stage of our knowledge, seems much too forced to apply to what happens when we encode or decode film signs.

The types of films mentioned above—new wave, underground, Hollywood, and so on—seem much closer to what we can call questions of style. We are talking more about the differences between the utterances of Henry James and Ernest Hemingway, or between Allen Ginsberg and Robert Lowell, than we are of those between any poem written in English and any poem written in French. To be sure, English imposes certain stylistic restraints, just as a shoulder-held camera imposes technical and conceptual constraints, but that is far from the kind of rules we are talking about for verbal language. There are, however, valid and ascertainable stylistic constraints which are tied to culture and context in general and which explain certain usages in much the same way that knowing about the use of a chisel for carving stone explains why the Roman letter *U* appeared as *V* in early stone-carved inscriptions.

The notion of a style without a grammar commonly accepted (by a language community) was advanced recently by Pasolini (1966), who proposed that films in general have styles, but that each film develops its own grammar as it goes along. This seems intuitively to be much more the case. We would then be calling the differences between a film made in the style of Eisenstein—with many short edemes in sequence meant to be organized into sequences in "collision"—compared to that of, let us say, Godard, who often refuses to break up a scene by cutting the action into bits—a stylistic difference rather than a grammatical one. We would be calling the specific manipulation of edemes and the parameters across which they were manipulated, which would be consistent across the film, its own particular set of rules, which we could use in textual analysis, as it were, to verify our inferences. It may be that over time these particu-

lar "grammatical devices" would become so generalized within large groups that they might assume the roles and rule-governing status of grammar. At such a point a viewer would say, "Ah, yes, that film is in Hollywood language, but the director or editor is using the language ungrammatically." Something of this nature may indeed develop in limited areas, but I suspect that our judgments will be more along poetic lines than grammatical ones. We will recognize iambic pentameter but will allow the meter to be broken for effect, without calling that ungrammatical. This would be analogous to what we do when we read the line from Gerard Manley Hopkins, "the achieve of the thing." We know that it is a variant of the grammatical form *the achievement of the thing.* We accept in our coding or inference procedure that it is ungrammatical, but is used to give emphasis or weight to a unit of utterance. We make a correct inference from the line even though it is ungrammatical, because in a sense the style of poetry clues us to a new set of inference rules. It might be the same situation as exists when Godard uses a jump cut for emphasis. We assume he does it deliberately, that he knows but disregards the proscription for a reason.

In this connection, the categories devised by Barthes (1953) of *langage, style,* and *écriture* (which I would rather translate as "encoding" than "writing") offer some insights that might be applied to film research. Barthes feels that both language and style are closed by history and culture. Language carries the history of the medium, and the lexicon within it, vertically over time. Style is just as bound, but horizontally, over specific cultures and individual times. The writer has some choice of style, less choice of language, and the greatest choice in encoding within a language and a style.

In a sense, the "language" of film, the knowledge and recognition of the edemes in a film, is fairly universal among men. We perceive and code analogic images of the outside world fairly similarly. It is the rules of coding these images that may differ, and what rules we find may be universal rules for a coding system which covers a vast variety of styles.

It seems to me, then, that the development of a semiotic of film depends not on answering linguistic questions of grammar, but on a determination of the capabilities of human beings to make inferences from the edemes presented in certain specified ways. Should we discover rules for manipulating edemes that make inference impossible or highly improbable, we might reconsider the question of whether there is a deep structure of innate responses in the brain, governing our coding habits for film and being responsible for a grammar of film.

Let us take one simple but prevalent controversy among film

theoreticians. Eisenstein proposed that inferences are made by taking the edeme *A,* juxtaposing it with *B,* and having the audience infer *C.* It was a notion stemming from his familiarity with both the operant conditioning research of Pavlov and his reading of the early Russian formalist linguists. Although he made no attempt to verify his theories experimentally, he made his films according to them. Recently Bazin and his followers have attacked this notion of film style. A scene or an action, they say, should not be broken up into little pieces and rearranged in an arbitrary way; such a breakdown of human behavior is "unnatural" and is not the way human beings perceive. If this is to be a meaningful criticism, it must mean that a filmmaker cannot imply a meaning to a larger group of people who will infer what he wants them to infer in this manner. "Unnatural" must mean not understandable or, at the very least, demonstrably less understandable than some other system. The rule for the use of film signs that Bazin must be suggesting is that if an action is broken up into pieces, we will be less able to infer a meaning from it than if it is shown us as one continuous cademe.

Clearly this is verifiable. Intuitively it sounds like nonsense, more the edict of the president of the academy than a serious statement about how things are. But perhaps some breakdowns in action or behavior, or some juxtapositions, are less understandable than others. It certainly seems reasonable to expect that I could take several cademes and so break them down that an audience would not know what they were seeing. At what point would this occur? Here it may be possible to discover some rules.

Hochberg (1966) in a series of recent experiments in perception, found that contrary to previous theory, humans can make sense out of units, or broken-up "bits," of a whole of perception. He used a Penfield impossible figure as his stimulus. When seeing the entire figure, subjects could make judgments that it was impossible. He then showed them single slides of the left corner, the central portion, and the right corner. Subjects were still able to make judgments about the figure, even though they saw them in what Bazin and others have called an "unnatural" way. When, however, the central slide was repeated several times, making the duration between viewings of the crucial corners longer and increasing the apparent length of the frame, subjects had greater difficulties in determining the impossibleness of the figure.

It would be important for understanding our coding capacities for film signs if such experiments, increasing the complexity of the edeme structure along the parameters of time, space, motion, and position, and *sequence,* were instituted by film researchers.

I am suggesting, then, that linguistics offers us some fruitful

jumping-off places for the development of a semiotic of film, but not a ready-made body of applicable theory leading to viable research in film. If we accept Chomsky's definition of language, we must be forced to conclude that film is not a language, does not have native speakers, and does not have units to which the same taxonomy of common significance can be applied as can be applied to verbal language. At this point, our aim should not be to change the definition of language so as to include the possible rules of film, although this may well be a result of further research in film, but rather to develop a methodology and a body of theory that will enable us to say with some certainty just how it is, and with what rules, that we make implications using film signs with some hope of similar inferences.

I have attempted in this paper to present what seem to be some of the fundamental problems before researchers in film semiotic. First, I proposed a basic description of the process of film communication, which is the phenomenon a semiotic must attempt to explain. Then I proposed a set of basic units, which seem to be the phenomena which filmmakers use in constructing their visual utterances. Third, I mentioned some of the problems in using verbal language and linguistics as a paradigm for the study of film. None of these presentations was exhaustive of the complexity of the process, the categories of units involved, or the conceptual problems of dealing with film from a linguistic base. They were meant as a perhaps oversimplified program for future research, rather than as a final word on the subject.

One major problem remains, which, while I have no reason to think it can be solved easily, must at least be mentioned. That is the problem of a methodology for research.

a methodology for research in film ●
For whatever reasons, sociological or psychological, persons interested in film have come to it from the study of literature, the practice of the various verbal and visual arts, or the ranks of the philosophy of aesthetics. On the other hand, those presently interested in the development of semiotics in general have come primarily from the social sciences—psychology, anthropology, linguistics. This latter group is, to a greater or lesser degree, interested in verifiability, scientific exposition, and theoretical development that ties in with other scientific knowledge of man's behavior. It must be said that up until very recently, the most interesting, perceptive, and exciting insights into how the process of film works have come from the former group.

There are some linguists who claim that poetry is not a proper domain for study by linguists, that in a sense it is extralinguistic, a set of judgments made about language rather than a linguistic prop-

erty within itself. All the more reason, then, for semioticians to guard against too close a bond with linguistic theories that might lead to the position that film cannot be studied scientifically.

The semiotician of film, at this stage of extremely limited knowledge of film signs, must, it seems to me, start out by attempting to discover and to describe what it is we euphemistically or metaphorically call a film sign. What is it that human beings encode and decode in a film? The intuitions of past and present researchers and filmmakers are incredibly valuable, but we must begin to systematize them and to test them. This testing can be done by observation and analysis of film-making and film-viewing behavior, or it can be done by controlled experiment. But what is needed is observations about specific hypotheses, problems, or statements.

I would, in this concluding section, like to present some problems that I think are ready to be worked on.

Are there specific communities that have a shared system of rules by which they imply or infer meaning from a specific set of edemes? Do Navajos, as Adair and I have suggested, have a set of rules that they apply to film which are different from that of urban dwellers in America? Can these "film language" communities be better described across national or linguistic parameters, or are they, as Basil Bernstein's evidence shows, better described across coding systems shared by socioeconomic classes or cultural groupings? Are we, in film, dealing with a problem of cognitive style rather than a problem of language? This kind of research calls for both observational and experimental procedures that, although not perfect by any means, are available in other social sciences. One of the reasons people trained in the social sciences have not tackled film yet is because the problems have not been clarified.

Another large area of possible research is one in which we would attempt to produce film sequences varying systematically across described units and parameters and test them to see if our manipulations of these hypothesized units result in predicted changes in the inference of viewers. If by adding, subtracting, or rearranging units we can communicate or not communicate, arouse or not arouse, imply accurately or not, we would begin to have some confidence in the nature and description of our hypothesized film sign.

Another possible area of research using the methodology and experience of linguistics would be the determination of units by the "same or different" question. Here we want to know, not what is instrumentally different, but what is psychologically different, what manipulations make a difference in inference, and to whom. It is clear with verbal language that we can tell the difference between *tomato*

and *tomahto,* but on one coding level we judge the two words the same and infer that they refer to the same designatum, and on another, we find the two words different and judge perhaps the social class, regional designation, or education of the speaker. What levels of coding are used for what signs in films? Do sequence and image themselves refer to designata, while angle, lighting, and so on refer to emotive, social, or other differences?

Given a set of cademes, would all people put them together following a similar, or even random, set of rules, or is it the case that different semiotic communities exist and that different groups would (1) make different edemes out of the same cademes and (2) organize them differently? Here we have an almost classical scientific experiment, in the sense that the finding either way, of no difference or of specified difference, would be equally an addition to knowledge. The above-mentioned procedure might throw a great deal of light on much more general problems of human cognition and coding which are difficult to tackle with words because no two language communities can handle the same set of words with equal knowledge as to their lexical meaning. The use of iconic signs capable of production and perception by almost all peoples was not possible previously. The movie camera removes the problem of the hand-eye skill which was necessary for the artist for the simple production of a desired image. With the movie camera, the cognitive and perceptual processes by which we deal with iconic signs become susceptible to study.

Again, this short list of possible research areas is neither complete nor specific. It is an indication of work to be done and a jumping-off place from which a semiotic of film might perhaps become viable. I use the phrase "jumping-off place" deliberately, because it seems to me that what we must find at this time is a point from which a landing place is, if not safe, at least visible.

two
a semiotic of
ethnographic film

Since what I will be dealing with in this paper will be concerned with communication, and with the signs and messages through which communication occurs, it might be fruitful to start by examining the title of this paper as a possible communicative event composed of a sequence of sign units.[1] Our first task ought to be a preliminary analysis of some of the signs I am using. (I am arbitrarily assuming at this point that I know that individual words are signs.) I will try later on to suggest that analysis of similar sign units might be necessary in the development of a semiotic of ethnographic film.

By a *semiotic,* as used in this paper, I mean roughly: a science, or a doctrine, of signs that will help to explain how human beings communicate with one another within a shared system, exchanging units that have common significance and a commonly understood set of rules of inference and implication. This is not a standard definition, since most uses of the term *semiotic* include signs and sign systems employed by nonhuman organisms and include signs that do not, or may not, have a communicative function or context. I would like for the moment to concentrate on signs used in human communication.

By *ethnographic,* I mean broadly the study, description, and pre-

1. This paper appeared in the Program in Ethnographic Film (PIEF) *Newsletter* 3 (1972): 8–12. An earlier version was presented at the 1968 annual meeting of the American Anthropological Association—Ed.

sentation of the customs and ways of people all over the world. By a *semiotic of ethnographic film,* I mean a method by means of which we can study the signs, and the rules of implication and inference, that we employ when we use those signs in films that are intended to describe and present the customs and ways of people all over the world.

An ethnographic film, then, is something that we employ for some particular purpose. It is a kind of film that its makers or viewers use for the study, description, or presentation of people and culture. Its users have by agreement attached some of the concepts of a discipline labeled "anthropology" to their use of film in this way and generally believe that there is some relationship between the goals of that discipline and "ethnographic film."

There can therefore be no way of describing a class of films as "ethnographic" by describing a film in and of itself. One can only describe this class of films by describing how they are used and assigning the term *ethnographic* to one class of descriptions. Just as one cannot say that any sign—the arbitrary word sign *dog,* for example —has a significance in and of itself, one cannot say that any film has a significance or meaning in and of itself. For any film, just as for the word *dog,* there must exist a common and shared significance among the members of a group who make implications and inferences or draw meaning from the use of a sign in a process of communication.

Just as words are signs of, and in, a speech event, so are visual images parts of an *image-event.* An image-event, however, is much more difficult in some ways to deal with than the speech events that occur in verbal language. We do not have a lexicon of images, as we do of words, by which we may check on a culturally agreed upon signification. To some extent, when we use visual images, we depend not on arbitrary sign meaning but on an expected common set of perceptual mechanisms and a common set of rules by which we perceive and organize the world. We are, however, learning that this set of rules by which we perceive and organize the world is as much dependent on our culture as on some set of built-in perceptual mechanisms. The Whorfian notion that the language we speak determines to some extent how we see the world around us must be considered quite literally when applied to film, and most particularly when applied to ethnographic film use. Although image-events appear in no lexicon that has been bound and stacked in libraries, differing cultures use, organize, and imply and infer meaning from image-events in differing ways.

If, then, no single film can be classed as ethnographic by looking at it, in and of itself, it follows that any film might become an

ethnographic film because of its purpose or its use. It would seem, therefore, that in order to know something about ethnographic films, we must examine not the films, primarily, but why they are made and how they are used.

What I am suggesting is the obvious fact that it is not enough for our purposes to study the film, or even a film code itself. In order to know about ethnographic films, we must study the code within some specific functional context. In our case, it will do us no good to study film qua film. We must begin to determine the relationship between a film code and its context not only within ethnographic research but within the culture or the subculture that both produces and uses a film.

To develop this point further, I would like to borrow a question formulated first by Sapir in 1938 and called to our attention by Hymes in a paper entitled "Why Linguistics Needs the Sociologist" (1967). It might become interesting if we were to challenge our interest in ethnographic film by asking why the filmmaker needs the ethnographer, or even why the ethnographer needs the filmmaker. In one sense, of course, the relation between these two disciplines can be of trivial intellectual interest, even though of great practical desirability. It might be thought of as analogous to asking why the anthropologist or the linguist needs a sound-tape-machine operator. The anthropologist in the field might need a similar technician to perform a visual recording service for him. "Make me a picture of that dance," he would say. Conversely, the filmmaker might want to make a film about Eskimos and would expect the anthropologist to act as a sort of straw boss in the field. "Ask those guys what they're doing, and do you think it's O.K. for me to say on the soundtrack that Eskimos love their dogs? Do you think that would be O.K. for the Board of Education?"

Unfortunately, such things have occurred. I am not talking about that kind of need. To clarify the original question, and to make more precise the area which is of significance intellectually, I should rather ask why the person interested in *studying* ethnographic film needs the ethnographer or why the ethnographer needs a person interested in the *study of film*.

Let us, for a moment, look at how film has been used by anthropologists in the past. I will not detail this history (see Ruby 1971), but would rather talk about types or categories of films used in a specific intellectual community—that of anthropology. Films may, of course, still be examined in terms of their own structure, but

if the use of the film determines its labeling as "ethnographic," it is its use that must first be established.

An ethnographic film is a set of signs used to study the behavior of a people. Films can be used in two basic ways to achieve this purpose: as a recording of data *about* culture, or as data *of* a culture.

First, a film can be made or examined as a particular form of data retention, collection, and transmission. Such a film records the basic data of culture in and within the cognitive system and value structure of the data collector. It is similar in this way to the linguist's use of the tape recorder. He chooses his speaker according to a determined set of rules developed by his discipline and saves memory storage by having a machine collect a particular set of sounds for analysis. In a like manner, one can choose a "chunk" of behavior and have the camera (with or without synchronous sound) record it. We can use that piece of film to save memory storage, or we can use it to observe units of behavior that are not visible at normal speed. Normally we do not see in units of 1/24 or 1/1000 of a second. The movie camera can record these chunks of behavior in frames passing before a lens at any given speed, and we can then observe this behavior at will, and at any speed. *We,* however, point the camera, determine the speed at which the film passes behind the lens, and determine what we will view, and at what speed we will view it.

Second, films can be thought of as a phenomenon of culture in their own right, reflecting the value systems, coding patterns, and cognitive processes of the maker. Here the ethnographer is interested in what has been called the "ethnography of communication," and studies not only the behavior recorded on the film, but primarily the behavior of the man who organizes image events on film. Such use is analogous to that of the anthropological linguist or the sociolinguist who wants to know what, why, and how specific people in specific contexts say or do not say specific things, and how their utterances are related to other aspects of their culture, and to the culture of people who live differently. Here one is interested in what things are said, why, to whom, and in what form.

Let us take these two different functions and try to see what we need to know in order to use film in these ways.

If one is interested in film only as a data bank, recording the behavior of an informant, one need not concern oneself with how the informant would organize the film. One must, however, be clear about how the ethnographer himself organizes the behavior he records. The notion that film is in some way an objective record capturing some elusive "truth" must be recognized as the nonsense it is. I

believe this notion, implicitly held and sometimes explicitly stated, has done more damage to ethnographic research than any other "contribution" made about the use of modern technology. It has done damage not only because it is wrong—I can conceive of some very wrong ideas having quite positive effects in a research situation—but because it has prevented researchers from examining their own methods of organizing and structuring the visual events that are recorded in the field and subsequently analyzed and described as the behavior of an informant or group.

The obvious problem here is that—as Margaret Mead and others have pointed out so often—we forget that other things are happening when the camera is pointing in one direction, or that other things are happening outside that frame. We also tend to forget that all films are edited by someone. Even "unedited" research films are edited. Someone placed the camera and started, stopped, and started the camera again. Someone decided to take a close-up or a long shot. Someone decided what events were worth recording and what events were of no significance and not worthy of being recorded. In effect, someone acted as a human being making research decisions in the field.

Anyone who has ever analyzed a film can testify to the almost insidious power of the medium. We tend to believe that what is on the screen *is*—and is thereby some act of higher truth. Once one has looked at a film of an action or an interaction a number of times (and in some forms of microanalysis, three hundred times is not a lot) one is hard pressed to remember that what one has seen is not what happened, but what the cameraman and camera put on his film.

There is, however, no point in taking the position that if film is not objective truth, there is no use to it. I am arguing that there is great value in visually recorded data of culture—so long as we know what it is that we recorded, so long as we are aware of how and by what rules we chose our subject matter, and so long as we are aware of how *we* organized the various units of film from which we will do our analysis.

If anthropologists are to collect data on film and to be trained to do this, it is necessary for them to conceptualize clearly the mode and specific methods of analysis that they will use, rather than to concentrate on the technology required to get a clear image on film. If Navajo Indians (Worth and Adair 1972) can learn to capture a clear image on film in two days of instruction, we ought to assume that anthropologists studying filming technique can do as well with a week's instruction, and that professors should spend time teaching something which cannot be picked up from an instruction book or from a day's instruction.

What I am suggesting is that a semiotic of ethnographic film concern itself, on this data-collection level, with the study of three things. First, a description of existing analytic methods that are used in analyzing behavior recorded on film. Second, a description of the alternative ways of organizing the film image itself, and third, the development of new methods of analysis tied to ethnographic and anthropological theory.

The first concern, the description of existing analytic methods, is relatively simple because they are so few, and those few are fairly well developed (Birdwhistell 1971; Lomax 1970; Hall 1968; Ekman and Friesen 1969). At present, however, there are very few people trained in even this small variety of analytic methods. Achieving this first goal is a problem of educational organization within a multidisciplinary field combining parts of anthropology, communication, and film.

The second concern, a description of alternative ways of organizing film, is a more difficult problem. There are at present few film schools in this country, few schools of communication, and almost no anthropology departments that I know of that are seriously investigating the ways human beings with differing cultures organize visual experiences when they record them on film.

The third concern, that of developing new methods of analysis tied to anthropological problems and theories, seems to me to be the most crucial. If we could make headway here, we would be able to integrate the study of ethnographic film into anthropology as part of a discipline.

Let me delay for a moment a fuller explanation of this point. I intend to come back to it after describing briefly the second of the two ways I mentioned earlier in which film can be used in the study of culture.

This second way in which film can be used is relatively new in some dimensions, but not in others. Here I am referring to the study of film as a phenomenon of culture itself, rather than its study as an anthropologist's recorded data of that culture. Here we would analyze films for much the same reasons that we analyze verbal language, methods of farming, child-rearing practices, and so on.

Using films this way, or calling films that we study for this purpose "ethnographic," demands not only some of the same skills and conceptual clarity that were discussed earlier, but also the integration of some fundamentally new problems into existing theory, both in communication and in anthropology.

Looking at a culture through the films made in that culture poses some interesting questions. Wolfenstein (1953), Weakland (1966),

Mead and Metraux (1953), Gerbner (1972), and many others have engaged in what Mead has called "the study of culture at a distance." They have made many assumptions which, so far as I know, have not yet been sufficiently clarified. Basic to much of this early work was the assumption that certain films—those made for mass audiences, primarily—reflect the "daydreams" of the culture that produced them. These films are then sampled and analyzed to ascertain basic values and interests of the culture in question. In many cases, such work yields fruitful insights. Yet some of the assumptions are much too simplistic. It is true that, analogously, the linguist taking an interest in problems of *competence only* can examine the utterances produced by such diverse groups as political figures, nightclub comics, or street-corner venders. But as long as the theoretical structure behind such analysis does not require one to differentiate among these speakers, and seeks only to deal with that part of language that they all share, it does not matter. If, however, the analysis has as one aim to compare value systems, "national daydreams," or traits in a body of films, and does not include an analysis of how the films were made, under what cultural rules, by what groups, for what purpose, the conclusions are bound to be difficult to substantiate.

For example, it is clear now (Guback 1969) that films made in the West (United States, England, France, Italy, Spain) are not so much national expressions as supernational products, designed, financed, and produced to appeal to as wide a group of viewers in as many countries as possible, by a multinational or supernational organization. It is almost impossible to single out a recent British film, for example, that was not financed and approved by American interests with multinational audiences in mind. The same holds true of the so-called Iron Curtain countries, whose films are financed by the Soviet Union and produced for much more than internal consumption.

It is important to realize that "films" are not all the same for ethnographic use, either. Certain films are made by individual members of a culture, but even here, as in "avant-garde" or "art" films, it is important to know which values and ideas are paramount for the filmmakers. Other films are made by members of a culture in a more ethnographic sense. But these have rarely been studied (Chalfen 1975). For example, "home movies" are made for showing to family and friends—for private, rather than public viewing—and probably reflect more of what we mean when we talk about how members of a culture organize their world through image-events than do the commercial infranational films. Recently, high school, college, and

independent groups such as Indians, blacks, and Chicanos have been making films for their purposes in their ways.

Once one realizes that films are not made by a culture but by individuals or small groups within a culture or sharing some common culture, one is faced with a problem that has long preoccupied researchers interested in the complex relationship between the use and performance of verbal language, and culture.

In developing a semiotic of ethnographic film on the level of film as a datum of culture, the problem of determining how film signs are used by individuals according to rules becomes paramount.

Here we would be asking questions that have been asked about other modes of communication—speech, of course, but also about painting, carving, architecture, and so on. These might be considered questions of form or, using linguistic terms, questions of syntax, as well as content, or semantics. In analyzing ethnographic films in this way, we might want to ask such questions as: Does film have the properties of a language, and if so, what are they? Are there language communities of filmmakers and film viewers? Does film have the same function for all communities? and so on.

The decision to concentrate for the time being on developing a semiotic rather than a grammar was made because it seems unwise at this state of ignorance to prejudge whether film communication should be considered a language in a formal and serious sense. The notion of a semiotic allows for the discovery of rules of the linguistic type for film organization, but does not preclude other, less formal, less commonly understood, and perhaps different, patterns of use.

For ethnographers, the study of film as another way to investigate the cognitive organization of different peoples opens a vast new area. Since people have divided themselves into different linguistic groups, those studying culture through language have been forced to surmount the very difficult translation barrier. Descriptions of the attitudes, customs, and way of organizing experience rendered by the members of the studied culture are always filtered through the ethnographer's eyes, ears, and cognitive system. He must translate the myths, redescribe the customs, and talk secondhand about how the "native" sees his own world and his experiences in it.

Films, just like still photographs and paintings, can be made by the native people in question, and, what is more, it may be the case that we can understand them as the native does. Notice the qualification—I said, "It may be the case."

This seems to be the first job that those interested in a semiotic of ethnofilm must be prepared to tackle. What are the implications that the maker of a film puts into his film, and what are the inferences

that a viewer infers from it? Are there universal patterns of inference, of narrative forms, of image use, that are of common, shared significance across all cultures, or across certain groups of cultures? Are there certain structures of film communication which are related to other patterns of culture, such as verbal language, kinship patterns, and so on?

Not only do we have to know how "natives" organize their visual perceptions, but we must study the anthropologist's own system of organizing the films he makes. Does the language that he, the ethnographer, speaks make for a particular system of implication or inference? Does the anthropological theory that he is working with, which the film, as data, is meant to elucidate, influence the way in which he sees the world that he is trying to describe?

Leonard Bloomfield (1964), talking of White-Thunder's use of Menomini, implies that "Menomini is a language no one speaks tolerably" (Hymes 1967:636). About which Hymes comments

White-Thunder forces us to face the fact that for both the individual and the community, a language in some sense is what those who have it can do with it. . . . Differences in facility and adequacy may be encountered that are not accidental but integral to the language as it exists for those in question. [Ibid.]

We must know not only the differences in facility and adequacy among different users of film, but if Navajos, Negro teenagers, or Trobriand Islanders make films, what must we know about their methods of patterning these sign units for us to use these films as data of culture? Using such films not only gives us the possibility of seeing and analyzing what the other person thinks important to show us— not only do we have the opportunity to determine the patterns by which he organizes what he shows us, but, as with language itself, we can see what he does not show and how he does not organize. In other words, negative cases count, and nothing never happens.

When I talked earlier about the need to integrate a theory of ethnofilm with theories in anthropology, I meant the kind of integration which would be useful in tackling some of the problems briefly and cursorily mentioned above.

The mechanical amalgam of a film theory not concerned with ethnography with an anthropology not concerned with ethnofilm problems will not do. The kind of training in which anthropologists learn about Eisenstein's theory of editing and filmmakers learn some basic anthropology will produce—perhaps—filmmakers who know a little anthropology, and anthropologists who know a little about how

to make films, but will not contribute much to the development of problems whose solution can be integrated into a scientific theory of culture.

Rather than attempting to list a set of problems appropriate to this kind of analysis, let me give one example of the kind of problem for which an adequate theory must be developed if there is to be such a thing as a semiotic of ethnofilm.

Whorf and others have advanced the notion that the language one speaks influences the way one perceives and organizes the world. Let us state as a hypothesis that the way one organizes units of a filmed event depends only on the way one organizes verbal descriptions of that event. (I do not think this is true, by the way, but it is a testable hypothesis.)

Obviously, if this were true, it would be extremely important to both anthropological theory and to film theory, yet neither group can at present deal with the complexities of the problem. It would, in order to test this hypothesis, be necessary to develop a descriptive system of film organization similar to grammar and syntax that can be compared with other relevant dimensions known to facilitate ethnographic description.

It would be necessary to examine much more closely how indeed the use of verbal language, in narrative, mythic, and everyday events, relates to what we normally call the grammatical or syntactic. At the same time, we would have to examine how film "narrates," "tells stories," and deals with everyday events, in a way that could relate that to the formal, structural, or syntactic codes of film use. The concept of "Language and Culture" as a label for the relationship of culture to modes of communication is clearly too narrow. When we make films, paint pictures, carve doorposts, dress, set our tables, and furnish our homes, as well as when we speak, we are using symbolic forms which are part of culture and which are all possibly related. A semiotic of ethnographic film is part of the study of the relationship between culture and communication itself.

Unfortunately, I have not had time to present the above arguments as fully as I would have liked to. Let me sum up, however, by restating some of them and indicating some of their perhaps controversial implications.

(1) There is no such thing as an "ethnographic film"; or, to put it another way, any film may or may not be an ethnographic film, depending on how it is used.

(2) Learning how to make films as films, with the emphasis on the technical or artistic aspects of the medium, is not relevant to anthropology. Learning how to study about films in relation to some

specific anthropological problem is relevant. At present, this kind of study is almost nonexistent.

(3) Whether those interested in analyzing culture through film use or define ethnofilm as their record of their observation or as the native's own way of seeing things, a similar body of knowledge about ethnofilm analysis is required. I am suggesting that this knowledge must include: a) a description of alternative ways of manipulating film; b) a description of alternative ways of analyzing film; and c) the development of a body of theory, or at least the identification of problems relevant to existing theory that the analysis of ethnofilm will be designed to solve.

(4) A semiotic of ethnofilm should be concerned with questions that have broad disciplinary interest and that stem from new problems generated by the congruence of film analysis and the analysis of culture. In other words, a semiotic of ethnofilm, if it is worth getting involved in, must become part of the science of culture and communication, and the questions and problems it deals with must be those that the larger discipline cannot help getting interested in —not only because films are fun, but because film studied in this way offers answers to questions that concern us as professionals.

(5) Fifth, but by no means least important, is the fact that training students in this new area is extremely difficult to do at the moment. Some universities have instituted ethnographic film services, some are experimenting with joint courses run by filmmakers and anthropologists. Various plans are afoot, but, in my opinion, we have just begun. The problems have hardly begun to be clarified, and training in this area is still not accepted as necessary for a degree in film, communication, or anthropology.

Although the interesting questions are the research questions, I would like to emphasize the pedagogical implications of such interests. If culture and communication are worth studying, the entire field must determine their relevance and the methods of training which will enable those entering the field to pursue these problems. Just as the study of language has not been left to the formal linguist alone, so the development of a semiotic of ethnofilm cannot be left only to the filmmaker or only to the ethnographer.

three
toward an anthropological politics of symbolic forms

Imagine a world where symbolic forms created by one inhabitant are instantaneously available to all other inhabitants; a place where "knowing others" means only that others know us, and we know them, through the images we all create about ourselves and our world, as we see it, feel it, and choose to make it available to a massive communication network, slavering and hungry for images to fill the capacity of its coaxial cables.[1]

Imagine this place that is so different from the society within which we nourish our middle-class souls, in which symbolic forms are not the property of a "cultured," technological, or economic elite, but rather are ubiquitous and multiplying like a giant cancer (or, conversely, unfolding like a huge and magnificent orchid), and available for instant transmission to the entire world.

Imagine a place where other cultures (in the anthropological sense) and culture (as digested at ladies' teas) are available to all; a place where almost anyone (some will be too young or too infirm, physically or mentally, ever to be involved) can produce verbal and visual images, where individuals or groups can edit, arrange, and rearrange the visualization of their outer and inner worlds, and a

1. This paper is reprinted with permission from *Reinventing Anthropology,* edited by Dell Hymes and published by Pantheon Books, a division of Random House, Inc. © 1972 —Ed.

place where these movies, TVs, or "tellies" (a marvelous word coined from television, and connoting the verb "to tell" so subtly as almost to be overlooked) can be instantaneously available to anyone who chooses to look.

What will the anthropologist, as the student of man and his cultures, do in this world? Imagine this place; for it is where we are at *now*. Let me review the situation in bald technological terms.

In 1850, information traveled at the speed of man, on foot; on an animal's back; or on a ship at sea. Men knew each other across time by the symbolic mediation of words and the interior images they created. A memory storage of a small portion of the earth, created by an even smaller percentage of persons, was laboriously collected in libraries. The look of things—a man, a god, a place—was fixed in visual images created by a small group of highly trained and talented men who painted pictures, carved statues, and illustrated books. A man could personally see but few things in the world. If he traveled, he could see only the people and places he actually passed through and looked at. Visual knowledge was limited by space and time. All else was known by the words of other men, by their descriptive power, and by the ability of readers and listeners to give body and image to the symbolic event of verbal interaction.

In 1850, information and the knowledge it created still traveled at about the same speed it had attained in 3000 B.C.

In 1900, words and all their magical symbolic fruits were traveling by radio waves at the speed of light—from 15 miles an hour to 186,000 miles a second in fifty years. Instantaneous communication was possible, and by the time of World War II most men on earth had potentially available to them everything sent out by radio wave. Men sat at home in New York City and twirled a dial, picking up broadcasts from Japan, from India, from Africa, from Germany, and from Russia. And in those places men also twirled dials and listened, knowing for the first time in history that potentially everyone could be listening at the same time to the words of a president proclaiming an infamous act on the part of Japan.

In 1905, the same year that Freud published *Studies in Hysteria* and suggested a new way of making inferences from the symbolic forms created in dreams, Thomas Edison invented the motion-picture camera.

Thus, at the beginning of the twentieth century, at the same time that man was given a new and revolutionary glimpse of inner "reality," the motion-picture camera came into being, hailed as the technology supreme, the machine that would finally allow man to capture the outer world, as it "really" was. For the first time in man's long

attempt at symbolizing and representing himself in his environment, it became possible to make an image that was, in Peirce's sense, not an icon—a visual resemblance of object reality—but an index. We no longer had to depend on the hand-eye skills of a few highly trained picture-makers who created images that *resembled* objects—more or less.

While the iconic sign of the hand-drawn image was always a resemblance, a similarity to the "real" world, the camera image was accepted as an indexical sign of it, a true mapping, a point-to-point correspondence with the reality before the camera. With indexical signs, we no longer had to doubt the individual notation systems of other cultures. All perspectives were "true," and the puzzles of Chinese perspective or Egyptian profiles and side views were understood as cultural creations reflecting a specific way of creating similarity or resemblance to the "real" world. The indexical sign achieved the status of reality-substitute; it became the base upon which visual imagery rested. We really believe that the camera image records the reality of places, people, and behavior.

By 1905, men had developed the ability to create symbolic forms in modes that had never before been possible. Men could "reproduce" their actual voices, and could send these voices, unaccompanied, all over the globe in such fractions of time as to appear instantaneous. Men could "reproduce" actual places and people by a technology that created indexical signs without the hand-eye co-ordination and skill of the graphic artist. One could produce images and sounds of anything in the world; one had only to be able to point a camera and a microphone at the world.

Three-quarters of a century ago, we learned to reproduce sound and to create indexical camera images. By 1930, we had learned to combine sounds and images to create talking pictures, and by 1940 we had learned how to make these images speed unaccompanied around the globe.

It is clear that we have learned to produce talking images, but it is not quite so clear why we use these images as we do, or how we ought to understand our use of them. We often tend to forget even the short history of moving pictures and to assume that the way we use movies now is the way they were always used, and further, that the way we think of movies now is the way they will always be. It might be argued that the fifty-year period between 1930 and 1980 will be considered an aberrant period in the history of the use of the moving/sound image.

Movies developed along a dual path: one direction can be clearly

seen as motivated initially by a naive ethnographic concern, and the other as motivated by a mythmaking, magic, and storytelling impulse.

It is of central importance to the thrust of this paper to understand the underlying and continuous influence of the ethnographic impulse in the development not only of the technology of film, but of the art as well.

The very first "movies" created in the Edison Laboratories were simple exercises in ethnographic description: a one-minute film of a sneeze, one minute of a lab assistant playing his violin, and another one-minute movie of two lab workers kissing. The brochure that Thomas Edison printed to describe his new invention had as its headline *Recordings from Real Life.* Lumière in Paris also used the first movie camera invented in Europe to record the ritual behavior of everyday life: workers punching a time clock, workers walking through the factory gates, and Parisians rushing to get on a train at the Gare du Nord. Within several years, movies were being "manufactured" on both sides of the Atlantic. These early films shown in the United States in storefronts called nickelodeons continued the ethnographic directions of Edison and Lumière. Films with titles such as *Washing the Baby, The Train Arrives at the Station, Cleaning the House,* and *Making the Bed* were shocking, delighting, and often frightening to audiences. Early newspaper accounts and interviews with audience members emphasized that these new moving pictures were valued because "they were just like what people really did."

In Germany, in 1905, ethnographers going to the field carried with them a motion-picture camera—a new *scientific* instrument with which they could record for further study the behavior and rituals of the "primitive" peoples they observed. As a matter of fact, the very beginnings of the development of the motion-picture camera as we know it today stemmed from what Ray Birdwhistell has termed *kinesics.* Eadweard Muybridge, an engineer with the Union Pacific Railroad, was asked by Governor Leland Stanford of California to invent a way to settle a bet. Stanford, an owner of racing stables, had wagered a large sum of money on the assertion that a racehorse at a gallop had all four feet off the ground at the same time. Muybridge, who in addition to his engineering skills was interested in the biology of motion, developed a camera that would record the images of a racehorse in motion. It seemed natural, once Muybridge had invented his motion camera, for biologists and anatomists all over the world to consider it not as an artistic instrument but rather as another scientific tool for the recording and reproduction of visual events.

It seems inevitable that the first motion pictures were "intuitively" about culture, motion, and the ritual of everyday events. The real was available, was captured, and was made into data by motion-picture film on a reel.

The other direction—that moving toward the creation of myth—started with the magic shows of Méliès in Paris in 1902. This movement attempted to provide inexpensive theater. The movie was thought to be an extension of the stage, with more flexibility as to locations portrayed, but still dependent upon actors and playwrights. The period of moviemaking between 1920 and the present seemed to be dominated by the mythmakers and storytellers of the stage. What most people knew about the movies were the story films of Hollywood and the giant studios. The ethnographic impulse, however, continued increasingly to affect film theory and practice. The so-called documentary movement, developed in the Soviet Union as a political tool immediately after the revolution, matured through the documentary film boards of Britain and Canada until, in the late fifties and early sixties, the ethnographic films of Jean Rouch and Edgar Morin of the Musée de l'Homme in Paris became the theoretical inspiration for France's "new wave." Today, even "fiction" films are designed with ethnographic theory in mind. The art of the film today in large part is concerned with the depiction of ethnographically valid imagery and symbols. The theorists of film in France, Britain, Poland, Italy, and lately in the United States are supporting their film theories and analyses, rightly or wrongly, with references to Lévi-Strauss, de Saussure, Chomsky, Mead, and a host of other anthropologists and linguists.

The technology that made the "new film" possible—lightweight cameras and portable synchronous sound equipment—was developed originally to support ethnographic research in the field. Rouch and Morin, needing the ability to capture actual behavior with sound in the field, made it possible to do so. It was after seeing their *Chronicle of a Summer* that Truffaut and Godard realized what they could do with the ethnographic method.

While all this was happening in movie theaters, the home screen, through electronics and the television tube, was also being developed. After World War II, it became possible for millions to sit at home and watch moving pictures of events in any part of the world (and later the universe) *as they occurred.* With the advent of television, we thought not of *listening* to events, as with radio, but finally of *watching* them. The mediation of symbols through which our ontology is in large part created had finally encompassed the image.

Symbolic events could now be constructed to match face-to-face observation—or so it seemed.

While everyone can speak, however, not everyone could make movies or television. These forms demanded vast allocations of economic or technological resources beyond the reach of any but a new elite. And, further, movies and television seemed to have built-in limitations. Movies could not be seen at home: they were public events, rivaling theater. Custom decreed it that way, and "home movies" were not fully acceptable until after World War II. Television, however, had even more stringent limitations, set not by custom or economics but by physical law. While radio waves could broadcast multidirectionally and across the entire globe (given a large enough power source), television waves could broadcast only by line of sight —in straight lines, interfered with by tall buildings, mountains, and simple distance on the curvature of the earth. Television was also limited by the amount of the electromagnetic spectrum it consumed in broadcasting. It used up, as it were, much more of the air waves for its signal, and so the granting of licenses to broadcast originally limited the number of communication channels to twelve. And in order to safeguard the integrity of the signal, most localities used only alternating channels, limiting the channel space to six.

It seems "reasonable" under these conditions for societies to control the channels of communication. Control of scarce resources makes sense. With a technological limit of channel space, it seemed appropriate that a new elite, controlling the input devices of television channels, develop. After all, everyone could look without charge. The enlightened new elite fought for its "rights"—the right to show what *they* wanted, the freedom of speech to show what *they* felt important.

Technology in our culture seems almost like the mythic mountain climber who does what he does because "it's there." Television's limitations were not only technological. This limited broadcast ability also limited markets. A toothpaste ad broadcast on one side of a hill was unavailable to those who lived on the other side. Consumers could not be created and cultivated out of people who wanted to, but could not, tune in to the commercials.

A small group of entrepreneurs invented a solution. They would build a large antenna on the top of the hill, receiving the TV signal from its input source, and create another channel by wire, which would deliver the "message" into the home. People would pay for the wire—the channel—not the message.

This solution of creating another channel of wire to eliminate the inherent limitation of the TV broadcast signal was of such huge

import that hardly anyone involved saw what was at stake for the concept of culture. The greatest device for the accomplishment of cultural homogeneity was created to sell toothpaste. For, incredibly enough, wires were not licensed. Anyone—with enough money and political power, that is—could put up an antenna and send received signals by wire. These wires were owned privately and went into only such homes as paid for them or were chosen to have them. The TV broadcasters, that conglomerate elite of fighters for freedom of speech, were at first delighted by wire. Now people would pay to be able to receive their free signals. They were somewhat annoyed at not having a piece of the action—the rental fee for wire—but were basically so happy about the expanded audience market that they allowed the cable TV companies to live. After all, how many mountains are there, anyway?

Within five years, however, the cable TV companies had developed their technology to the point where one wire was able to carry up to twenty different signals, and it was clear that a wire could be built that would allow up to several hundred simultaneous signals. Suddenly the cable TV people, the Ford Foundation (an alliance of McGeorge Bundy, formerly of the White House, and Fred Friendly, formerly of CBS), Bell Telephone, and even Howard Hughes began to see the magnitude of the future.

This was the situation in 1960. TV broadcasting required incredible economic resources, but TV program origination required even more. Not only money but talent was scarce and hard to find. Imagine the state of the cable TV owner. He had a system that could broadcast (in effect) a hundred programs over the same channel (wire) at almost the same cost as broadcasting one program. No channel-space restriction, no geographical restriction, and no program-origination cost. With TV satellites, all signals from all over the world could, theoretically, be received by special ground stations and broadcast simultaneously on cable. The set-owner paid only for the wire, and the wire-owners vied to provide the set-owner with the greatest number of choices. The problem, as it is phrased in the trade, is one of "product": "Where the hell are we going to get enough product to fill up the cable?"

We are now past 1970. It is technologically feasible right now for a moving image with its accompanying sound to be broadcast from any place in our solar system and to be received in hundreds of millions, or even all homes attached to the wire—simultaneously. It is further possible for all homes to have their choice of hundreds of messages received simultaneously.

Cable TV, unlike radio and broadcast television, also has output control. When the astronauts broadcast from the moon, *anyone* can watch and listen. With cable, any single set or any group of sets can be switched on and off for particular messages. Total control of reception is therefore also possible.

That is the state of channel capacity and control of symbolic forms available to us right now.

What does this mean for the anthropologist concerned with the study of man and of his culture, conceived as almost infinitely diverse, hard to find and to understand in its diversity, disappearing with the onslaught of technology and urbanization, and basic to the development of a science of man?

With this background in mind, I would like now to describe some of the current problems and plans for the development of what communications technologists are calling the "wired planet." Then I shall try to project some of the very probable developments of the next ten to twenty years. And finally I would like to formulate some of the questions and problems that I see as crucial concerns for the field of anthropology, both in terms of how anthropologists of the future are to be trained and of the anthropological problems that will face the student of culture in the immediate future.

For the first sixty years of the age of the moving image, the production and control of these images were limited to small groups of men who controlled the vast economic resources thought to be necessary for the creation of moving pictures and television. In the first five or ten years after the invention of the motion-picture camera and projector, individual men with no previous training (where could they get it, in the beginning?) became the owners of movie cameras and the makers of moving pictures. For the next fifty years, a myth system was created, implying that only a special group of "artists," "communicators," and (later) "journalists" could, and should, have access to the making of motion pictures. But the young, brought up since World War II in a world in which the moving image was first a babysitter and second their window on the world, began in the late 1950s to demand to have this tool—along with the car—for their own use. All over the Western world, and particularly in the United States, young people began to demand that they be taught the use of the motion-picture camera, not to make "moving snapshots," which their parents made to show to their relatives and friends, but to make "movies"—stories about a world that they could call their own, in ways that were their own.

A few researchers began in the early 1960s to examine what would happen when young middle-class children, ages nine to

twelve, black teenage dropouts, ages ten to fifteen, and college students were taught the technology of the camera and allowed to use film to structure "stories" of their world in their way. John Adair and I taught Navajo Indians in their own community to use the motion-picture camera (Worth and Adair 1970, 1972). They learned to make movies easily. One of our students, age twenty-three, taught her mother, age fifty-five (who spoke no English and said she had never seen a movie), to use a 16-mm. Bell and Howell triple-lens turret camera in three hours. Everyone who has worked with youngsters in our culture, or with members of other cultures, has reported that no one failed to learn the technology quickly, and that everyone asked seemed, at the very least, interested and most highly motivated. The most "primitive" man can learn to understand a picture or a movie in a very short time. The reports of primitive man's difficulties with movies are anecdotal and sparse, but these same reports confirm the speed (hours and, at the most, days) with which any men seem to adapt to symbolic communication through motion pictures. At a fundamental level, universals of visual communication come into play much more readily than those of verbal language. At the same time, we have found that peoples with differing cultures make movies differently. When given instruction only in the technology of the camera and film, they tend to structure their movies according to the rules of their particular language, culture, and myth forms, as in the case of the Navajo, and according to their social roles and cultural attitudes, as in the case of black and white youngsters in our society. In sum, it is not unreasonable to expect that anyone who has mastered enough technology to build his own house or tell his own story in words can learn in a very short time to use a movie camera. It is not unreasonable to expect that the New Guinea native, the American Indian, the Eskimo, the peoples of developing and developed states in Africa and Asia, as well as various segments of our own society, will soon be able to make moving pictures of the world as they see it and to structure these images in their own way to show us the stories they want to show each other, but which we may also oversee.

Right now, at Mt. Sinai Hospital in New York, the Department of Community Medicine is training doctors and patients (on a limited scale) to make movies about health. The doctors are showing their idea of health, and the patients are showing theirs. This hospital is planning now to install cable TV in several housing projects and health centers, to institute the beginning of a "wired community" in East Harlem, where doctors and community members will have joint access to several channels through which they may "broadcast"

whatever they wish. Such projects are being thought of in communities throughout this country and in Europe, for health, for education, and of course for *political control.*

Let us imagine the planet Earth somehow managing to escape the horrors of ecological or atomic disaster for another twenty years. What will its people be like in their capacity to produce and live by visual communication? The large industrialized nations, both East and West, will have a majority of their households wired. Teaching, banking, newspapers, and most shopping will most certainly be done through the "tube," wired to computers and to special videophone outlets connected with the tube. We shall use libraries by video printout or just read off the tube in our studies.

Fidel Castro might provide for all of Cuba, or all of the planet, direct TV coverage of the newest methods for harvesting sugar, and of course the United States could (if it chose) broadcast the entire war in Vietnam continuously. The anthropologist in the field could easily broadcast his entire field experience (edited his way, of course), supplemented by films or simple continuous broadcast of the stream of behavior as seen by his informants, whom he would have trained to use the camera.

In general, men today need no longer depend on verbal reports of distant places and people. One can see them. One can see the man on the moon by television and see the Dani of New Guinea making war by film. Moreover, while hearing a Greek on radio may have evoked the response "It's Greek to me," it is harder, if not impossible, to *see* a man laugh, or weep, or die, and feel that he is a stranger. A man going about his day, planting, hunting, or simply sitting alone near a fire, is in a situation that speaking does not make available to us. Movies do.

It would seem that Malinowski's stricture that the function of the ethnographer was to see the native's culture from the native's own point of view could at last be achieved—literally, and not metaphorically.

What would such a world be like, and more importantly, what problems have we to set before our students now that will, at the least, not hinder them from coming to an understanding of an age in which man presents himself not in person but through the mediation of visual symbolic forms?

Although the problems that I see before us in this area can be divided into three groups—what I shall call the political, ethical, and theoretical areas—it should become clear that none of these categories can in actual practice be separated. It is only for convenience of articulation that I shall start with what seem to be theoretical ques-

tions and go on to ethical problems, which are, in the long run, probably all political questions anyway.

By theoretical, in this paper, I mean theories and methods that will have to be developed and articulated in order to understand a world suffering from (or blessed with) the democratization of culture, a world, that is, where all cultures are potentially available to all people through this new visual symbolic mythmaking form.

Epistemological and ontological questions—how we know and what we know—have always been of concern to anthropologists and other students of man. Poetry, myth, stories, and tales have always been created and studied as a singularly important source of the world view mediated by symbolic forms. Language itself has been a central problem in anthropology. But this "language" that we have been mentioning refers only to a verbal output received through an auditory channel, the ear, taking visual form only in the anthropologist's transcription. Our own sense of epistemology and ontology is reflected in the fact that our language carries within it the notion that *the* mediating symbolic system is the word, so that we use the terms *language* (or *grammar*) to refer to any organized body of rules or structure in the symbolic domain. Speaking, however, is not limited to the aural mode and grammar alone. It is a multichannel, multimodal communicative system composed of sound, body movements, interpersonal distances, expressions, inflections, and contexts which grow more complex as our understanding becomes clearer. And even verbal language, with its accompanying body channels, is no longer the sole device by which we become familiar with the world removed from our immediate time and space.

We have passed that stage of anthropological methodology where, as in Boas's time, we had to prepare our students for hundreds of dreary hours of transcribing native ceremonies and speakers by hand. We are now at the point where the anthropologist must know how to teach others to tell him about themselves through movies and television, and further, where he must know how to analyze a completely new symbol system by which people will be creating new forms for old myths about themselves. In the past, the field of anthropology could get away with training visual illiterates to study verbal illiterates. It is now no longer possible for the student of culture to ignore the fact that people all over the world have learned, and will continue in great numbers to learn, how to use the visual symbolic mode. Anthropologists must begin to articulate the problems that will face us in trying to understand others when their point of view is known to us primarily through movies distributed by broadcast television and cable. How can we help our students and

future colleagues to overcome the inevitable tension between the world they will study and their own cultural backwardness in terms of a mass-distributed visual symbolic mode?

An ethnography of communication developed on the basis of verbal language alone cannot cope with man in an age of visual communication. It is necessary to develop theories and methods for describing and analyzing how men show each other who they are and how they are. Theories of vidistics[2] must be developed to supplement linguistic and sociolinguistic theories, in order to describe, analyze, and understand how people who organize their films in different ways than we do are understood or not understood. Just as anthropologists in the field must learn the verbal language of the people they study (or find informants who know the anthropologist's language), so now must they begin to learn the visual "language" of the people they study.

This, however, raises further questions. All anthropologists speak at least one verbal language and report their work in at least one verbal language. The anthropologist is, however, most often "mute" (there is no word in English to refer to those who cannot make movies) in film. He cannot make films, and he certainly has not been trained to analyze them and to infer facts of culture from them.

In a world in which people of other cultures are being taught to make movies, in a world in which our own children are learning to make movies and are being increasingly acculturated and educated through film and television, can the anthropologist afford to remain a "blind mute"? Can a blind mute ever have anything to say to a person who respects visual "speaking"[3] and whose culture demands social interaction through pictures?

I do not mean to imply here a McLuhanesque position that

2. "Vidistics is concerned, first, with the determination and codification of visual elements as used by the image-maker. Second, it is concerned with the determination of those rules of visual or pictorial symbolic forms by which a viewer infers meaning from cognitive representations and interactions of the elements in sequence and context. Vidistic 'rules,' in this sense, are thought of as a set describing the interaction of specified elements, operations on these elements, and inferences appropriately made from them in specified contexts" (Worth 1968).

3. The frustration of not having a word for those who communicate through film, comparable to *speaker,* is great. I have resisted coining another jargon word for "speaker through movies," in the hope that the constant frustration of quotation marks and the ambiguity of the word *speaker* will jar on my readers' sensibilities as they do on mine and serve the rhetorical function of constantly reminding us of the fact that we are dealing with something that our verbal language and our culture have not learned to deal with adequately.

words are out of style. I do not think the advent of mass-distributed visual symbolic forms will replace speaking or reading; on the contrary, I suspect that interest in visual symbolic forms will enhance interest in verbal and written forms. Once one learns to communicate well in one channel, one begins to find needs for further channels. It is significant that the interest in and development of films among the young took place spontaneously among those of our youth who were most educated and most literate. What I wish to emphasize is the need to expand our articulatory and analytic powers to cover many modes of symbolic interaction and communication. We have a tendency in academic life to continue examining and thinking only about inherited problems, rather than those problems and modes our children, our students, and even we ourselves pay most personal attention to.

What I am suggesting for anthropologists, as a first step, is the development of the capacity to articulate in motion pictures, as an artist, if possible, but primarily as a simple "speaker" in this new mode of communication. But anthropologists cannot rest with the "speaker of film" ability alone. The native speaker has no need to articulate his knowledge of how he knows to speak and to understand his language. The student of language and of culture must know more than how to speak; he must know how he knows to speak and how others speak. He must know how he puts visual events together to convey meaning through film, and how others do it. He must be able to analyze the way people communicate through movies, as well as to do so himself. He must, in fact, not only be taught to make movies as children, Navajos, and others all over the world will be taught; he must learn how to teach others and must formulate theories about what to teach others.

It is when we begin to think about the problem of teaching film and television to others that we must face a host of ethical problems which anthropology has never had to face before. In teaching people to read, we implicitly teach them what to read. When we teach people to speak—and the same is true of most people when they learn to speak—they also learn what to say, what not to say, and to whom and on what occasion to say it. The use of a mode of communication is not easily separable from the specific codes and rules about the content of that mode. Speaking is something that most people do anyway; anthropologists do not have to teach it. Film and television are not something that most people do—at this time. Someone has to teach it. Whoever teaches it will have a large and powerful impact upon the culture of the people using it and viewing it. If anthropol-

ogy is to study culture, it must begin to understand how the use of new communication forms affects it, how best to introduce a communications technology, and, I suppose, first and foremost, how to observe and to study this kind of situation.

Anthropology has always had a kind of doctor-patient relationship with the people it studies. As in the Hippocratic oath, the first premise has always been, "Do no harm to the people you study."

In the past, it has been the case that one person, or at most a handful of people, have provided us with the information about many of the cultures of the world. Not only did our knowledge of Highland New Guinea, for example, depend on the observations of a few anthropologists and missionaries, but these same few, it was hoped, could be counted on to protect their informants in every way possible.

Carpenter (1971) reports in *TV Guide* that his own introduction of pictures in 1970 to people in New Guinea created vast changes in a short time. He reports that after the taking of pictures of a circumcision ritual, the people gave up the ritual and substituted pictures for it. He questions his own role in this matter and wonders if he himself had given enough thought to the change he unknowingly created.[4] This change was created, not by teaching people to make and to control their own visual symbolic forms, but merely by showing them pictures he had taken. How much greater might the change have been had he introduced into that culture the ability to make their own movies?

The problem cannot be solved by avoiding it. The anthropologist cannot "save" the people he works with by refusing to introduce motion pictures to them, for the simple reason that they will be introduced by others with methods and effects that are in many cases

4. Stephen L. Schensul (*Newsletter of the American Anthropological Association* 12, no. 3 [March 1971]) feels that

the intent of [Carpenter's] article in elucidating the effects of mass media upon our society by "experimenting" with a New Guinea group is obviously ridiculous and requires little comment. Further, current ethnographic data from the Sepik River region indicates neither the reported isolation nor the fearful reaction to technological innovations reported by Carpenter. The article contains little that is either conceptually or empirically valid.

But, the truth of Carpenter's statements aside, I find the nature of his "experiments" to be highly immoral and unethical and his description of the results at least ethnocentric, if not racist. His methods of developing rapport and the way in which he *thrusts his electronic equipment on these villagers* makes Captain Cook look like a cultural relativist. [Emphasis added.]

The "truth" of Schensul's statements aside, his letter points up the highly charged atmosphere in which research dealing with television and people of other cultures is currently being discussed. I repeat that we know very little about what happens when we thrust, or even gently introduce, electronic media or other new symbolic forms to anybody in any context.

known, but in large part unknown. The effects of commercial televi-
sion and the aims of economic control and commodity advantage are
quite clear. Up to now, political control has been largely a by-product
of marketing tendencies and demands. With the advent of cable, and
with a greater understanding of the possibilities of political control
through television, political segments of all societies will begin to see
the need for their own programs and procedures. The manipulation
of the symbolic environment by elite groups in any society becomes
a major focus for the study of culture.

Right now, the major television networks in the United States
are giving away complete transmission facilities to developing na-
tions all over the world—giving them away and training technicians
to operate them so that these nations will develop a hunger for
"product" to fill their air. That hunger is, and will continue to be,
filled by American product sold "cheaply" to those who now have
transmission facilities. Throughout the world, the air is being filled
with reruns of "Bonanza" and ads for toothpaste, mouthwash, and
vaginal deodorants. Should the anthropologist become the person
who teaches the people he studies to present themselves in *their* way,
or should he stand back and allow the democratization and subse-
quent homogenization of culture through "Bonanza" and commer-
cials? If left unchecked, Bantu, Dani, and Vietnamese children, as
well as our own, will be taught to consume culture and learning
through thousands of "Sesame Streets," taught not that learning is
a creative process in which they participate, but rather that learning
is a consumer product like commercials.

If left unchecked, we, and perhaps other nations like us, will
continue to sell the technology which produces visual symbolic
forms, while at the same time teaching other peoples our uses only,
our conceptions, our codes, our mythic and narrative forms. We will,
with technology, enforce our notions of what is, what is important,
and what is right. The questions that anthropologists have been
struggling with (related to whether we, as anthropologists, should
help the oppressed as well as the oppressor), whether we should take
sides in questions of culture change or even culture destruction,
assume new dimensions when transformed from physical to sym-
bolic forms. While answers are not simple in this area, should we not
consider the question of whether we who strive to learn about others
should take some responsibility for helping others to learn about
themselves? Should we not consider whether we have a responsibil-
ity, at the very least, to explain to those we study that new technolo-
gies of communication *need not* be used only in the ways of the
technological societies that introduce them?

Further ethical problems exist. Some of our studies, in which we

compared films made by black, white, and Navajo young people, show clear differences in these groups' social organization around filmmaking, thematic choices of material and subject matter, and attitudes toward the use of film.

For example, from analysis of our current studies, it seems that blacks prefer to manipulate themselves as image, while whites prefer to manipulate the image of others, but rarely themselves.

Black teenagers want to be *in* the film; they want the film to be about themselves, and consider their important role and status in filmmaking to be the construction of the plot or story and the choice of themselves as actors. They fight over who will be in the film, but rarely over who will make the image, who will operate the camera. They seem to attach little importance or status to who will edit the film, and to consider it a chore to be gotten over with so that they themselves can appear on the screen. They will often leave the camera unattended, forgetting that someone has to run it.

By contrast, the white teenager almost never appears in his film. "It's not cool," he says. "It's unsophisticated." His film is about others. He competes with his peers in the film group for the role of cameraman, director, or editor. Further, the films made by black groups involve behavior close to home and neighborhood, while the white teenager's films are often about the exotic, the distant, the faraway. He rarely shows his own block, his own home, or his own self.

Space does not permit a fuller examination here of the differences noted, but from our studies these differences seem not at all inconsistent with the predominant imperialist ideology of the white Western middle-class world. It is "reasonable" for whites to "capture" the image of others and to manipulate it to tell a story, to make a world based on symbolic events captured from far away and not of themselves. They then find status and pleasure in manipulating these events (often not even of people but of clouds, flowers, and "artistic" images of peeling paint, or crashing seas) to tell about themselves.

Anthropologists, too, are notorious for studying everyone but themselves. The "anthropological film," interestingly enough, has from its very inception always been defined as a film about others, exotic and far away. "Culture," in film, is frequently defined as in the *National Geographic:* strange rituals, exotic dances, and bare breasts. A study of anthropological films reviewed in the *American Anthropologist* shows that not one film reviewed was about us—always about how *they* live. Until the last few years, and then only rarely, when used in the classroom, anthropological films were always used to show us about "others."

Our own study of Navajo films shows clearly that what the Navajos show us about themselves in their films is very different from what an anthropologist shows in his. Even in a film about weaving, the Navajo concentrates the bulk of his film on things that are never seen in an anthropologist's film on the same subject (Worth and Adair 1970).

Can anthropologists in the future learn how to look at other cultures in ways different from the way "our" culture teaches us? Can we learn from the way others communicate themselves through film to think of the very term *other cultures* in new ways? Can we teach our students enough about this new mode of cultural communication so that they, perhaps, can develop insights that we do not have?

And what of the ethical problem posed by the very fact of our knowledge of different ways to organize and manipulate visual events on film? Should we teach others our way of conceiving the world on film? Should we, as anthropologists, as intellectuals, teach others to study and to reveal themselves when we do not? Should we teach them to go out and make movies of others as we do of them?

And how should we teach other people to protect themselves from the onslaught of a wired planet? Or, if "onslaught" is too loaded a term, what is our responsibility to help them to understand a world in which their every act of living can be televised and viewed by a watching world?

In this context, I do not mean only people in other cultures far away. I am thinking of ourselves as well. Several years ago, during a student sit-in and strike at my own university, Pennsylvania, the student and faculty leaders were confronted with television cameras and documentary directors from both the commercial and educational stations. None of them had any idea of either their rights or their responsibilities, or the methods that they could use to control the images of themselves and their ideas that appeared on the air. Although they were aware of the fact that what they were doing could be manipulated and distorted by this process, they felt, and proved to be, helpless. A young faculty member, "sophisticated" and with a knowledge of the situation, was chosen by the striking group to narrate the final "documentary" that would appear on educational television. Although he would never allow anyone to write his books, he was manipulated by the technical crew in such a way that he actually recited their words, in their way. Few of us, in our culture or in others, know how to deal with the images that can be made of us and beamed to all corners of the earth.

It is now, as I have noted earlier, also possible for the anthropologist in the field to broadcast his view of another culture

directly from the field. Should he do it? And if so, how? What safeguards can there be, or should there be, on a wired planet? What should he show, or better yet, what should he not show?

One can project this problem further into the future and envision a world in which it would *seem* that the anthropologist need not go to the field at all. The doctor will soon see his patients on video phone and will have to see them face to face only in those rare instances when physical manipulation needs to be performed by him, rather than by a machine. The medical student will be able, by next year, to sit in his study cubicle and dial access on the tube to movies of any kind of health event he wants to learn about—from initial interviews for diagnostic purposes, or complete psychotherapy sessions, to examples of every rare disease and every surgical procedure performed. Not only will it be unnecessary to spend much time with patients; it is being planned to teach much of the medicine of the future this way.

Will it perhaps "make sense" to think of ethnographic field work as consisting of sitting in a study watching the movies that people make, or have made, of themselves and of others? Will this mean that the ethnography of the future will be concerned mainly with the view of others we get from the tube? Some anthropologists now feel that trusting the word of one individual who has observed a culture for a short period of time and reported his singular view of it is a slipshod way to go about studying culture. Already, anthropologists are installing TV cameras in homes and broadcasting the view of the "other" to their offices, where they watch what's going on on the tube and preserve what they feel is important on television tape. For years, many anthropologists have argued that studying how people live by merely looking or listening is too coarse and rough-grained a view. They have argued that only through repeated and close viewing of a motion-picture film of human behavior can certain aspects of behavior be studied. It seems time now to begin to clarify those aspects of human culture which can best be studied through film.

We need theories and values to help us clarify exactly what justification there is for intruding upon other people's lives in order to study them on film. It is not inconceivable that, in the same way that large segments of American Indian and Asian populations are even now refusing anthropologists entrance into their communities, most others will soon refuse to let us study them. Why should not others demand the right to learn the technology of film and television and to communicate with us as *they* wish, about what *they* wish, when *they* wish?

It might be that we shall be forced to know others only from the movies they choose to broadcast to us, or that, if they allow us to observe them, they will want a voice about what we show of them. At least until recently, the ethical question often could be blurred when it concerned a written scholarly report. Few read these reports, and the peoples studied did not know our verbal language.[5] With film, this argument no longer holds. It will be quite easy for others to view the films we make of them. Should we therefore show only that which another group wants us to show of them? Should we teach them not only to make their own films but to censor ours as well? The problem as I see it is: What reasons do we have *not* to insist that others have the right to control how we show them to the world? Questions such as these stem not so much from the problems of understanding the presentation of self in everyday life as from the presentation of self in symbolic life.

I have mentioned the possibility and the likelihood of a wired planet. I have also introduced the possibility that everyone can have access to input channels, but the probability that access will be freely given to all those capable and desirous of access to television is small. Access to channels of communication is too valuable to power elites, who are fast discovering that control of the symbolic environment is as important as control of the physical, biological, and social environments. The political problems that I would like now to touch upon stem directly from the theoretical and ethical questions I have posed. Essentially, they are questions of power and control. Whereas in earlier times, power and control were seen as being involved with natural and technological resources and with the control of labor and man's production from that labor, political power now seems to be tied more and more to the control of information.

Any of the arguments of the New Left in the social sciences would lead one inevitably to the realization that anthropologists must make a major effort to study the ways in which societies control the production and distribution of symbolic forms. Anthropologists have always been interested in these areas in terms of culture change

5. Sofue (1971) writes: "Kloos has pointed out (*Current Anthropology* 10: 511) that 'publishing an item may be harmful to the people concerned, while not publishing is harmful to science.' I would like to see some discussion as to how we are to face this problem. It would be a help to have some concrete examples of cases in which publication was harmful to the informants or others. (*Sun Chief,* by L. W. Simmons, is probably one example.) The problem is very serious in Japan, where all villagers are literate and many have access to ethnographic publications through bookstores in nearby towns."

and, less frequently, in terms of cultural stability and the prevention of change. Change, stability, and repression are now intimately affected by the visual forms distributed by the mass media or by individual "tellers of tales" about themselves, such as I am proposing here.

Anthropologists have also always been involved with governments; they have always needed, and often sought, permission to go where they wanted to study. Frequently this permission had to be obtained, not from the people they studied, but rather from the imperialist powers that controlled those areas of the planet, or from other groups of elites that controlled areas and societies. The control of information has to a large extent always been in the hands of others and only in minute amounts in the hands of the anthropologist. From permission to go into a territory to funds to pay for field work, the anthropologist has never been totally in control of where he could get information. Frequently, to the dismay of some, and quite properly, in the view of others, papers and publications were censored for a variety of reasons.

With the advent of a wired planet, however, the problem of control becomes enormously greater. Children are being taught by television; funds have been, and are now, available for the production of "anthropological films" for teaching, from first grade to university level. *The only group of professionals involved in the making and use of anthropological films who have no training at all in the making, analysis, or use of film are anthropologists.* One can count on the fingers of both hands the anthropologists who are trained to study films, not as a record of some datum of culture, but as a datum of culture in its own right. I have stated elsewhere [chapter 2, above] that anthropological films seem to mean one thing to anthropologists and quite another to those interested in an ethnography of visual communication. To the anthropologist today, film is like the tape recorder or the pencil and notebook—a convenient way of assembling a record of data in the field, a memory aid, a device by which overt *behavior* can be studied microscopically and over and over again, as "real" behavior cannot. Film in this view is quite often thought of—falsely—as an objective record of what's out there.

To the person interested in vidistics or in an ethnography of visual communication, ethnographic or anthropological film cannot be defined by the film itself. A movie is a datum of culture in its own right, and every film *can* be an ethnographic or an anthropological film—if it is looked at anthropologically or ethnographically. The anthropologicalness of a film depends *not on the film but on the mode of analysis of that film.* It is becoming increasingly clear that the films members of other cultures make for any purpose can be studied to

tell us about that culture. Just as the study of kinship systems, myth, and other rituals and modes of living can be seen as helping to develop an understanding of universals and differences in culture, so must the free exchange of films by broadcast and wire be seen as an integral part of the study of culture.

But just as the anthropologist has been concerned with the problem of culture change in the old ways—how it changed without him and how it changed because of him—he must now become concerned with the fact that culture *will* be changed because of the introduction of film and television on a wired planet.

Politically, many anthropologists have traditionally been categorized as "liberal." Today, many, particularly the younger ones, prefer to think of themselves as "radical." What could a radical position be in regard to the democratization of culture through the homogenization of symbolic forms? Should the radical anthropologist cry "Eureka!" at the thought that CBS will introduce film and television to every corner of the planet and that Howard Hughes Enterprises will control most of the input to cable TV in the United States (at the very least)? Should the radical anthropologist take a stance favoring the control by government of input facilities into every home? Should the democratization of culture be thought of as liberating, or as potentially regressive and reactionary?

In his report to the Twentieth Congress of the Communist Party of the Soviet Union, Joseph Stalin presented a long section entitled "Nationalities and Language" (attributed to the linguist Margaret Schlauch, who had left the United States for Poland during the McCarthy purges). The "radical" wing of the party supported the position called in that report "the democratization of nationalities." They felt that the nationalities within the Soviet Union should be brought together under one language, one set of customs, and one way of life. Stalin took the "conservative" view. The report stressed the encouragement of individual nationalities, languages, and customs within the framework of socialism.

It seems to me that the anthropologist today faces a somewhat similar problem (without the political power of my previous example, of course). Should he take what might be called the "conservative" view—the view that tends to support the status quo (individual culture in all its diversity)—or should he take the "radical" view that tends to support cultural change, and technology, and what I have called the democratization of culture?

I have stated the problem too broadly, however, for the dichotomy is not quite so clear and is perhaps a false dichotomy altogether. It is a question, not of a battle between the status quo of diversity and the homogeneity of democratization, but rather of an interaction

between them. Just as the nature-culture question is falsely seen as a dichotomy rather than a dialectic, so can the previous question be seen as a dialectic between the existing culture of any people and the introduction of a technology enabling all of us to present ourselves to each other.

The problem, it seems to me, can also be seen as a dialectic of power, a struggle for skill and access to production and distribution technologies for the use of symbolic forms. If we are to study culture, we are inevitably involved in the study of the power relationships and control over mechanisms, messages, message-makers, and message-receivers.

But such a dialectic requires an understanding of the politicization of symbolic forms. It requires an ethnography of communication that has developed theories about the politics of the cultural changes that will be brought about by the ability of people to show themselves in their own way. It will require that anthropologists face the fact that they may soon not be allowed to study different cultures on their home grounds, that they must now think about whether they want to teach other people to present themselves and whether they want now to begin training themselves and their students to understand the visual presentations of others that they may be reduced to viewing on the tube in their studies.

Anthropologists must, in the coming power struggle over control of men's minds, develop an anthropology that can aid them in attempting to understand, and perhaps even to control by themselves, how men learn about one another through film. They must decide whether the images of their own culture that nurture *them,* on their children's, their students', and their very own television sets, are a proper concern for a new anthropology.

I have tried to present a picture of the planet Earth as it is today and as it is most likely to develop in the next few decades, concentrating on what I consider to be important anthropological problems of which most anthropologists are in large part unaware.[6]

6. In discussions of this paper with various colleagues, arguments were put forward regarding the probability of occurrence of the events described here. It was felt that other cultures would not, or could not, be made to participate in a wired planet such as I have described. It was argued that the dangers I try to predict are less real or less awful than I make out. The outcome, or the reliability, of these predictions is unfortunately empirical, and must await the future. Should it turn out, however, that we have prepared ourselves to deal with an anthropological politics of symbolic forms and the need is not as great as I have imagined, we will, I am afraid, still be ahead, for the understanding of the effects upon culture of a wired nation (our own) is an urgent matter right now—and one that we are not prepared to cope with at the present.

If I were reinventing anthropology in the light of the problems presented here, I would have to invent one that could handle the questions I have barely been able to formulate fully. It would have to be an anthropology that would be equipped theoretically and methodologically to formulate the subtler problems I believe are implied in some of the data and argument I have presented. I would have to invent an anthropology that could deal with culture on a wired planet.

Kluckhohn suggested that anthropology was invented "as the search for oddments by eccentrics." I would like to suggest that we move on to the invention of an anthropological politics of symbolic form.

four
the uses
of film
in education
and communication

All too often, debate about the place, purpose, and usefulness of film as a means of instruction and communication is clouded by confusion, defensiveness, and ignorance.[1] Knowledge about how film works, how it affects people in or out of the classroom, how it should be described, and how it should be analyzed is extremely difficult to ascertain and is more or less primitive. Research in the uses of film in education has, in the opinion of one of the leading researchers in this area, remained almost at a standstill since 1950 (Hoban 1971).

Current writing and discussion about film in the classroom has assumed at times the aura of a Marx Brothers movie, in which many people are scurrying about, bumping into each other, muttering dark accusations at nonexistent opponents, and, as in *Duck Soup,* challenging visitors to a duel at the very moment that cooperation and friendship are offered.

This state of affairs is not unique for those who are interested in film. Jean Piaget, in his survey "Education and Teaching Since 1935," notes under the subheading "Ignorance of Results" that "the first observation—a surprising one—that comes to mind after the

1. This paper is reprinted with permission from *Media and Symbols: The Forms of Expression, Communication, and Education.* Seventy-third yearbook of the National Society for the Study of Education, Part 1 (Chicago: University of Chicago Press, 1974), pp. 271–302 —Ed.

passage of thirty years is the ignorance in which we still remain" (1970b:5). It seems to me that knowledge about the use of film in education cannot be developed in a vacuum, without reference to the sociocultural context in which research about film in education and film as communication takes place.

The situation that I outlined in my opening paragraph refers to the current social context in which film is taught and in which film and film research is thought about. Piaget suggests that the social context (in relation to education) is crucial to an understanding of the problems facing educational research. It seems just as reasonable to consider as part of the social context the body of ideas current among spokesmen for, and researchers into, the use of film in education.

The purpose of this paper will be an attempt, first, to clarify some of the causes of the current confusion, which is characterized by seemingly irreconcilable goals, theories, and statements of purpose as to what film is and what it should be in education; second, to present a description of film as a process of communication that can be used in subsequent discussion; third, to discuss how film is used in the classroom; fourth, to present some evidence supporting several new directions in the use of film as a means of instruction, related to the notion that film is a means of communication; and fifth, to suggest lines for future research in education relating to such uses of film.

current theories of film in education ●
Before one can assess the role that film can play in education, it is necessary to examine its uses in sociocultural, artistic, political, and scientific endeavors. For the views developed about the role of film in education are necessarily colored by the views taken of film as art, film as propaganda, film as communication, and the views upon the effects of film on society in general. It must be further recognized that the arguments and theories involving film in general are in large part based on notions, on the one hand, about "art" and "language," and, on the other, about "television," "mass media," "pictures," and vision itself.

Consider some of the general assumptions that are made about film. First, there are those who argue the primacy of film on social and psychological grounds. This argument is based somewhat loosely (but adhered to firmly) upon the notion of "visual thinking," and leads to the conclusion that film or television is psychologically superior to words. Another form of this argument is expressed in assertions that "film is a language," that it is *the* language of the "now"

generation, and that it is becoming primary, sociologically and culturally.

A second view asserts the universality and potentialities of film as a medium. This position is reflected in statements that film is the newest art form, with the unexplored potential to do what words have failed to do: film is multimodal, multisensual, sensual (in its allied sense), and universal. Everyone, it is said, of all ages and across all cultures, likes and understands film. Most of the current discussion and justification for the use of film and television in schools can be traced to the above assumptions: psychological primacy, sociocultural primacy, communicative primacy (particularly as compared to words), and sensual primacy.

Research in the uses of film within a wide range of educational contexts—schools, churches, labor unions, the armed forces—and in the mass media in general has been going on since 1918. For the most part, this body of research was not designed to determine the truth of the previously mentioned assumptions, not because of unawareness of the assumptions but because of a conviction that they were not central to understanding how film works in the classroom. These assumptions have seemed so powerful and so implicitly true as to require only their assertion.

It is not the purpose of this paper to review the extensive research on the use of film for instructional purposes, numerous reviews of which are readily available.[2] Instead, it is my purpose to examine a series of arguments, positions, and ideologies that are currently being widely diffused and accepted in the educational and film communities but with very little research evidence in their support.

In commenting upon an earlier draft of this paper, Charles Hoban, one of the leading researchers in the use of film in the classroom, questioned the need for such a detailed treatment of the current ideologies of psychological, sociocultural, communicative, and sensual primacy. He felt then (1971) that these arguments seemed to have little influence in actual educational practice. Since his return from a field investigation of schools, teachers, and media practices in education in the United States (September 1972), he has commented in a personal communication: "These ideologies you discuss in your paper have spread throughout the educational community like wildfire. Their assumptions have not been examined, and the time has come for accountability in the implementation of these film

2. The best summaries of this body of research, in my opinion, may be found in Hoban and van Ormer 1972; Hoban 1971; and McKeachie 1967.

ideologies." This paper is an attempt, then, to begin the process of examining these assumptions.

Three major perspectives are involved in the analysis of the nature and effects of film.

First, there is the psychological perspective that has evolved from the application of the psychology of mind, perception, and art to problems of film. Rudolf Arnheim could be considered the paradigmatic figure in the development of an orientation relating certain psychological theories of perception and art to theories of film. For a variety of sociological and academic reasons, Arnheim's orientation, and particularly his idea of visual primacy, has become the central tenet of what may be referred to as an ideology of film. While this act of adoption may have distorted Arnheim's ideas somewhat, the ideology itself is so important that it merits further examination.

The second perspective is that developed by the artist-critics—most often practicing filmmakers or film ideologists who write theoretical and ideological statements about what film is, what place it has or should have in society, how films should be made, or what film's ultimate destiny might be. Theoretical work by filmmakers about film has a long and international tradition, beginning with the works of Eisenstein (1949) and Pudovkin (1949) in the Soviet Union in the late 1920s and currently continuing with Pasolini (1965) and Bettetini (1972) in Italy and Godard and Metz (1968, 1970) in France. America's filmmaker-theorist tradition, although very recent, may be presented through the work of Gene Youngblood, an American avant-garde film ideologue, whose book *Expanded Cinema* (1970) has taken the place of McLuhan in the minds and hearts of most young people interested in film. It is read by film students, recommended by film teachers, and treated with respect by most younger filmmakers in education. It is the most academic of the books by American avant-garde film theorists and bears the stamp of approval of Buckminster Fuller.

The third perspective has been developed by the film teachers, those who teach with film and from film, those who teach about film, and those who teach how to make film. Film has been used in grade schools since 1918 and taught in high schools and colleges in the United States since the 1930s, but its blossoming into a fullfledged subject, integrated into the curriculum, was not achieved until the 1960s. Most boards of education now have sections headed by media specialists who have supplanted in status the old audiovisual directors. Their job is to help teachers design, develop, teach, and use film in the classroom. These teachers come from almost every field of educational specialization, but most seem to come out of English or

language-study departments. Government agencies such as the American Film Institute support training conferences in film study for elementary and high school teachers; UNESCO and other international agencies publish training manuals in film education; and some churches and many universities have extensive teacher training programs in what has been called "training for film literacy." An example of this perspective is the latest book by a film teacher to cross my desk, *Film in the Classroom: Why Use It, How to Use It* (Amelio 1971), which reports on the author's work with film in his own classroom.[3]

visual primacy ○
Let us start with Arnheim, then. In the 1930s, he began to publish his first works on film (1957), describing it as an art form and arguing that it was art precisely because it did not reproduce reality exactly. It was art because, and to the extent that, it failed to reproduce reality and had the same potential for artistic expression as painting and sculpture. In a series of books and monographs since then, he has moved from what could be considered a limited interest in film as such to the study of the broader aspects of artistic vision. In his latest book, *Visual Thinking* (1969), he has moved from a study of the visual arts to what might be called a general theory of cognition. Basically, he argues that the visual modes of experience and expression have been underutilized and slighted in American education. He argues further that all thinking is basically and primarily imagistic and based upon visual perception. In contrasting words and pictures, Arnheim argues:

The visual medium is so *enormously superior* because it offers structural equivalents to *all* characteristics of objects, events, relations. The variety of available visual shapes is as great as that of possible speech sounds, but what matters is that they can be organized according to readily definable patterns of which the geometric shapes are the most tangible illustration. The principal virtue of the visual medium is that of representing shapes in two-dimensional and three-dimensional space, as compared with the one-dimensional sequence of verbal language. This polydimensional space not only yields good thought models of physical objects or events, it also represents isomorphically the dimensions needed for theoretical reasoning. [1969:232. Emphasis added.]

3. At the latest conference (October 1972) of the National Association of Media Educators, Amelio's book was singled out as the "kind of book we need more of" and was held up as an example for younger "media educators."

This quotation seems to me representative of Arnheim's arguments, containing unsupported assertions about the superiority of the visual over the verbal, based upon vague and oversimplified notions of language, and assertions about reasoning—equally unsupported—based upon his previous assertions of the superiority of the visual.

Essentially Arnheim's argument and its appeal to the film buff rest upon the reasonable assertion that visual perception contains, or is part of, what we normally call "thinking." But he then seems to argue that if visual perception involves thought, all thought is visual.

Arnheim attacks a wide variety of linguists, psychologists, and others, and singles out the art historian Gombrich for special criticism. Arnheim argues that Gombrich "suggests that the world of the senses is an impenetrable puzzle and that images are understandable only when maker and beholder share a set of conventions, by which statements about visual reality can be coded and decoded" (1966: 139). The linguist Whorf is similarly criticized for his famous view that "segmentation of nature is an aspect of grammar. We cut up and organize the spread and flow of events as we do largely because, through our mother tongue, we are parties to an agreement to do so, not because nature is segmented in exactly that way for all to see" (Whorf 1956:240). Arnheim argues that these ideas are an "extraordinary perversion" of the true state of affairs, and that those who hold these and similar ideas are responsible for the fact that the visual arts are in such disrepute in educational circles today. He argues further that "we are the *victims* of [these] traditions according to which the senses furnish nothing better or worse than the raw materials of experience" (1966:137; emphasis added).

Arnheim never argues that thinking has no relation to language itself, but because of his commitment to certain psychological theories of visual perception which lead him to say that language "serves as a *mere* auxiliary to the primary vehicles of thought" (1969:243; emphasis added), he underestimates or denies the extent to which symbolic systems or conventions mediate our knowledge of the world.

The place of symbolic systems or conventions in human thinking has been powerfully represented by aestheticians and art historians (Gombrich 1961, 1963; Kris 1952; Goodman 1968; Wolfflin 1950), psychologists (Neisser 1967; Piaget 1970), anthropologists (Boas 1955; Lévi-Strauss 1963), linguists (Sapir 1921; Whorf 1956; Chomsky 1957, 1968), sociolinguists (Hymes et al. 1972; Labov 1966), and historians of science (Kuhn 1962). Essentially they have shown that what we see and what we think about is determined at the least as much by our symbolic systems and conventions for

representing the universe as by the universe itself. They have shown that pictures, verbal language, tales, myths, scientific theory, and speech itself do not depend only upon what is "out there" but also, and in large part, upon the structure of symbol systems that make up the culture.

In his zeal to argue against the idea that language and other symbol systems are central to the visual modes of expression and communication, Arnheim declares, "True visual education presupposes that the world can present its inherent order to the eye and that seeing consists in understanding this order" (1966:148). Therefore the works of such writers as Gombrich, Whorf, and Goodman, for example, are characterized by Arnheim as a "monumental attempt to devalue the contribution of perceptual observation" (1966:139). But Arnheim's views similarly devalue the role that language and other symbolic systems play in thinking about, organizing, and articulating man's impressions, perceptions, and thoughts about the world he lives in—the interior psychological and cultural world, as well as the external objective world. The consequences of this overemphasis on certain theories of mind leave one "at a loss," as Jonas in his review of *Visual Thinking* commented, as to "where to start getting straight so much mischief committed by overzeal in a noble cause" (1971).

As we shall see below, this insistence upon visual primacy in thought and the subservient and even "perverse" nature assigned to language as a means of ordering the world has been taken as the unassailable premise for the arguments of the film theorists and teachers we shall now discuss.

the film theorists ○
It cannot be denied that a large number of young people throughout the world, and particularly in the United States, profess a deep love for film. A major reason for this, many of them say, is that they can "dig"—rather than understand—a film easily. They can just sit there and allow it to envelop them, to "wash all over" them. No wonder they find Arnheim's thesis—that the world presents itself to them and all they have to do is keep their eyes open to understand it—so congenial. It fits a commonly expressed desire of youth to sit there and be "turned on." It is the world that presents, not they, not man.

Buckminster Fuller, in his introduction to Youngblood's *Expanded Cinema,* begins by telling us a science fiction fantasy. All the unborn children in the world are in communication with each other. They can communicate with each other in a total sense. These "superborn in the womb" plan to go on strike. They will not emerge because the world is in a mess created by the outsiders. If they do emerge, this

perfect communication they have with their fellows will be destroyed. He goes on:

All this brings us to this book by Gene Youngblood . . . the first of the youth who have emerged from childhood and schooling and social experience sufficiently undamaged . . . [to provide] world-around men with the most effective communication technique for speaking universal language to universal man. . . . Youngblood's book represents the most important metaphysical scenario for coping with all the ills of educational systems based only on yesterday's Newtonian-type thinking. Expanded Cinema is the beginning of a new era educational system itself. . . . Tomorrow's Expanded Cinema University . . . will weld metaphysically together the world community of man by the flux of understanding and the spontaneously truthful integrity of the child. [1970:34–35]

This spontaneously truthful integrity of the child, which exists in the womb where the child cannot see, will be accomplished for those who leave the womb by that great metaphysical welder—the film.

Youngblood says, "Expanded Cinema isn't a movie at all: like life it's a process of becoming, man's historical drive to manifest his consciousness outside of his mind, in front of his eyes. This is especially true in the case of the intermedia network of cinema and television which now functions as nothing less than the nervous system of mankind" (ibid.). Not only does the world present its reality directly through the eyes, but man becomes, man manifests his very consciousness, through film. It is nothing less than the nervous system of man. It is the science fiction dream come true.

Youngblood begins by adopting the assumption of visual primacy: "As a child of the new age . . . I am *naturally* hypersensitive to the phenomenon of vision. I have come to understand that all language is but substitute vision. . . . The new cinema has emerged as the only aesthetic language to match the environment in which we live" (ibid.:45, 76; emphasis added). In pursuing this point, he comes to a self-contradiction of which he seems unaware: "We are conditioned more by cinema and television than by nature" (ibid.: 54). "We have come to see that we don't really see, that 'reality' is more within than without. The objective and the subjective are one" (ibid.:46). "The world's not a stage, it's a TV documentary" (ibid.:78). There is a subtle shift in his thinking that culminates in a strange transformation toward a newer manifestation of visual primacy. "The filmmaker has not moved closer to actual *unstylized* reality itself but rather a reality *prestyled* to approximate our primary mode of knowing natural events: *Television*" (ibid.:80; emphasis added). It

is not the world out there that presents itself to us but rather a world given to us by television and having the inherent order of the medium itself.

Whereas Arnheim thinks of a structured universe already given, Youngblood posits a stylizing agent that acts upon the universe, that orders and styles what we see. TV is that agent: it prestyles. It is the medium itself that gives order to what we see. "Reality" is abandoned, and in its place is the primary giver of reality—television. This is not merely perverse. Although *Expanded Cinema* is replete with humanistic pieties and presents itself as an appeal to make people more human and more related, it is in fact based on an assumption necessary to the visual primacists: the denial of man's activity in the creation of his world. However, the concept of communication as a process by which men share a variety of symbol systems for handling meaning demands a recognition that man orders his films and his television programs, that man stylizes and prestylizes and presents his view of the world. It is only by treating man as a noncommunicator, as an animal that doesn't share any symbol system at all, that it can make sense to talk of reality presenting itself, or of television as a medium prestyling reality. Let us see how Youngblood develops his theme of noncommunication through film.

Because it [Expanded Cinema] is entirely personal it rests on no identifiable plot and is not probable. The viewer is forced to create along with the film, to interpret for himself what he is experiencing. If the information . . . reveals some previously unrecognized aspect of the viewer's relation to the circumambient universe . . . the viewer re-creates that discovery along with the artist, thus feeding back into the environment the existence of more creative potential which may in turn be used by the artist for messages of still greater eloquence and perception. [Ibid.:64–65]

A man creates. A viewer experiences and interprets. Perception itself is creation and discovery. Skill, taste, thought, meaning, concepts, ideas, are absent, as indeed, by definition, they must be. For the "unrecognized" is the core material for the formation of "creative potential." Youngblood seems to think that by willingly sacrificing communicative processes for personal, private perception and revelation, he is avoiding the dull, destructive, and uncreative aspects of film. Tyros in the arts always forget that creation and originality cannot even be recognized (or perceived) except within a context of convention and rulelike behavior—*especially* in the arts. It is not within the context of an ordered universe that art exists, but rather within the context of man's *conventions for ordering that universe.* But, for

Youngblood, revelation of the unrecognized is creation. If we achieve this, Youngblood continues, "we shall find that our community is no longer a community, and we shall begin to understand radical revolution" (ibid.).

Tomorrow's Expanded Cinema University will (according to Fuller) weld us together in a world community of man by the flux of understanding and the spontaneous and truthful integrity of the cinema child. This is a dream that breeds monsters. Instead of welding us together in a world community, Youngblood's ideas, as he himself tells us, will destroy community.

If these ideas were merely the jottings of Fulleresque, McLuhanite, and Madison Avenue acolytes, we could smugly ignore them as confined to the lunatic fringe. But we cannot ignore them, for they have become embedded in current educational thought. The movement to use film as an educational tool is permeated by these ideas, both to support programs in film education and to justify using film in such ways and for such purposes.

the teacher ○
Let us turn now to a teacher. Chapter 1 of *Film in the Classroom* (Amelio 1971) is entitled "A Rationale for a High School Film Program." I will quote his five-point rationale in its entirety:

(1) Sixty-five percent of today's film audience is twenty-four years old or younger.

(2) For one-fourth or more of their waking hours, from infancy to adolescence, children live in a semantic environment their parents did not create or control.

(3) "Sesame Street," the TV program, reaches five million children, almost half of the nation's twelve million children under five.

(4) Eighty thousand college students are now enrolled in three thousand film courses.

(5) For every book the average college student reads, he views twenty films.

Not one of his reasons reflects any educational purpose at all. They are defensive and puerile. Reasons 1, 2, and 5 could as easily be given for studying rock music, sports, and, hopefully, sex. Reason 3, that "Sesame Street" reaches five million children under the age of five, is to me not even clear. Saturday morning cartoon television probably reaches ten million children under five, but perhaps "Sesame Street" is chosen because it is labeled *education* and therefore assumed to be education, while Saturday morning television is assumed not to be education. Argument 4, that eighty thousand college students are enrolled in film courses, puzzles me. Over two million college students are enrolled in ROTC, and what does that prove? It

is not that the arguments are bad or nonexistent, but rather that all too often a case for the study and use of film in the schools is made without the awareness of any educational justification for such study or use.

While Arnheim and Youngblood at least present complex arguments purporting to make a case for film and visual primacy, teachers themselves say that "whether the schools like it or not, film is here and it is vigorously affecting our children." Or, "for too many years schools have concentrated on teaching skills in verbal language. As a result, for many students in many schools 'tedium is the method' " (ibid.). Both Arnheim and Youngblood, as well as many others, argue convincingly for changes in emphasis in the teaching of communication modes. The issue is not whether we have overemphasized words in our educational system, but rather how and for what purpose we should introduce film into the educational process as a substitute for the "debased" verbal language.

In the second section of the book on film language, Amelio proposes to rectify what he considers to be the prevalent student attitude toward words: "Purpose: To train the student to become aware that the medium can be the message" (ibid.: 37). The reasoning seems to be: children are bored with school, the medium is the message, children watch movies, children do not read; ergo, teach film. Based on these reasons, one can honestly ask, why not teach hopscotch, or why not abolish school altogether?

film as a process of communication ●
It is almost with relief, therefore, that I find a place to state my own position. Film *is* a means of communication and instruction. Our problem is not in deciding that. The problems to which educators and communication researchers must address themselves are rather to describe (1) how film as a process of image-making in our culture comes about, how and under what conditions it becomes a form of communication, how one person can use it to articulate meaning about something, and how others who see the film can make meaning or sense of it; and (2) how knowledge of this process enables us to understand and to use film in the very process of education itself.

Education must be thought of as a special case of acculturation, the complex process by which a culture manages to ensure that almost all of its newly born become viable members of the group. In our culture, film, like television, books, newspapers, and other message systems, is institutionally organized and supported. Like school, it is a part of the acculturation process. Like verbal language and other symbol systems, film could not be a part of the acculturation

process if it were not also capable of being used to communicate. In this sense, communication requires that members of a social group share the meaning of the symbolic forms that they use.

Film communication may be considered as a *social process* whereby a transmitted signal is received primarily through visual receptors (and, often, sound receptors) and is then *treated as a message* from which *content or meaning is inferred.* Film, as a symbolic form, is a process of communication that employs film, the medium, with its technology of optics, emulsions, and cameras, to produce a piece of celluloid with a variable-density silver nitrate surface. It is man who creates film communication. This definition suggests that a piece of film, in and of itself, is meaningless—that meaning exists only in a special social and cognitive relationship between a filmmaker and a viewer. This relationship occurs when a viewer *chooses* to treat a film not as mere signals triggering perceptual awareness and biological responses, but as message units that have been put together intentionally and from which meaning may be inferred.

I suggest that in simplified form the process works something like this. First the filmmaker puts together or articulates a set of images in a nonrandom fashion in order to "tell" someone something, or in order to make someone "feel" something. The process of putting these film-image events together is a complex, intentional act requiring skill, knowledge, and creative ability. This organizing process takes place not only in planning but in photographing the actual images, and in the selection, rejection, and sequencing that make up the editing process. At some point, he decides to "release" his film. It is now no longer a personal act but a public and social one; it is a symbolic form available for participation in a communication process.

When another person sees this film, he must (depending on how one talks about such acts) receive it, decode it, or recreate it. Since meaning or content does not exist within the reel of acetate, the viewer must recreate it from the forms, codes, and symbolic events in the film. This definition of film communication would exclude films made, for example, by blind men who pointed a camera at random and sequenced their images in editing without being able to see them. For communication to occur, meaning must be implied by the creator and inferred by the viewer or recreator.

The use of film in education, then, must be understood to mean *film communication:* a method of image-making involving a set of conventions through which meaning is transmitted between people by a process of implication and inference. The piece of acetate in itself is not a communication, a panacea, a method, an instruction, or an education.

Those who wish to use film and to understand how film is, or

can be, a part of the communication process must therefore address themselves to the problem of describing exactly how and in what contexts viewers assume that the film-worker intends to express himself, to deliberately make implications from which viewers will infer his meaning.

A host of questions can now be raised which have until the last few years received very little study by those interested in film. How do people make implications with film? Is there a code—the schemata that Gombrich suggests? Is there a system? How do people make inferences from film? Do they know the code? How does one describe it? Is it like a language? Do all people, across cultures, language barriers, and social groupings use the same code? If not, are there different codes, used by different cultures? And, most important for those who are involved in the process of education: How do people learn to make statements in film, and how do people learn to make inferences from film?[4]

film in the classroom ●

There are two predominant uses of film in the classroom. First, and most frequent, is the substitution of films for books or lectures—that is, teaching *through* film. Second, and growing in popularity, is teaching *about* film. Teaching through film has been used since the invention of film itself. Films of "strange dances" by "primitive peoples" were made by German anthropologists and used in German gymnasiums in 1905. Films of animals and humans in motion were used by zoologists, anatomists, and artists to teach their various subject matters in universities, medical schools, and art schools as early as 1907. All of us must have seen many films describing such things as "other lands, other people," "community helpers," and so on. One need not review the variety and quantity of such films. They number in the

4. For a fuller explanation of the concept of implication/inference in communicative interpretation see Worth and Gross (1974, chapter 5, below). Briefly, one "implies" through film when one organizes images in such a conventionalized manner that a viewer can infer meaning from the organization or structure of the film, justifying his interpretation by calling into evidence some formal properties of the film itself. For example, "In that sequence the filmmaker means that the policeman is a pig, because first he shows a close-up of the policeman and then shows a close-up of a pig." Or, as in the case of *Birth of a Nation,* "Griffith means to say that people in the North and people in the South faced the same problems, because he has a long shot of the woman in the northern city waving goodbye to her husband, then a long shot of the woman in the southern city doing the same, then a close-up of the first woman tearing a lace handkerchief in grief followed by a close-up of the second woman doing a similar thing. When you have similar shots of different people, it always means you have to put them together in your head."

tens of thousands and represent the allocation of hundreds of millions of dollars.

What is important to note, however, is that the media entrepreneurs, both those engaged in the production of films for the classroom and those engaged in the development and production of the hardware that these films use, act on the assumption that teaching through film is a preferred method, proven and accepted by the educational establishment. The points these entrepreneurs talk about in their brochures, conferences, and books are those of ease of use, availability of large collections of materials, and instant acceptability to the student. Educational administrators who buy and demand funds for these materials accept the basic premises on which the audiovisual industry operates. Gross (1974) makes clear that there is a genuine question about whether the use of film or pictures as a teaching device is effective in achieving any of the commonly stated goals of education.

At best, film used this way has one massive advantage. It allows schools to perform a custodial function more easily. Film "to teach through" can be administered, like mass injections, at the will of the school administrator. Unlike a book, which a student must read on his own, a film can be administered to hundreds and even thousands at a time in classrooms and assemblies. The only problem is getting the student to stay awake, and hence the development and use of advertising-commercial techniques—as in "Sesame Street"—that will keep his eyes glued to the screen.

In recent years there has been a movement toward the recognition of this deficiency of the so-called teaching through film. Not only are these films not particularly suited for developing intelligence (in the Piagetian sense to be discussed later), but they do not address themselves to what this new movement has called "film literacy"— teaching *about* film.

The film literacy movement, developed in England after World War II and expanded in the United States since the middle 1950s (Hodgkinson 1964; Peters 1961), takes as its aim the development of abilities in the child that will enable him to understand the techniques and "language" of film. By and large, however, the movement is devoted to showing commercial films, having the children learn a new terminology consisting of words such as *fade, dissolve, truck, pan, zoom,* and *cut,* and discussing the films they have seen as examples of literature, history, plot development, mood, emotional experience, and so on. Amelio suggests that "the student can learn how film differs from other art forms, how important the director is, and why film editing is an art. Thus our goal is to develop in the student a basis

for criteria for aesthetic awareness so that he can evaluate film" (1971:37). The films shown in his lesson plan range from *Potemkin* through *This is Marshall McLuhan: The Medium Is the Massage* to *How to Use the Griswold Splicer,* not neglecting *Citizen Kane* and other "classics."

The goal is exemplary. The question is whether we know the answer to such questions as "why film editing is an art," or whether watching films and discussing them is the best way to teach students a basis for aesthetic awareness. An even more cogent question is whether this approach will lead toward the research and analysis necessary for educators to understand how film works and what potential uses it has for education.

It is not only that film and television pervade our culture and help us form our attitudes, values, and ways of organizing experience, but that this happens in ways that are very poorly understood, either by the researchers or by the children and young adults whose attitudes are thus formed. If film literacy were needed only as an antidote to film itself, it would still be worthwhile to understand it and to teach it. But an understanding of this mode of communication has much deeper implications for the very concept of education itself.

Many authors have shown that understanding the process of thought itself requires an understanding of a variety of symbolic modes through which we relate to our environment, become human, and become members of our culture (Gombrich 1961, 1963; Kris 1952; Olson 1970; Gross 1974; Worth 1969; Worth and Adair 1970). It is clear that thinking is a multimodal symbolic process that uses much more than words. It is not necessary to argue that words are inferior, debased, or unnecessary to make the point that more than a knowledge of verbal language is involved in education. It does not necessarily make sense to argue for the primacy of the visual any more than it does to argue for the primacy of the mathematical, the verbal, or the musical. What is needed is to show how a knowledge of the use of a particular mode can help in the development of the thinking and behaving capacity of the human organism.

The ability of the child to function as a creative human being in his society rests on his ability to organize his experience, while he both perceives it and thinks about it, and to articulate his attitudes, judgments, statements, and inventions about himself and his universe in such a way as to be understood by his fellows. Education is a process by which we not only learn to take in an environment, but in which we develop ways to communicate about it to others—by choice and by intention.

Of course, men "say" things by pictures and by film—things, it is important to note, that they could not and did not choose to say by music, by dance, or by verbal language. Film is one mode in which people can record image-events, organize them to imply meaning, and through them communicate to others.

Making a film not only can help a child learn how films are made or why they are art, but can help him to learn how to manipulate images in his head, how to think with them, and how to communicate through them. I have used the phrase "making a film," as opposed to "studying film" or "learning film literacy," to emphasize what I consider to be the crucial aspect involved in the use of film in education; of course one can learn to some degree how to achieve a certain effect by watching, as well as by making films.

Making a film can be part of a process of teaching children how to understand and to use the visual mode in thinking and communication. Listening alone is not the best way to teach people to play the violin or to compose symphonies; neither are looking and talking the best ways to teach people to use the visual mode. Gross has summarized much of the research in the acquisition of competence in symbolic modes:

All competence in a skillful mode is acquired on the basis of constant practice and repetition. . . . One achieves competence in a medium by slowly building on routines which have been performed over and over until they have become tacit and habitual. . . . It is on the basis of a repertoire of often repeated actions that the child can begin to introduce and perceive slight variations and thus extend the range of his perceptual-intellectual competence to more complex forms of organized behavior.

The acquisition of competence in modes of symbolic communication entails the learning of the "vocabulary" for representing objects and events proper to a particular mode, and of the "grammatical" and "syntactical" operations, transformations, and organizational principles which are used to structure these into conveyors of meaning and intention. [1974:73]

Filmmaking, like other modes of expression and communication, must be done, to be understood fully.

new directions in the use of film in education ●
Communication, and perhaps all social behavior, requires that the initiator of such behavior must put himself, whether consciously or not, into the role of the receiver. Social behavior does not occur just because people are there; it occurs between people who relate to the symbolic nature of their behavior in some shared way. It is social because we have made it so, no matter how deeply embedded such

behavior may be in primary biological processes. Seeing a tree bend in the wind and making attributions from that observation to the probability of rain in the future is different from showing in a film a close-up of a tree bending in the wind. In the latter case the filmmaker is using the image of the tree to imply something in the context of other images he has put together. He—the filmmaker— assumes in the potential viewer a shared ability to perform certain perceptual, cognitive, and interpretative procedures upon the film. He places himself in a viewer's shoes and is able to test the viewer's behavior by checking it with his own, by assuming that they have agreed in some way to think about things in the same way. As I write this, I read it over, and place myself in the reader's position in order to judge whether what I am writing can be understood as I want it to be. I attribute to the reader a set of mental operations and skills similar to my own.

Conversely, when one reads, one places oneself for a moment in the position of a writer. One assumes intention, judgment, choices, meaning, and other things on the part of the author. If I didn't assume that a book was meant to communicate to me, I could read it for only one purpose—to use it as a stimulant for my own purposes. It would cease to be a *social object* and would become a piece of the environment to which I might respond as to water, sunshine, marijuana, or a toothache.

So with a film. When a viewer sees a film, he may, for a variety of contextual and cultural reasons, assume intentionality, purpose, meaning, and order. If so, he will treat it as a possible communication. If he does not assume an intention to communicate, he can only respond as one does to the inanimate universe. A viewer assumes, for example, that if a shot of a wind-bent tree occurs, it was put there, and he may further assume that, as in a story, it is there for some purpose. The child will assume, for example, that some films tell "a story," and further, he will "know" how stories are formed in his culture and will place the images he sees into story forms that "make sense" to him.

In our culture, however, most knowledge that children and adults have of film is viewer knowledge. It is difficult for them to place themselves in the role of the filmmaker. Most of us don't know what a filmmaker does when he puts a film together. A vague notion that films are "true," are "worth a thousand words," and somehow just come to be underlies our own behavior toward film. It is true, as Arnheim has pointed out most forcefully, that education has ignored pictures, and truer (if that use of *true* makes sense) that education has ignored teaching how films make sense.

Two educational questions emerge: first, can everyone be taught to make films? Second, are there indeed rules that govern the organization of the pictured world for communicating through film?

Research by Worth (1966), Worth and Adair (1972), Chalfen (1974), and others has answered the first question. Almost anyone who can hold a camera and has the cognitive and manual dexterity to type, for example, can learn to make a film. Children in the United States and England as young as eight have made 16-mm. movies. In our own research, black and white girls and boys who ranged from lower-class dropouts to middle-class high school students, and from eleven to twenty-five years of age, have learned to make professional-looking 16-mm. movies. In a detailed research program, we have taught Navajos ranging in age from sixteen to sixty, some of whom spoke no English, to make such movies. All of these people learn easily, are extremely motivated, and are able to deal with complex and creative ideas.

It is the concept of sequence—the ability to arrange many image-events in an ordered fashion to produce implications—that contains within it the major significance for education in visual symbolic manipulation and articulation. Educational programs could reasonably aim at developing and strengthening the child's skills in organizing his visual world for purposes of both thinking and communicating. Film offers a new means or mode of cognition and communication that stands parallel to the established modes; hence, it does not deny the intellectual, creative, and social values upon which our society is based. Giving up the dependence on words alone does not necessitate throwing out either verbal language or the cognitive skills associated with the ability to speak, read, and write.

For research purposes, at least, it is reasonable to give movie cameras to people of varying ages and cultures, show them how to use the equipment, and study and analyze how they behave when they organize themselves as filmmakers and how they organize the images they make by editing. Our own research is an attempt to discover if there are rules and codes of communication that all people, or at least groups of people, share when they attempt to make movies (Worth and Adair 1972). We want to find out how communicating by means of movies relates to the verbal language and culture of various peoples. A question remains as to whether there are different patterns, rules, structures, or even "languages" that people use when they make and view films. Related to that question, and perhaps even more important, is the question of how children in a particular cultural context learn these rules.

The use of film in education therefore depends not upon the

naïve assumption that nature or reality presents itself directly, but rather upon a more elaborate conception of intelligence.

The problem of intelligence, and with it the central problem of the pedagogy of teaching, has thus emerged as linked with the fundamental epistemological problem of the nature of knowledge: does the latter constitute a copy of reality or, on the contrary, an assimilation of reality into a structure of transformations? The ideas behind the knowledge-copy concept have not been abandoned, far from it, and they continue to provide the inspiration for many educational methods, even, quite often, for those intuitive methods in which the image and audio-visual presentations play a role that certain people tend to look upon as the ultimate triumph of educational progress. [Piaget 1970b:28]

Piaget—and here it is worthwhile reminding ourselves of the arguments presented in the first part of this paper—describes the functions of intelligence as consisting "in understanding and in inventing, in other words, in building up structures by structuring reality" (1970b:27). The process of filmmaking is precisely such a process. It is a process of structuring reality, because a filmmaker must collect a set of image-events on film and must build up a set of structures by ordering and organizing these image-events into a communication sequence. The cognitive patterns, structures, rules, or "languages" involved in making implications with, and inferences from, film are precisely the means of structuring reality afforded by the process of filmmaking.

In our research (Worth and Adair 1972) Navajos were told that they could "make movies of anything they wanted in any way they wanted." They were taught the use of motion-picture equipment but not the "right" or "appropriate" way to photograph, what to photograph, or how to structure the image-events they had recorded. Would the Navajos use the cameras at all, and, if they did, what images would they take? What rules for organizing images would evolve? Was this ordering process by which they structured their reality through filmed images related to their language, narrative style, myth form, or other modes of communication?

The Navajos learned to use the cameras easily. On the first day of instruction, they learned how to operate a Bell and Howell triple-lens turret movie camera, how to load it, how to take exposure readings, and how to use the lenses for viewing and shooting. On the second day, they were given a hundred feet of film and told to "use the camera—for practice—to do anything you want." Almost all of our six Navajo students "discovered" the editing process in the first

days of working with film. One of the students wondered whether if he "put film of pieces of a horse (close-ups) between pictures of a whole horse (long shot), people would know that the pieces belonged to the whole horse." He thought about this, shooting "pieces" of the horse one day and shooting "whole horses" at a squaw dance the following week. He then spliced the pieces "in between" the whole horse, and after he looked at the result on a projector he declared, "When you paste pieces of a horse in between pictures of a whole horse, people will think it's part of the whole horse. That's what I think it is with film." It is difficult to know how Johnny "learned" this rule, but no matter how he learned it, Johnny after two days "knew" that people infer that a close-up acts as a modifier of a long shot in certain circumstances. Further, he not only assumed that one could manipulate film by sequences and spatial organization (close-up and long shot), but also seemed to know that certain shots "had to go" with others while certain other shots "didn't go" with others.

We were also able to show that the Navajos organized certain sequences in their films in conformity with the rules of the Navajo language. That is, certain classes of objects in the "real" world were connected by the Navajo language to special grammatical structures, and the Navajos assumed that images of these same classes of objects had to be connected in a film sequence in ways similar to the ways they were connected in speech. Specific sequences were often organized according to Navajo linguistic rules. Also, the very images and methods they used when they chose to tell a story on film were similar to the images and methods they chose when they told myths and stories in words.

It might be thought that the Navajos, or other filmmakers, would depict on film the reality they ordinarily experience. This also was shown to be an oversimplification. When an act or a sequence of actions in a film comes into conflict with that culture's rules of narrative organization, often "reality" and "history" are changed to conform to "how stories are told." The same filmmaker had a Navajo silversmith in his film mining silver to make jewelry. When confronted with the fact that the Navajos never mined their own silver, he replied, "It has to be that way—that's how you tell a story on film." In Navajo myth and religion, all things have to start at their origin. It was not a question of reality presenting itself to Johnny. It was Johnny manipulating and ordering reality in order to structure the world in a communicable manner.

Many of the editing techniques that the Navajos used were unfamiliar to us, or "wrong." The Navajos frequently cut in ways

that had people jumping around the screen as if by magic. A boy who was walking toward a tree from the left would suddenly jump to the right side of the screen on the other side of the tree, or a man kneeling would suddenly appear walking. When asked whether these sequences looked "funny" or had "something wrong" in them, the Navajos were at a loss to answer, even though they knew they had made a "mistake," and they wanted to give the right answer. Finally we had to ask point-blank, "Doesn't it look funny to have Sam suddenly go from kneeling to walking?" The filmmakers answered, "Oh—of course not! Everyone knows that if he is walking, he must have got up." Or in the case of the boy and the tree, when we asked a similar question, they replied, "No, it's not funny—that's not wrong—you see, why should I show him behind the tree? Everyone knows that if he's first here and then there, he got there. When he's behind the tree, you can't see him walking anyway."

It might be said that this represents a lack of ability on their part, or that all beginners make "mistakes" like that. On the contrary. For example, black youngsters in Philadelphia, aged eleven to fourteen, were taught in the same way as the Navajos and produced a film that was edited as smoothly as any half-hour television series film. The black youngsters had "learned" how to structure the universe "our" way, either by merely being a part of our culture that "sees" that way or by having been brought up on movies and television that structure that way.

These studies detail many levels of such structuring, ranging from the different things that people of different cultures choose to photograph and make films about to the specific ways that certain sequences are organized and manipulated to imply meaning, according to the tacit cognitive rules employed by the filmmakers.

In current research, Larry Gross and I (cf. chapter 5) are exploring the developmental process by which children learn to interpret visual symbolic events. At what age, for example, do children learn to make inferences from a film? That is, at what age do they begin to say that their responses to a film come from what the film "says," rather than from what they already know? In the former case, children are inferring; in the latter, they are attributing. When a child says, "The doctor in the movie was a good doctor, because doctors help people, and that's good," and yet the doctor in the movie didn't help people, the child is not inferring, but attributing meaning to an image. However, another child says, "The doctor is not a nice man." You ask him how he knows, and he replies, "Because you showed him, in that picture, not helping a man hurt in an accident." This child can be said to be making inferences from the film. How does this development

occur? When does a child learn to deal with the film structure of his society? How does one teach him? What structures help him to become creative and to make inferences, and what structures encourage passivity and attribution? Does film competence develop in a way analogous to linguistic competence? An understanding of this competence and its acquisition is necessary not only for the production of an artistic product, but also for the development of children's intellectual skills. In film, as in verbal language, man develops his capacity to communicate to the extent that he learns to structure reality by symbolic means.

It is not that film is language or is structured in the same way as verbal language (Worth 1969), but rather that all of man's cognitive abilities are related. When a child learns the concept of metaphor in language, he is all the more able to use it in other modes, both in implication and inference. When the child develops his ability to create cognitive structures as he learns to talk, he is developing the ability to create them in pictures and in film. It may even be true, as Arnheim states, that "the thinking on which all learning is based takes place at the source. . . ." (1966:148). I assume that by "the source" he means the eye in its first contact with an object. But that is certainly not where education and instruction must stop. Arnheim completes the sentence, ". . . and continues to draw on it." It is not the source that we must deal with and continue to draw upon, but rather the child's ability to do something with it. It is literally inconceivable that one mode of symbolic thought operates with a presented universe that arrives ready-made to man's brain, while other modes somehow require the mind to manipulate and to structure. Film, like verbal language, like gesture, mathematics, music, painting, and dance, is a method by which different people articulate their experience and present themselves to one another. What we need to know is more about how this is done across modes, across codes, and across cultures.

What kinds of problems and questions, then, must we set before ourselves in order to understand how to teach film and what to teach with it?

research for the future ●
The research that I have briefly outlined is clearly only the very beginning of such study. We need to know more about how audiences in different cultures, and those with different social positions in one culture, make inferences from film and how these inferences may differ across cultures.

Let us now consider the institutional implications of developing

in our children the ability to utilize pictures in a way similar to that in which they speak, read, and write their verbal language. Are we preparing them for the encounter with other cultures that will become possible through film and satellite television distribution? That world will be a place where almost anyone can produce verbal and visual images, where individuals or groups can edit, arrange, and rearrange the visualization of their outer and inner worlds, and where these movies or television films can be instantaneously available to anyone who chooses to look.

Imagine a world where symbolic forms created by one inhabitant are instantaneously available to all other inhabitants, where "knowing others" means that others frequently know us and that we know them through the images that we all create about ourselves and our world, as we see it, feel it, and choose to make it available to a massive communication network hungry for images to fill the capacity of its coaxial cables.

Imagine this place, so different from the society within which we nourish our middle-class souls, in which symbolic forms are not the property of a "cultured," technological, or economic elite, but are rather ubiquitous and multiplying like a giant cancer (or, conversely, unfolding like a huge and magnificent orchid) and available for instant transmission to the entire world.

It is technologically feasible right now, through the use of cable television and communications satellites, for a moving image with its accompanying sound to be broadcast from any place in our solar system and to be simultaneously received in hundreds of millions or even all homes attached to the wire. It is further possible for all homes to have their choice of the hundreds of messages that are simultaneously available.

We have passed the stage in our educational processes where the teacher had to present "our" views of the strange antics of "others." We are now at the point where the teacher should know how to teach us to "tell" others about ourselves visually, through movies and television. The teacher must also know how to analyze new symbol systems, for other people will be creating new forms for their old myths about themselves, and our own children must be taught how to do that also. In the past, teachers could ignore the goals of visual literacy while pursuing those of verbal literacy. But now it is impossible to ignore the fact that people all over the world have learned, and will continue in great numbers to learn, how to use the visual symbolic mode. Communication researchers must begin to articulate the problems that will face us in trying to understand others when their

point of view is known to us primarily through movies distributed by broadcast television and cable. How can we help our students and future teachers to overcome the inevitable tension between the world they will study and their own cultural backwardness in the face of a mass-distributed visual symbolic mode?

It is necessary to develop theories and methods for describing and analyzing how men show each other who they are and how they are. Theories of vidistics (Worth 1968) must be developed to supplement other linguistic, psychological, anthropological, and educational theories, in order to comprehend how people who organize their film in ways different from ours are understood or not understood. In a world in which people of other cultures are being taught to make movies and television, in a world in which our own children are learning to make movies and are being increasingly acculturated and educated through film and television, can the teacher afford to remain a "blind mute"? For a blind mute can never have anything to say to a person who respects visual "speaking" and whose culture demands social interaction through pictures. What I am suggesting for the teacher, then, as a first step, is the development of the capacity to express himself through film, as an artist, if possible, but primarily as a simple "speaker" in this new mode of communication. But the teacher cannot rest with the "speaker in film" ability alone. The native speaker has no need to articulate how he knows how to speak and understand his language. The teacher of film and visual communication must know more than how to speak; he must know how he knows how to speak and how others speak. He must, in fact, not only be taught to make movies as children, Navajos, and others all over the world will be taught; he must learn *how* to teach others and must formulate theories about *what* to teach others.

It is when we begin to think about the problem of teaching film and television to others that we must face a host of ethical problems. In teaching people to read, we implicitly teach them what to read. In teaching people to speak, or, as is the case with most people, when they learn to speak, they also learn what to say and what not to say, and to whom, and on what occasion. The use of a mode of communication is not easily separable from the specific codes and rules about the content of that mode. Speaking is something that most people do anyway; we do not have to teach it. Film and television are not something that most people do—at this time. Someone has to teach it. Whoever teaches it will have a large and powerful impact upon the culture and intellectual development of the people using it and viewing it.

Up to this point in the development of our educational institutions, teachers have concentrated on reading, writing, and arithmetic, without great concern for the underlying political issues. Who controls the mass media that children, through the development of these skills, are getting access to? With the advent of a wired planet, a planet in which movies and television produced by diverse peoples are available to almost all, teaching about film must include teaching how film and other visual modes are produced, distributed, and controlled. Is it enough for the teacher to concentrate only on individual cognitive processes when he teaches and trains others to teach filmmaking, or must he also concern himself with how these media influence other people and institutions as well?

Further ethical problems exist. Some of our studies, in which we compared films made by black, white, and Navajo young people, show clear differences in these groups' social organization around filmmaking, thematic choices of material and subject matter, and attitudes toward the use of film. For example, analysis of our current studies suggests that blacks prefer to manipulate themselves as image; they want to be in the film. Whites prefer to manipulate the image of others, as producers, directors, or cameramen. While the films made by black groups involve behavior close to home and neighborhood, the white teenagers' films are often about the exotic, the distant, the faraway. They rarely show their own block, their own homes, or their own selves.

Hence the use of film in education and communication involves more than teaching our children about film or how to make film. It will require the sensitive guidance of teachers who know how to teach about film as communication, so as to foster the development of personal intelligence and cultural sensitivity.

With the advent of a wired planet, control of the use of film in education not only means understanding how to teach through films, how to teach about films, and how to make films; it consists also in knowing how to control the use of educational film and television in the mass media themselves. "Sesame Street" and other programs using it as a model are now part of the educational system. By such programs, our children are being "educated" to consume, rather than to create. Educators themselves constitute the largest and only group of professionals involved in the making of educational film, in television, and with teaching machines, who have no training *at all* in the use or the analysis of film as a process of communication. Hence it is mandatory that we teach teachers the very things that I have argued have to be taught to children.

some concluding comments ●
The major concern that I have voiced in this paper relates to the reasons and theories upon which an increasingly large number of people in education base their case for the use of film in educational practice. Certainly, film and visual communication should receive greater attention from schools and educators. What I disagree with are the assumptions underlying the educators' arguments. The assumption of visual primacy, with its attendant uncritical film ideology, gives an unfortunate bias to research problems, to teaching methods, and to curricula, as well as to theories of education and public policy. The truth is *not* that the visual is psychologically, culturally, and sensually the primary way of experiencing and knowing the world, but rather that the visual mode of communication, along with other modes, permits us to understand, control, order, and thus articulate the world and our experiences. The process of becoming intelligent is the process of "building up structures by structuring reality" (Piaget 1970b). Film*making* could become one of the important tools by which we allow and help the child, as well as the adult, to develop skill in building cognitive structures and in structuring reality in a creative, communicative way. Although we can teach *through* film, we must begin to understand how the structure of film itself and the visual modes in general structure our ways of organizing experience. Salomon (1972), for example, has shown that exposure to the kind of short, choppy sequences used in "Sesame Street" has a profound effect on a second grader's perseverance.

Film, as Youngblood and Fuller seem to indicate, may be the way we can destroy community. The way we study visual communication, the questions we ask, and the way we teach people to make films and to look at films may very well determine this larger social question. It is my hope, therefore, that this paper may lead some to question current theories, ideologies, methods, and research approaches in the uses of film in communication and education.

five
symbolic strategies

with larry gross

The world does not present itself to us directly.[1] In the process of
becoming human, we learn to recognize the existence of the objects,
persons, and events that we encounter and to determine the strategies
by which we may interpret and assign meaning to them.

Our encounters with the world can be thought of as being both
natural and symbolic, since we often make distinctions between
events that we consider natural and events that we will interpret
symbolically. What, then, are the conditions governing that assess-
ment? What strategies do we use in order to assign meaning to
natural and symbolic events?

The interpretation of the meaning of a natural event, or the
assignment of it to a place in a scheme of things, is embodied in our
recognition of that event's existence. The interpretation of the mean-
ing of a symbolic event, on the other hand, is embodied in our
recognition of its structure—that is, in our recognition of its possible
communicational significance. In order to recognize the structure
which defines a communication event, as distinguished from a natu-
ral event, we must bring to that act of recognition an assumption of
intention. We must assume that the structure that we recognize is,
in a sense, "made," performed, or produced for the purpose of "sym-
bolizing," or communicating.

1. This paper originally appeared in the *Journal of Communication* 24 (1974):27–39—Ed.

The assessment of events as natural or symbolic determines whether we use an interpretive strategy which we shall call *attribution,* or an interpretive strategy which we shall call *communicational inference.*

Let us give an example. You are walking along a street, and from a distance you notice a man lying on the sidewalk. As you draw closer, you notice that he appears to be injured. In assessing this situation, if you assume it to be a natural event, you will most likely ask yourself, "What happened?" and "What should I (or can I) do?" However, if you notice a sign pinned to his shirt which reads, "sic semper tyrannis," you might make a further and more complex assessment. Suppose you remember, at that point, either that a guerrilla theater group has been performing in your neighborhood or that you read about guerrilla theater in a book. Your assessment of the situation might now be quite different. As the possibility of assuming communicative intent enters the assessment, you might then bring to bear a different set of rules by which you will interpret the meaning of that event—the conventions of guerrilla theater. Under these rules, you might ask yourself, "What does it mean, and how can I tell?"

Now let us take the same situation in a social and formal context which most clearly labels it as symbolic. You go to the movies and see a film that you call a "fiction" or "feature" film, which begins with a shot of a street in which the camera moves toward a man lying on the sidewalk, as we have described above. The film cuts to a close-up of the man's head and then to a shot of the note pinned to his shirt. There is no question that in our culture, a moviegoer, assuming communicative intent, would not ask, "Is it real?" or "What should I do?" but rather, "What does it mean?" And what's more, in our culture that viewer expects to learn the answer to that, and many other questions in the course of the film.

This rather bizarre example can help us differentiate three basic types of situation and the interpretive strategies they evoke. The first group are what we call *existential meaning* situations. These occur when persons, objects, and events which come to our attention are quickly assessed as having no symbolic meaning beyond the fact of their existence. Problems of communication and the interpretation of meaning will not be particularly relevant in these situations.

The second group are *ambiguous meaning* situations. In these, something in the event or in the context of the event makes us pause and assess it in terms of possible significance or signification as a symbolic event. We then seek additional signs on which to base our choice of an appropriate interpretive strategy.

The third group includes situations we clearly "know" to be

symbolic and communicative. We call these *communicational meaning* situations. We read books, go to the movies, talk to our friends, and interact in ways in which particular strategies for the interpretation of symbolic codes are invoked. These are situations in which there is no ambiguity as to the communicative nature of the event. Being a member of a culture "tells" one that certain events are communicative. Interpretive problems which arise in clearly marked communication situations will concern the assignment of a specific meaning, or meanings, to be inferred from some specific event.

Persons, objects, and events that we encounter may also be classified as "sign-events" or "nonsign-events." Nonsign-events are those activities of everyday life which do not evoke the use of any strategy to determine their meaning.

Figure 5-1 describes the larger context in which human beings interact with their environment and with the persons, objects, and events that they perceive and recognize. In certain contexts, people learn to treat some of these situations as signs to which they may assign existential or symbolic meaning.

It is important to note that the distinction between sign- and nonsign-events must not be taken as a categorical classification of any particular persons, objects, or events. Any event, depending upon its context and the context of the observer, may be assigned sign value. By the same token, any event may be disregarded and not treated as a sign.

Sign-events may be *natural* or *symbolic,* but always have the property of being used in the interpretation of meaning. If we assess them to be natural, we may do no more than tacitly note their *existence* and

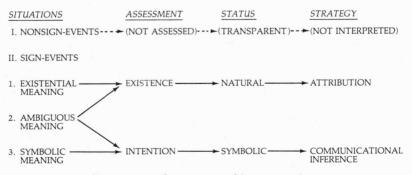

figure 5-1. the context of interpretation

interact with them in a variety of adaptive ways (requiring little conscious or even tacit interpretation of meaning). We may further *attribute* to them stable, transient, or situational characteristics. If, on the other hand, we assess them as *symbolic,* we consciously or tacitly assume *implicative intent* and call into play those interpretive strategies by which we *infer meaning* from communicative events.

One further term that we will be using in our discussion is *articulation.* An articulated event is produced by a person's own musculature, or by his use of tools, or by both. The articulated event must be thought of as mediated through the use of a communicative mode —words, pictures, music, and so on. An articulated event is a symbolic event. (A natural event may be produced by either human or nonhuman agencies, and *may be* treated as symbolic. However, the signness of a natural event exists only and solely because, within some context, human beings treat the event as a sign. An example of a natural event would be a tree bending in the wind, which may be treated as a sign of a coming storm. An example of the same event treated as articulated and symbolic would, in a film, be a close-up of a tree bending in the wind interpreted as an implication on the part of the director that a storm is coming up.)

An event, then, may be produced by human entities as well as by natural forces, but its "signness" is always *assigned* by an observer who can tell the difference within his own cultural context between those events which are articulated, and thus treated as intentional and communicationally symbolic, and those events which are existential and natural. Knowing and assessing that difference is often difficult and problematic. We are concerned with the strategies people use for solving that problem: are they natural or communicational?

Communication shall therefore be defined as *a social process, within a context, in which signs are produced and transmitted, perceived, and treated as messages from which meaning can be inferred.*

Let us review briefly some of the terms we have introduced earlier and place them within the context of this definition of communication. The concept of articulation and interpretation must be seen as relevant to both the production and transmission of signs, as well as to their perception and subsequent treatment. While the perception and treatment of symbolic events might be thought of as acts of interpretation, and production and transmission seen as acts of articulation, they can most fruitfully be seen as parts of a *process.* We articulate in terms of the subsequent interpretations we expect, just as we imply only in those terms which we expect others to use when they infer.

In such a situation one shifts, mentally, back and forth between articulation and interpretation, asking oneself, "If I say it (or paint it, or sequence it in a film) this way, would I (as well as others) make sense of it—given the conventions, rules, style in which I am working?"

Going back to our definition, it should be clear now that meaning is not inherent within the sign itself, but rather in the social context, whose conventions and rules dictate the articulatory and interpretive strategies to be invoked by producers and interpreters of symbolic forms. It is our view that only when an interpretive strategy assumes that production and transmission are articulatory and intentional can communicational meaning be inferred. In a communicational sense, therefore, articulation is symbolic and implicational, and interpretive strategies are designed within social contexts in order to make inferences from implications.

A critical distinction in terms of social *accountability* must now be made between behavior that is viewed as intentionally communicative and behavior that is not. We are all held accountable for certain aspects of our behavior. In the simplest sense, we are most accountable for our intentionally communicative behavior. A tic of the eye cannot be taken as a social offense; a wink may be so taken in certain circumstances, even though the physical event may be exactly the same in both interpretive contexts. It is our knowledge of the conventions which govern social behavior in general, and communicative behavior in particular, that allows us to determine the intentionality of behavior, and hence the nature and extent of accountability that may be appropriate in a specific situation.

Let us now turn to the question of how people develop the competence to assess and interpret symbolic intent. The distinctions in figure 5-2 are meant to explain, not an ideal state of knowledge or competence, but the actual use of certain abilities in the articulation and interpretation of meaning in communication situations.

We learn to articulate in a variety of symbolic modes and codes, as we similarly learn to interpret in an appropriate set of ways. As Gross has shown, the competence to perform (either as creator or interpreter) is dependent upon the acquisition of at least minimal articulatory ability in that mode (1974).

Figure 5-2 diagrams what we are hypothesizing as a model of the levels of articulatory and interpretive abilities and indicates a series of recognition stages that people apply to sign-events. These stages or levels are seen as both developmental and hierarchical. They are developmental in that we believe they are acquired according to a

specific order over a period of time, depending on age, cultural con-
text, and particular communicational or attributional training. We are
not asserting, however, that these articulatory and interpretive abili-
ties are acquired by all people for all modes, nor at specific chronolog-
ical ages. These abilities are hierarchical in that we see this order as
one of increasing articulatory and interpretive complexity in which
each succeeding stage contains within it the preceding stages. While
we are implying, therefore, that the development of competence to
perform on the earlier levels is necessary for its emergence in the later
complex levels, we are not implying that the earlier levels will disap-
pear or wither away. The process we envisage is one of elaboration
rather than replacement, much like the progression from crawling to
walking. Once we learn to walk, we do not lose the ability to crawl.
Once we have learned to recognize at all levels, we can choose our
strategies depending upon our assessment of the sign-event situa-
tion.

The first stage in the recognition of a sign-event as shown in
figure 5-2, occurs at the level of its person-ness, object-ness, or
event-ness. This occurs at the simple perceptual level of iconic repre-
sentation or symbolic reference. The symbolic sign-event (word, pic-
ture, sound) has as its paired partner a person, object, or event we
have learned to juxtapose with it in a simple recognition process. This
stage of recognition discrimination is required of a child before the
simple sign-reference relationship can develop. The child must learn
this recognition technique before he or she actually can articulate or
use the concept of sign in any deliberate intentional way. Before any
strategy for interpretation is developed, a symbolic consciousness
must come into play which allows a child to recognize the relation-

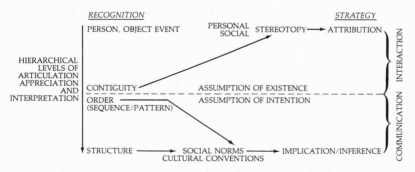

figure 5-2. competence to perform in a communications event

ship between a sign and some referent person, object, or event in the real world.

In figure 5-2, note that the arrow moves from person, object, and event recognition, through personal and psychosocial stereotype, to attribution. Thus, if the child sees a picture of a man whom he recognizes as "father," his interpretation of the picture will not be based on the meaning *within* the picture so much as the meaning within the child (viewer) based on what the child knows about "fathers," "his father," and so on.

The next level of development is the recognition of relationships among a number of sign-events. The recognition of these relationships is the second major stage in the development of a competence to perform. Relationships, however, can be recognized, and their status assessed (as we show in figure 5-2), at two qualitatively distinct levels. We would like to distinguish, therefore, between the recognition of simple existential *contiguity* and the recognition of intentional *order (sequence* or *pattern)*. It is with the recognition of order that the observer will be able to deal with a sign-event as communicational rather than as existential.

Contiguity consists of a juxtaposition of units or events over time, space, or position. The alphabet, in this context, can be seen as an example of contiguity. Recognizing its contiguity requires that the person grasp that A goes before B, which goes before C, and so on. The recognition that shapes repeat themselves in a certain way in a design or that objects in a room have their places is a recognition of contiguity. The same shapes in the same design can, in another context discussed below, be seen in different ways. The concept of recognition is one which places emphasis upon the person's cognitive manipulation of signs and their perceptions, rather than upon some intrinsic quality of events.

Order, on the other hand, is a more complex quality of symbolic arrangement. An order *is a deliberately employed series used for the purpose of implying meaning, rather than contiguity, to more than one sign-event and having the property of conveying meaning through the order itself, as well as through elements in that order.*

The recognition of order results from an awareness that an arrangement of elements has been produced intentionally and purposely, whereas the recognition of contiguity simply involves the awareness that certain elements exist together. Our use of the term *order* is meant to include spatial as well as temporal configurations. In painting and the graphic arts, for example, order occurs in space rather than in time and is most closely akin to what is often called "design" or "composition." We shall employ the word *pattern* for

such spatial arrangement on the level of order. Temporal orderings, such as occur in movies, music, or literature, we shall call *sequence.*

The recognition of pattern or sequence is the bridge to the level of *structural recognition.* While the earlier levels of recognition deal with single elements or with multiple elements in contiguity, structural recognition calls for an awareness of the *relations between elements* and their implicational/inferential possibilities. Structural recognition enables one to deal with the relations between *noncontiguous* elements: the beginning and end of a story, variations on a theme, differing perspectives on one canvas, and so on. Structure may be thought of as starting with order and being the level of formal organization that links the elements of a communicative event.

We have argued that the articulation and interpretation of symbolic events can be characterized in terms of a hierarchy of levels and that these represent increasing degrees of complexity as well as different stages of development. They also require, for a person's competence to perform communicatively, the possession of increasingly sophisticated articulatory and performatory skills. The simplest sign-events consist of single or unrelated elements; complex sign-events are those wherein the elements are placed in relationships, and in which these relationships are governed according to the organizational principles of a symbolic code. We have also suggested that this hierarchy represents a developmental sequence, in that the competence required to perform on the higher levels of articulation and interpretation will emerge on the basis of prior competence on the lower levels. This analysis parallels that of the development of specific symbolic skills, such as drawing and painting, in which children acquire a repertoire of elements, rational formulae, and, finally, the ability to combine these, intentionally, for the purpose of creating visually meaningful, structurally organized images (Lindstrom 1962).

We will now deal with the interpretive strategies linked to these levels of recognition as they are applied to mediated representations of behavior. Sign-events which are recognized as natural events are taken as informative rather than communicative, and interpretations are made of them in terms of what we know, think, or feel about the persons, objects, and events they represent or refer to. That is, we *attribute* characteristics to the recognized sign-elements on the basis of our knowledge of the world in which we "know" they are found. For example, if we view a film of a psychiatric interview taken with a hidden camera, we will feel justified in making attributions about the patient, the therapist, or the nature of their relationship. We will feel constrained in our interpretations (having assessed the situation

as natural because of our knowledge of the hidden camera) because we may not know to what extent the behavior we see is a function of stable characteristics of the patient or therapist (personality, role), or of transient characteristics (mood, physical state), or of the situation itself (a psychiatric interview, the first interview, and so on).

Most adults in our society are aware of the fact that the appropriateness of such attributional strategies for the interpretation of the film described above derives from the film's status as a record of a natural event that did actually occur in the real world. Were the camera crew to have been in the room during the interview, moving around and filming the event from various positions, or were the film to be clearly edited and rearranged by the filmmaker, most of us would realize that we were seeing a symbolic event which had been intentionally put together for the purpose of implying something the filmmaker wished to communicate. We would recognize that the events we observed had been selected and organized into a "whole," and that the appropriate interpretive strategy was one which analyzed the structure of the film and the relationships of its elements, in addition to incorporating any attributional interpretations which we might make about the people in the film on the basis of our general social knowledge.

If we are correct in our assumption that the levels of recognition and interpretive performance that we have described represent a developmental sequence, and not merely one of increasing complexity, it would follow that the distinction we have just detailed would not be made by children until they achieve the higher levels of the hierarchy. This assumption has been investigated in a series of studies that we and our students have conducted on the nature and development of interpretive strategies (Harlan 1972; Messaris 1972; Murphy 1973; Pallenik 1973; Wick 1973; Messaris and Pallenik 1977).

In much of this research, we have been concerned with the development of the child's ability to tell, in words, what he has seen in a series of pictures and what he thinks they "mean." The basic study used photographs that show a sequence beginning with a man (easily recognized as a doctor, because of his white coat and stethoscope) doing various tasks in a hospital. He then takes off his white coat, puts on an overcoat, leaves the hospital, and walks down the street. The following picture shows the "doctor" in the background, and in the foreground an obviously damaged automobile from which a man's head and one arm are visible hanging partway out of the door. It is quite clear that the man may be (or is) injured. The next picture shows the "doctor" in the foreground looking at the car and

the injured person in the background. The "doctor" crosses the street, continues walking, enters an apartment house, opens a door, and is finally shown relaxed, holding a drink, and smiling at a woman sitting next to him (see Messaris and Gross 1977).

Murphy (1973) showed these pictures to children in the second, fifth, and eighth grades, who were then interviewed individually in order to elicit their versions of the "story in the pictures." Murphy investigated the evidence the children used in justifying their interpretations. We have also used the same design and procedure with college students aged seventeen to twenty-three (Messaris and Gross 1977).

In the responses of the children and the college students, we have distinguished several classes of behavior that appear to parallel our conceptualization of the development of interpretive performance. In the earlier grades, children were able to recognize the persons depicted in terms of conventional attributes (doctor, nurse) and report the events contiguously ("The doctor was talking to the nurse . . . then he left the hospital"). However, when asked about the meaning of the sequence in terms of what is implied about the persons and events depicted, these children gave answers that were completely consistent with, and dependent upon, the general social knowledge they had about the persons in terms of role attributes, *even when these stereotyped images had been directly contradicted by the information they were given in the pictures.*

For example, all of the second grade children said that they liked the doctor, and, when asked why that was so, said they liked him because he was a doctor:

Q: "How do you know that he is a good man?"
A: "Because doctors are good men."
Q: "How could you tell this one was a good man?"
A: " 'Cause he was a doctor."

Similarly, most of the younger children thought that the doctor must have helped the accident victim, not because they saw him do so, but because "that's what doctors do." In fact, most of these children said that the "meaning" of the story was that doctors are good and that they help people:

Q: "What was the most important thing in the story?"
A: "He was a doctor, and he helped people a lot."
Q: "How do you know?"
A: "Well, I think he helped that person in the car wreck."
Q: "How do you know?"
A: "Well, I don't know. But I think he helped him, because that's what doctors are for, isn't it, helping people?"

Many of these younger children were aware of the accident, were aware that the doctor didn't help, but still said that the man was a "good doctor," because "doctors are good—because they help people." What they attributed to the "doctor" on the basis of prior learning about doctors as a class was more powerful than any other interpretive strategy which they were able to apply.

We would say that, at this stage, children are using attributional strategies of interpretation. It is not so much the interpretations they give as the reasons they advance for these answers that determine our classification: they are calling into play knowledge that they have from outside, which is relatively unrelated to the set of pictures they are being shown (Donaldson 1971). The children's use of attributional strategies is grounded in their assessment that the events they see in the pictures are real, natural events and must, therefore, have the same meaning that they have learned to assign to such events that they have experienced directly:

Q: "Why do you think [the pictures] are real?"
A: "Because doctors walk home."
Q: "How do you know that?"
A: " 'Cause my uncle's a doctor, and he does it himself."

At an older age, the children begin to realize that the pictures do not, in fact, represent a simple record of a natural event. They recognize that it is highly improbable that such a complex sequence could be captured in pictures unless it had been staged: "A guy's going to think something's wrong when every minute a guy pops up in front of him and takes a picture." The younger children took the "realness" of each part of the sequence as evidence for the naturalness of the entire sequence; the older children realized that their assessment must be made in terms of the entire set of elements.

We shall, for illustrative and space-saving purposes, construct a composite interview which will allow us to point out the different kinds of responses that are involved in structural recognition, assumptions of intention, and implicational/inferential interpretations. The following would be an example of an interview from which we would judge the child to be displaying a knowledge of structure and of implication/inference.

Interviewer: "Could you tell me something about the pictures you saw?"
Child: "You mean about the story?"
Interviewer: "Uh-huh."
Child: "Well, he didn't help that guy in the accident."
Interviewer: "How do you know?"
Child: "If they had wanted me to think he helped him, they

would have had a shot of him with a stethoscope or something, bending over the guy in the car. They would have shown him helping somehow."

Notice the concepts involved in this child's interpretation. First, he refers to the set of pictures as a "story"—he recognizes story structure. Then he says, "If they had wanted me to *think . . . ,*" clearly indicating (1) that the "story" was "given" to him by the experimenter, (2) that the "storyteller" may want him (the viewer) to think along certain lines, and (3) that information comes from "a shot" that is purposely inserted or omitted.

But most important, his interpretation of the doctor is based on a process that is clearly inferential: he knows that for his interpretation he may use only, or mainly, the information given to him in the communication event. Communicational implication/inference demands just this kind of behavior. The child must subordinate what he already knows about doctors to what he knows about the rules and conventions of communication, and must use the information given in the structure he has recognized (Donaldson 1971).

When a child (or an adult for that matter) fails to recognize structure, he will make interpretations through attribution. When he recognizes structure, he knows that implicational/inferential strategies of interpretation are called for. The reasons for this knowledge are imbedded in recognition of structure, for basic to that recognition is what we are calling the *assumption of intention.*

Intention is not an empirical datum, nor is it verifiable by the result of an interpretation. The verifying process is the fact that the interpreter gives *reasons* for his inferred meaning, based upon the implications he derives from the messages. It is the kind of reasons given for the interpretations that distinguish between attribution of meaning and inferences of meaning. It is important to recognize that an isomorphic relationship between signs and their interpretation does not constitute either sufficient or necessary cause for describing an interpretation either as an act of interaction with the environment or as a communicative event.

Intention is an *assumption* which is made about an event, allowing us to treat the elements of that event as sign elements in a structure which *imply,* and from which we may *infer, meaning.* In figure 5-2, the assumption of intention is contrasted with the assumption of existence. We are reserving the use of the word *communication* for those situations where an assumption of intention is made.

It should be clear by now that when we use the term *assumption of intention,* we want it understood as an "assumption of intention to mean." Interpretation consists, in a communicational sense, of a pro-

cess by which X (the interpreter) treats Y (the utterance, sign, or message) in such a way that the assumed intention is for X a *reason* (Grice 1957) for, rather than a mere cause of, his interpretation. This is why empirical evidence of the assumption of intention is not the "correctness" of the interpreted intent, but rather the *reason* and *reasoning* given by respondents.

The assumption of intention is felt to be within the control of the interpreter, as well as the articulator. The interpreter, further, can distinguish, and finds it important to distinguish, between what signs "suggest," what he "attributes" to signs, and what he "infers" from signs.

This conceptualization of intention and meaning differs from many referential, behavioral, and semiotic theories of meaning which are not concerned with implication, inference, and intention. We are arguing, for example, that a stimulus-response theory or a simple learning (conditioning) theory which defines meaning as the tendency to behave in certain ways upon the presentation of signs or conditioned stimuli is totally inadequate for the interpretation of human symbolic behavior.

We have presented a brief description of a new way to examine the concept of interpretation. First, we are suggesting that interpretation is best seen within a comprehensive framework of communication which distinguishes between "natural" interaction and communication. We have also suggested that the process of interpretation occurs whenever signs are used and that interpretations can be made in situations that are not communicative. When such interpretations are made, we have described them as attributions.

Second, we have presented both a hierarchical and a developmental concept by which the process of interpretation and articulation can be described. We have then described a series of recognition stages culminating in a process of implication and inference within which communication—a social event—takes place.

Third, we have presented, as two basic theoretical constructs, the concept that the assumption of existence leads to attributional strategies of interpretation and the concept that the assumption of intention leads to implicational/inferential strategies of both articulation and interpretation. We have further said that the assumption of intention is very closely allied to the concept of the intention to mean, and that therefore implication and inference, as we are using the terms, suggest implication of meaning and the inference of meaning.

We have argued that intentionality (when used in relation to

communication) is always an assumption. The articulator means to imply; the interpreter means to infer. Intention, therefore, is not verified by an isomorphism between implication and inference, nor by an isomorphism between individuals who happen to be articulators or interpreters. Intention is verified by conventions of social accountability, conventions of legitimacy, and rules, genres, and styles of articulation and performance. These are the bases which make our assumptions of intentionality reasonable, justifiable, social, and communicational.

seeing metaphor as caricature

Being neither a literary scholar, critic, nor theorist of literature, and, further, being identified with that sort of event that is often said to be worth a thousand words, I have wondered how to approach a collection of words about metaphor as extensive, divergent, and thorough as those that have been assembled in this collection.[1]

I have considered whether I was chosen to comment on this series of papers because of what I was not[2]—a researcher of words or of verbal behavior; or whether it was because of what I was— because the editor felt that the concept of metaphor was broader than the purely verbal, and that a scholar of visual communication might find some common elements within the largely verbal elements that most of the articles would have. I have taken the easy way out and will assume that I was asked to comment on metaphor for both reasons, for what I do not study as well as for what I do.

The striking thing to me about this collection of essays is that on the whole, and with a few exceptions, every author "assumes" that metaphor is a verbal event—a verbal "thing" of some sort. This

1. This paper originally appeared in *New Literary History* 6 (1974):195–209, as an invited discussion of a special issue on metaphor—Ed.

2. A notion suggested to me by my reading of Professor Sparshott's paper and his intensive discussion of the concept of metaphor as a way of talking about something as it is not.

seems to be so deeply founded a notion as to make me think it might be made of the very stuff that culture is made of. What we absorb with mother's milk, and what we hardly ever question. My first effort, therefore, is to question that. Is the concept of metaphor one that can or must only be applied to verbal events? Has it, in fact, only been used in verbal behavior—in speech or in written materials? If the answer to these questions is not a clear yes (and I will try to show that it is a clear no) the second question that must be examined is why it seems to have been assumed by the writers represented in this issue that metaphor should largely be examined as only, or mainly, a verbal phenomenon or event. The answer to this last question is more complex than an appeal to context; that is, that the authors represented are writing for a literary journal. I think that in general all the authors are writing not only within the context of a literary journal but within the context of a literary and verbal culture as well.

I do not mean by this to imply the tired McLuhanesque refrain about "electronic media," the "film generation" of Buckminster Fuller, or variations on Rudolph Arnheim's "visual thinking." I also do not mean that the contributors to this issue of *New Literary History* are "behind the times," "retrogressive," or not "with it." I am suggesting that indeed they *are* with it; that many of the ideas expressed by people such as Arnheim and McLuhan about the centrality of the visual mode in our culture are simply not the case. I am suggesting that the contributors to this volume do represent the ethnographic present as regards thinking about a concept such as metaphor, and that the challenge is to explore some of the reasons why such discussions center around words, verbal discourse, and verbal texts.

First allow me to dispose of the duty to define metaphor. I shall, not only out of diffidence in the face of massive scholarship, but out of wisdom, refrain from anything but a cursory discussion of how I plan to use the word.

First, like almost all the contributors to this issue, I think of metaphor as a structure, rather than an artifact or a chunk of speech or writing. Metaphor is a structure composed of elements in any mode (as I shall try to show) related in certain ways. Most of the structures analyzed by such authors as Derrida, Ricoeur, Hamlin, Sparshott, and Todorov seem to fit, if not always agree, with my usage, and I have no general disagreement with them. In general, I will assume that although the issue is complex, by the time readers get to summary sections such as this one, definitional questions can be allowed to languish. In general, I like to think of metaphor as a structure that has inherent in it the Lévi-Straussian formalism $A:B::C:D$ (read as "A is to B as C is to D"). The statement "the sun

is to the moon as man is to woman" leads to the commonly under-stood metaphor, "she is my moon," and to the somewhat shocking and richer metaphor, "he is my moon," the initial relationship of sun: moon :: man:woman being known as part of the things one knows in our culture.

Ernst Gombrich uses a similar notion in discussing visual meta-phor. He starts with Homer's phrase about Achilles, who "leapt, a lion, on his foes," and carries this notion of verbal metaphor to its use in pictures, such as Jupiter carrying a thunderbolt, St. Catherine a wheel, and Charity, children. He continues: "In contrast to this use of images as labels, the lion . . . is not a code-sign. The image of the lion can be used in different contexts . . . to convey very different ideas. The only thing these ideas have in common is that they are derived from such traditional lore about the lion as is crystallized in bestiaries and fable. It is this lore which defines what may be called the area of metaphor" (1963a:12).

In one case, of course, we can decide to use the notion of nobility associated with lions and in another the notion of bestiality. In a similar but different way, "she is my moon" depends on our common social knowledge that the moon is gentle, soft, pale, and so forth, and that "she" is often, within our culture, associated with those attrib-utes.[3] "He is my moon," however, demands that we structure the elements of that phrase within the same attributes we used in the previous similar structure. The change is not between different aspects of moon—that is, between different *contexts*—but between different pronouns attached to the metaphoric structure—that is, between different aspects of *grammar.*

It will become clear below that it is just this difference between grammar and context in similar structures that is at work in the visual mode, and that it is precisely these aspects of metaphor that are most richly manipulated by filmmakers and painters. I shall further argue that visual structures can clarify a general and abstract notion of metaphor.

Three major issues suffuse all the papers presented here: inter-pretation, formalization,[4] and representation. All of these issues seem to be considered as literary, or at least as issues involved in forms of verbal use, either as discourse, or as verbal or written articulation,

3. The fact that this conception of "she" is at issue at present confirms the power of the cultural stereotype employed in these structures.

4. Space does not permit me to develop any discussion about the problems of abstrac-tion or formalization across visual and verbal modes of metaphor.

expression, or communication. Yet none of these issues is limited to the verbal mode, and all have obviously and explicitly been basic to the history, analysis, and criticism of the visual arts for at least the last three hundred years.

Most recently, the same three issues and concepts have become central to theories of semiotics and, in particular, to theories of the semiotics of film. Ricoeur, Sparshott, and Todorov particularly address themselves to, and lend themselves to a discussion of, questions of interpretation. What seems to emerge from all their discussions is the clarity with which they feel that metaphor must be interpreted. That is, that metaphor is not some event which is intrinsically known to the person who comes upon one. Almost all of the papers implicitly or explicitly understand metaphor as a formal device or structure demanding some kind of active interpretive behavior. (It might be important here to point out that David Edge conceives of metaphor in an entirely different way: one that not only doesn't demand interpretation in the way I shall be using the word but seems more akin to what Thomas Kuhn has called a paradigm. Not only does Edge use *metaphor* in a broader sense than anyone else; I believe that he so broadens the use of the term as to make it useless as a term describing a particular cognitive structure.)

It is clear that in this view, a "collection," "bundle," "bunch," or "gaggle" of signs, visual or verbal, in and of themselves and by themselves, have no (intrinsic) meaning, any more than the arbitrary sounds of language have meaning by themselves, without some sort of social agreement, as evidence, for example, in a lexicon (written or handed down verbally). In his famous Soviet film *Strike,* Sergei Eisenstein uses a sequence in which a factory foreman (who has informed the cossacks about a coming strike) is shown in a close-up which Eisenstein then immediately follows with another close-up of a jackal running into the woods. Who, today, doubts that that film sequence is to be interpreted as something akin to the verbal notion of "the informer is a jackal"?

In Dusan Makavejev's film *W.R.: Mysteries of the Organism,* completed in 1971, this Yugoslavian filmmaker uses complex structures of metaphor which seem to surpass the kind of structures we use, or perhaps can use, verbally. He combines commonly held knowledge about Wilhelm Reich (that he wrote about sex and politics) with commonly held notions about Stalin and current Chinese leaders (that they are dictators and powerful authoritarian figures), and produces metaphoric sequences that *show* people writhing in Reichian therapy, followed by a man writhing in electroshock, connected only by visual structure. As the metaphor continues to unfold, we see a

sequence of erotic art, and artists at work, which ends with a long series of shots showing a woman artist making a plaster mold of an erotic magazine editor's penis. This is followed by a shot showing the mold being opened and the emergence of a series of penises made out of red plastic. This is followed by a shot of hundreds of thousands of Chinese waving the little Red Book, followed by a sequence beginning with a close-up of Stalin taken from an old film; we (the audience) do not know if it is a documentary, and thus the "real Stalin," or a drama, and thus an "acted Stalin."

The question of how we know ways to make interpretations of such complex visual metaphors in films seems to revolve around questions of the complexity of learning and of describing interpretive strategies for verbal structures. But the notion of complexity often is a red herring, akin to concepts that linguists used to have that some languages were more complex than others, and that of course the more complex (read "civilized") state was the end development toward which the simpler (read "primitive peoples") aspired. In comparing filmic events to verbal events, we might sometimes be tempted by the same simplistic concept of complexity. But a moment's thought should show us that it is not complexity, but different forms, rules, and procedures which are at work. For example, "she is my moon" offers no difficult interpretive *syntactic* problems for native speakers of English. "He is my moon" offers no syntactic problems either. Native speakers of English are certain of the grammatical rules to apply to both metaphors. One may argue about or reflect upon the "traditional lore," the special cultural meanings, or the particular social and aesthetic principles displayed in those two verbal metaphors, but not their syntax.

In a visual metaphor, whether one as seemingly simple as the Eisensteinian double close-up of foreman and jackal or the one just briefly and incompletely described as used by Makavejev, the syntax is much more at issue than the cultural and traditional lore which forms the boundaries within which the structure of metaphor operates.

Interpretation of visual metaphor raises questions about the interpretation of "language" or syntactic forms for nonverbal matters for which we have very little social agreement, thereby raising the question of the semiotics of metaphor. That is, is metaphor a metastructure dealing with a code which is transformed upon a variety of modes—visual, musical, verbal, and even mathematical? Must metaphor therefore be studied across modes in order to extract the particular cognitive functions which make it so powerful a structure of human thought?

This question of the semiotics of interpretation which I have

dealt with more lengthily elsewhere can be briefly summarized for the purposes of this paper by mentioning several central issues of interpretation (see chapters 5 and 7). First, interpretation of any sign system takes two distinctive and opposed forms, one interactive, the other communicational. The interactive (see figure 5-2) is related to strategies of interpretation leading to attribution. The other strategy is communicational and is related to structures of implication and inference. Metaphor is a communicational code depending upon the recognition of structure and the assumption of intention on the part of the "articulator," "artist," "producer," or "creator" of the form we are to treat as metaphor.

Space obviously does not allow a full exposition of this theory of interpretation, but the mention of its significant terms might be sufficient to allow the reader to follow these remarks. Attribution as a strategy of interpretation in any mode puts onto the interpreted event meanings that come from outside the event only and does not use rules and grammatical "instructions" from within the form. Communicational inference uses both knowledge from outside and knowledge from syntactic forms. Communicational strategies make use of social knowledge, as opposed to purely personal or psycholog-ical belief. We may personally love men with black hats, but in dealing with Western film metaphor, we "know" that the man with the black hat or the black horse is the bad guy. We may think lions are cute, but we "know" about the symbolic use of the lion as ferocious, noble, or as king of beasts. In a film sequence of "hunter stalking his prey silently" and "lion stalking his prey silently," we would have to be careful (since filmic syntax is still relatively unclear) to arrange our shots in such a way that the *metaphoric* rather than the *narrative* aspect of the sequence was apparent. That is, we would have to arrange the shots in such a way as to make it clear that we weren't meaning (because one shot of a lion followed a shot of a hunter) that "the lion is hunting the hunter," or in a reverse arrangement that "the hunter is hunting the lion." Rather we would have to structure our film so that it was clear that we meant the metaphoric structure, "the hunter is a lion." In further sequences, we could clarify whether we are invoking concepts of nobility, ferocity, and so on.

The semiotics of interpretation demands a delineation of cultur-ally accepted rules. In the interpretation of dreams, as well as of movies and poems, cultures must and do provide us with syntactic, semantic, and communicational rules. Whether these are based on Freudian principles, the oracles, or (as with the Walbiri of Australia) a semilinguistic form of dream interpretation employing drawings in the sand is not the important factor. The important point is that every culture provides its "native speakers" in any mode with a code for

interpretation. These formal metasemiotic structures which deal with all forms of cognitive organization within the context of mode, genre, and culture seem to offer the most exciting new roads to the understanding of metaphor.

I would like to jump now to a possible set of rules exemplified by Sparshott's conception of metaphor as talking about something as it is not, since he also is one of the few authors who mention the possibility of metaphor in other modes such as music and painting. In semiotic terms, Sparshott's "first impulse" that a portrait "is literally pigment and metaphorically person" is simply a confusion in terminology. As "literally pigment" it is not a "portrait," since "portrait" is a social term that at various times has various meanings, none of them "literally pigment." In thinking of photography, however, C. S. Peirce fortunately has given us some terms to handle the "portrait" problem. Some photographic faces can be thought of both as a "portrait" and as an "index." It is when we think of a portrait as an "icon," as not having a point-to-point similarity—being an index —with its referent, but as having something called a resemblance or a similarity—being an icon—that the closeness which Sparshott recognizes between a metaphor and a portrait becomes central to the point we also are trying to elucidate. When we look at the portrait of Churchill that Sparshott presents to our imaginations, we must, in order to see it as a portrait, assume certain intentions on the part of the portrait maker.[5] We must assume not only an intended portrait but an intended *structure,* an intended relationship between the elements on the canvas and the elements connected to the sitter. This connection could be perceptual (how he looked—cigar and all) as well as cognitive (how he was thought to be—by the painter or photographer, as well as by the public).

A portrait is not like a cloud that looks like a camel or a flower that I see as my love, but like "a flower that is my love." That is, a portrait is like a sentence; it is a structure of a certain kind, and could

5. The very notion of "portrait" is much more complicated than I can hope to deal with here. Historically, "portraits" are labeled not only by a known resemblance, but, as in the case of late Roman mummy portraits, by an assumed intention to present a likeness. In other historical contexts, a portrait can be "identified" by certain stylistic features: a face in a painting containing pimples, uneven ear sizes, or defects in physiognomy, which are assumed by art historians to have "meant" that the face was a portrait of "someone" rather than an idealized version "made up" by the painter. My point is that a "portrait" as a metaphor is a structure used as a label within a specific context. Neither portraits nor metaphors can be considered anything other than cognitions of a certain kind. (Much of my understanding of the complexity of the seemingly simple concept of "portrait" I owe to lengthy discussions of this subject with Debora Worth Hymes.)

be a metaphor if its form had the structure of metaphor. When, then, can a portrait be a metaphor, or what, then, would it mean to say that a particular portrait was a metaphor? Here we must go back to the "common lore" which Gombrich talks about. "Red," he continues in a later passage, "the color of flames and of blood, offers itself as a metaphor for anything strident or violent." He later mentions such things as gold and glitter as becoming metaphors of value in certain periods, and other art historians have pointed out that because of their cost, the actual pigments (ultramarine, for example) became metaphors, or stood for importance, wealth, and value in painting.

If metaphor is "talking" about something as it is not, a portrait is somewhere smack in the middle, and this points up why I believe that an examination of the issues of metaphor in visual codes will clarify the issues raised for verbal codes.

A portrait clearly is an event that is not the "real thing," but it is clearly *as* if it *is* the real thing. Rather than being like a cloud that looks like a camel, a portrait is a "camel" that looks enough like a camel so that people can say that it is *that* camel. A picture of Churchill is enough like Churchill to be recognized as Churchill. This, however, is not really what is interesting in either metaphors or portraits.

It is clear, but has not been discussed enough, that some intended portraits or some paintings of faces do not "come off." No one recognizes Churchill. It is also clear that some portraits of Churchill are more like Churchill, or better of him, than others. It is also clear that some metaphors do not come off and that some are better than others, more exciting, more revealing, and more illuminating of the condition or situation they mean to communicate.

It seems to me that understanding the nature, or the "meaning" (as Ricoeur uses that term) of a picture as a portrait and as a metaphor requires of us not only an understanding of what it means to make something look like something else (as in iconic structures) but also to understand those iconic structures that look like, but also deliberately are in many ways not like, the thing with which they have an iconic relationship. I speak here of course about that form of portrait we call a caricature. The argument I shall be making is that metaphor might most fruitfully be understood in comparison with theories and concepts of caricature, rather than with theories of representation. Theories of metaphor as representation, such as Sparshott's,[6] are in my opinion possible only because they use verbal labels and philo-

6. I single out Professor Sparshott's paper not because I mean to quarrel with it, but rather because it is both clear and presents almost all issues I wish to discuss. While I disagree to some extent with some of his formulations, I admire their originality and have found them profoundly stimulating to my own thinking.

sophical traditions that historically deal solely with the analysis of words. That is, arguments as to whether a verbal sign (spoken, written, and so forth) is true or false, or speaks of things as they are, or as they are not, apply only to those modes for which truth tables, concepts of true-false, and the formal ability to assert the negative in propositional forms may be applied. Pictures do not have these abilities to make true-false statements or to assert the negative: they cannot say ain't, either.[7] Music is neither true nor false, and metaphor can best be understood outside the largely verbal traditions of true-false and negation.

A caricature, like a picture, is neither true nor false, but, like a metaphor, is a structure that reveals a set of meanings intended to communicate a certain set of relationships within some understood or understandable context and bounds. A caricature is a structure that means *neither* that something is *as it is* or *as it is not.* A caricature is, rather, a structure that relates several elements on one level (in shorthand—that of "reality") with elements on another (the symbolic). It puts things together *both* as they are *and* as they are not, and the point of caricature, like that of metaphor, is that neither is only a "portrait." A metaphor is more than "as it is," but it cannot be totally "as it is not." A tracing of a photograph of Nixon will sometimes make a recognizable portrait of him, but most often not. A caricature of Nixon will always include some arrangement of his famous jowls, his hairline, his nose, his ears, and one or two other distinguishing features. But not all drawings of people with jowly cheeks, long ski noses, and receding hairlines will be recognized as Nixon. If labeled as such by lettering, audiences will often treat this as a sign of incompetence on the part of the artist, assuming that he knew it didn't look like Nixon and therefore needed to use a written label. The famous Escher drawings of buildings and stairs in strange perspectives are labeled by viewers as "impossible," rather than as untrue or false. The word *portrait,* just like the word *metaphor* or *caricature,* is a label *we* place upon a structure. In the verbal mode, this structure may allow us to make meaning "from a clash between literal meanings" (cf. Ricoeur). On a semiotic level of analysis which relates all modes, metaphor may be a system that helps us to provide meaning to structure through the juxtaposition in space or in time of layers and levels of elements in a variety of codes, modes, and contexts. Metaphor may be that special code that allows us to put together that which seemingly doesn't go together, and which also, and at the same time, provides us with the rules or lore which

7. This point is developed in chapter 7, below—Ed.

tell us that everything that "isn't" does not necessarily go together.

I am suggesting here that the rules governing the structure of metaphor in any mode are designed as much to prevent putting the wrong things together as to help us to put the right things together. In the hunter and the lion sequences, the conventions and rules of film metaphor are there to prevent us from interpretations such as "he is hunting the lion" and to facilitate interpretations such as "the man is to nobility, grace, and hunting ability as the lion is to those very qualities."

Let me illustrate this with quite a different example taken from the work of David Perkins (1974). A caricature of Samuel Beckett by Levine shows Beckett with a huge beaked nose, a long neck, and a spindly, almost legless, body. The nose is drawn more like the beak of a bird, and around the neck we notice what might be a collar of feathers. Somehow the drawing suggests a kind of bird of prey, a vulture out of some strange bestiary. And yet the picture also looks like Samuel Beckett. Compared to a photograph of Beckett, the resemblance is extraordinary. But the photograph doesn't intend to mean anything about Beckett the poet. The beaklike, vulturelike drawing of a swooping bird of prey, however, *fits* one cognitive concept we may have of Beckett's plays and novels. Somehow, not only does this caricature look like Beckett while also looking like a kind of bird which obviously doesn't look human or like Beckett, but it also reveals its meaning to us in the "clash" that Ricoeur mentions between the psychological attributions we make about Beckett the poet and about buzzards as birds of prey. The same caricature also relates something about the quality of Beckett's work that is succinctly put together in this clash of meanings between what Beckett looks like and what he doesn't, and between what Beckett's work is like and what a bird of prey is like. Here Lévi-Strauss's structure that I suggested in my opening pages helps to explain as film montage not only verbal metaphor, but caricature as well. It is as if in one drawing we have put together the following structure: "This drawing of Samuel Beckett is to the way the 'real' Samuel Beckett looks as the way we feel about buzzards and birds of prey is to the way we feel about certain aspects of the work of Samuel Beckett." Nothing here is like it is, everything clashes with our recognition of oppositions and relationships, and yet nothing is the way it is not, either. It all seems to fit.

The problem of metaphor is therefore somehow the problem of fit—of iconicity. How much similarity do we need in order to make something similar, and how do we know that something is similar enough for us to say that it is a "picture," or a "description," or a

"representation," or an "instance" of *X?* Metaphor, like painting but unlike written language and music, has no notation system. As Nelson Goodman, in *Languages of Art* (1968), has so clearly pointed out, we cannot have a performance of a painting, but we can have a performance of a Bach sonata, of a play, or of a poem. We cannot have a performance (or, again unlike painting, a forgery) of a metaphor, either. And yet the problem of how we know that some metaphors in any mode "work" is akin to how we know that certain performances of a Bach sonata have reached a point where we say, "It just is not that sonata anymore," or further, "I don't know what you are playing." It is the problem of how we know when a variation on a theme is a variation and not a new theme. Often, after hearing variations one through twenty consecutively, we can tell that variation number twenty comes from (is a transformation of) variation number one and is structurally related to it. But listening to or looking at one and twenty without knowing the intervening steps, we are often unable to discern the structure that, through transformations, made the latter a variation.

Theorists who seem as far apart as Freud and Chomsky sound precariously similar when they discuss how we know that one thing is related to another by some form of similarity. The knowledge a child has that the statements "John hit the ball" and "the ball was hit by John" have similar, if not identical, meanings comes in part, according to Chomsky, from the fact that both sentences were generated from some basic form, and that children know these principles of generation. He further proposes a theory of mind which suggests (and often states) that the human mind is "wired," or has developed in such a way that certain features of "Language" called "deep structure" are inborn. Individual "languages" are transformations from this basic deep-structure "Language," and the reason all children learn to speak their surface-structure specific languages is that transformations from what is inborn are relatively simple.

Freud (to my consternation) often sounds like Noam Chomsky. He seems to suggest throughout his work that there are certain "things"—love, death, sex, sex organs, and so forth—that everyone is unconsciously concerned about and that everyone deals with in dreams and other unconscious behaviors. These finite subjects or things (like Chomsky's linguistic rules) have infinite symbolic representations (like Chomsky's sentences). That is, for Freud there is a finite group of unconscious materials we work with, which have an infinite number of symbolic representations. Thus, for example, "penis" is a member of the finite group, but "chimney," "pencil,"

"snake," "cigarette," and on and on, are members of the infinite set of things with which we symbolize penis. And so with "vagina" as "viola" and "violin," and so on.

Freud, however, becomes much more relevant to a theory of metaphor as caricature. His answer to the question, "How do we know that snakes 'mean' penis?" is disarmingly simple. He posits an innate, unconscious ability on our part, never quite clearly described, to tell which things are recognized as similar to other things. In modern Chomskian terms, Freud posits a theory of innate iconic recognition. Our brains must be "wired"; we "know" somehow that certain things are similar to other things. We don't need to learn it; in fact we don't need to consciously know it.

If we accept these theories of innateness, the problem of metaphor is solved. We are born with the ability to recognize certain similarities in verbal language, in images of dreams, and presumably therefore in pictures, and probably in music (who would want to postulate so unparsimonious a brain as to leave music out of any theory of innateness?). The problem, however, is that some peoples "see" (think of) bananas as well as many other so-called phallic symbols as fertility symbols and as indisputably female, and that rules of deep structure, like computer translation of Shakespeare, are a dream that seems to be slight and fleeting.

We are still left with the question of how we know the similarities that metaphor brings together. Here I find the early part of Ricoeur's paper the most congenial, and the one open to expansion across modes. He mentions Richards, Black, and Beardsley as those with whom he agrees as to the meaning of metaphor. It might be interesting to conclude by describing some of the theoretical writings on film that I mentioned earlier, and to use their explanations of what is called "montage" in film to explain both the filmic examples described previously and to amplify the concept of metaphor as defined by Ricoeur. Ricoeur uses several key concepts: opposition, clash, and shift of context. All of these were described most succinctly in the early writings of Sergei Eisenstein and others (Eisenstein 1963; Jarvie 1970; Worth and Adair 1972). I shall not quote here, but rather paraphrase to save space. Film meaning, Eisenstein suggested in 1925, occurs by a collision of filmic ideas. This collision occurs in the form of "shots" (which are, he suggested, the basic units or elements of film form) in opposition. Each shot must correspond to a concept or feeling, so pictured as to present to the audience an idea. The following shot in the sequence presents to the audience another idea, but one in opposition, one designed expressly to create a conflict or collision of ideas. From this collision of ideas comes a synthesis—a

new idea, depending upon the previous shots, but not being merely additive.

In my opinion, Eisenstein was describing a theory of how metaphor works. His films and his writings detail this theory, going on to describe how shifts of context by the filmmaker could make the same image change meaning. By that he meant, in a simple filmic sense, that if you put a shot of a weeping woman (in a film in which the dramatic action concerned a son jailed for revolutionary activity) in between several shots of ice crashing and breaking up in a swiftly flowing river, you would get an entirely different meaning than from a sequence in which the same shot of the woman was placed between shots of birds gracefully flying through the air and children playing happy games in a sunny, wooded countryside.

But although a filmic theory of montage, editing, sequence, or interpretation is, in my opinion, essentially a semiotic theory of metaphor in general, its understanding depends not upon some innate notion of similarity between our receptors (ears or eyes) as postulated by Chomsky, Arnheim, or Freud, but rather on a variety of theories related to how we learn to organize the world around us so that it makes a little more sense to us now than it did when we arrived in it with that Jamesian sense of a "booming, buzzing confusion."

Theories of metaphor depend not only on our knowledge of film structure and linguistic structure, as described by such linguistic theorists as Whorf, Sapir, Hymes, and others, but upon social theorists ranging from George Herbert Mead to Erving Goffman. Knowing about metaphor means knowing how to organize the universe within our minds, knowing systems of myth, of grammar, of behavior, value, and art as they are defined by our group now, and have been in the past. I am afraid we learn about metaphor not only through "art" but also through symbolic behavior in general, through learning how to speak, by watching "bad" movies and reading "bad" books and "cheap" comic books. We learn about metaphor as we learn to stand close or far away from others and to do the million and one symbolic acts that our particular culture, in a particular context, teaches us as the traditional lore.

It is this traditional lore of symbolic and communicational behavior that helps us to know that in only some contexts are bananas to be thought of as penises, and violins as vaginas; and that in some contexts only, is an eye a gazelle. But most important, we know about intention, and the rules for structuring metaphor—in films, in speech, and in poems. That cultural knowledge makes it possible for us to use this marvelous structure of human thought.

It is the fact that we learn the agreed-upon rules for the intentional creation of meaning within specific contexts that makes metaphor possible. We learn the structure of metaphor, and we learn the schemata, the conventions, and grammars by which each creator in each mode of symbolic behavior intends meaning through transformations of a basic structure within which elements and contexts are shifted, made to clash and collide, and thus made to illuminate a complex and difficult world. A metaphor, like a great caricature, hits us like a blinding flash and forever reorganizes the world.

seven
pictures can't
say ain't

In this paper I should like to begin an exploration into how, and what kinds of things, pictures mean.[1] I also want to explore how the way that pictures mean differs from the way such things as "words" or "languages" mean. In order to explore these things, I will compare them along dimensions which I believe are central to the existence of both verbal and visual signs as communicative modes. I will first present an outline of two kinds of meaning, which I have called *communicational meaning* and *interactional meaning,* and relate these meanings to the kinds of interpretations that can be made from visual (pictorial) signs and verbal (linguistic) signs. Second, I will argue that pictures—paintings, movies, television, or sculpture—cannot be either true or false signs, and that therefore they cannot communicate the kind of statement the meanings of which can be interpreted as true or false. I shall then argue that picture interpretation is very different from word interpretation as regards its so-called pictorial code, convention, or "grammar," and also that syntactic, prescriptive, and veridical aspects of verbal grammar are very difficult to apply to pictorial events. I shall further attempt to show that differing assumptions accompany these different strategies of interpreta-

1. This paper originally appeared in *Versus* 12 (1975):85–108. The paper has been edited to eliminate sections that essentially repeat material presented in chapter 5— Ed.

tion,[2] and that these assumptions—of intention, in the case of communication, and existence, in the case of interaction—determine how we deal with the concept of truth or falsity in pictures.

Before I begin to discuss the problem of communicational meaning, I should like to clarify the distinction I will be making between *pictorial signs,* or *visual signs,* and the term *pictures.* Semiotic literature either ignores "pictures" or equates them with something called visual or pictorial signs. Signs, as we know, can occur in a natural state. Wind, and trees bending before it, can become a sign or signs of an impending storm. That is, we can abstract and separate from the natural flow of events a set of units which we call, and treat as, a sign. Anything may become a sign in that way, provided it fits our particular criteria for the use of signs. A sunset in general or a particular sunset may become a sign, but it can never become a picture, because a picture is not a natural event. It may, if the viewer so thinks about it, indicate certain relationships to natural events, but a picture is a *symbolic event* and therefore a *created social artifact.*

Pictures may mean in many different ways, as well as mean different things, and I shall argue later that the meaning of a picture on one level of interpretation determines what signs go to make up that picture on another level. I shall therefore expect you to treat the term *picture* with some notion of a distinction between it and the term *sign.*

It is obviously beyond the scope of this paper to deal extensively or widely with the term *meaning.* I shall try to be as narrow as I can, hoping to keep as tight a hold as I can on a slippery concept. In order to compare pictures and language (or visual signs and verbal signs) along dimensions of meaning, it is necessary for me to distinguish at least two differing kinds of meaning: *interactional meaning* and *communicational meaning.* Pictures, and words for that matter, mean in both ways, but how they mean in each of these two interpretive modes or strategies is completely different. This difference in the way—in *how*—we arrive at meaning determines to a large extent the kind of meaning and the level of meaning we live with, both on an articulatory and on an interpretive level.

Let us start with interactional meaning, since to some extent it

2. Much of the work on strategies of interpretation reported in this paper, both theoretical and empirical, was done with the collaboration of Larry Gross and is reported in Worth and Gross (1974). I have also benefited greatly from discussions with him about most of the material in this paper.

is a larger and more encompassing class than communicational meaning. One position taken by some theorists (Charles Morris 1946 would be the paradigmatic example here) holds that signs "set up" in observers some "response" or "disposition to respond," and that that response is *the* meaning of the sign or is closely connected to what the sign means. This is similar to some communication theories that define communication as a situation in which two or more entities are mutually interdependent. Thus genes, muscles, and atomic particles, as well as people across generations and spaces, "have meaning" for each other—are in communication. It is true that if one object or event causes, or is correlated with, a corresponding bit of behavior, we can say that somehow event X "has a meaning" in relation to event Y. In some sense every stimulus *means* its response, and the experiments with Pavlov's dog, as well as subsequent research in operant conditioning, show that some responses do indeed mean their stimuli. However, mutual interdependency, a stimulus-response relationship, or any other form of interaction in which entities or people merely engage their environment do not seem to me to be cogent dimensions upon which to build an understanding of symbolic behavior, communication, and meaning.

Let us look at interactive meaning from another point of view, that of interpretation. We observe an event in the "real world" and sometimes are able to say "that means. . . ." In this sense, the meaning of the world around us is an interpretation that we must make "correctly" in order to stay alive. Gustave Bergmann frequently made a similar point in his logic classes: "I will," he said, "stake my life on the fact that the sun will rise tomorrow—but not my philosophical reputation, since I can never prove an induction." He would, and did, *attribute* meaning to the movement of the sun in exactly the sense that I shall be trying to distinguish.

In a larger and nonrestrictive sense, we can, of course, observe and interpret both natural sign-events and symbolic sign-events. That is, we can look at the tree bending in the wind, or a novel, a play, a movie, a painting, and so on. We can say about any of them that they "mean." Let me, however, limit myself in this paper to symbolic —man-made—events. Figure 5-2 (see chapter 5) is a schematic and hierarchical representation of some different ways in which we can make meaning from symbolic events. The major difference that should be noted at this point is the distinction between the interpretive strategy of *attribution* and the interpretive strategy of *implication/inference.* The hierarchical nature of these two processes must also be emphasized. When one learns to make inferences, one obviously does not lose the ability to make attributions. Implication/inference

procedures are built upon earlier stages of recognition. For the moment, let us concentrate upon what I have labeled "interaction" in figure 5-2—that particular part of the interpretive process that is connected with the strategy of attribution.

By using the term *attributional meaning,* I wish to distinguish a process by which people largely impose, impute, put onto symbolic events knowledge they have within their psychocultural selves, as opposed to other processes that I shall discuss as *communicational,* in which people interpret meaning from symbolic events using knowledge they acquire outside themselves and from within *the symbolic event itself.*

Communication, as I shall use the term here, is defined as *a social process, within a specified context, in which signs are produced and transmitted, perceived, and treated as messages from which meaning can be inferred.*

Going back to figure 5-2, we can think of the concepts of articulation and interpretation as comparable to the production and transmission of signs, as well as to their perception and subsequent treatment. While the perception and subsequent treatment of symbolic events might be thought of as acts of interpretation, and production and transmission thought of as acts of articulation, they can most fruitfully be considered as parts of a *process,* which will here be called *articulation/interpretation.* This process will be explained as being similar to *implication/inference.* By drawing attention to the processual nature of these cognitive strategies we can deal with the fact that one cannot be understood except in terms of the other; we articulate in terms of the subsequent interpretations we expect, just as we imply only in those terms which we expect others to use when they infer. Conversely, we interpret (in a communicational sense) in the terms which we recognize as articulated, and we infer what we assume was intended to have been implied.

I will subsequently argue that the inference process cannot take place without an assumption of intention on the part of the interpreter and that implication likewise demands intention. Further, it will be necessary, in order to investigate this process, to understand that the roles of implier and inferrer may and probably must be held simultaneously by people in a communication situation. In such a situation, one shifts, in one's mind, back and forth between articulation and interpretation, asking oneself, "If I say it (paint it, or sequence it in a film) this way, would I make sense of it—given the conventions, rules, style, and so forth, in which I am working?"

It should be clear now that I am suggesting that meaning cannot be inherent within the sign itself, but exists rather in the social context, conventions, and rules within, and by which, articulatory

and interpretive strategies are invoked by producers and interpreters of symbolic forms. It is my view, then, that only when an interpretive strategy assumes that production and transmission are articulatory and intentional can communicational meaning be inferred. In a communicational sense, therefore, articulation is symbolic, and interpretive strategies are designed within social contexts in order to enable us to make inferences from implications.

It is my purpose to narrow rather than enlarge upon common usage, so the argument that will be made further is that any and all interpretations of meaning (consistent with psychocultural process within the individual) are possible, from any mode, using an *interactional-meaning* strategy. Comparisons of pictures and words, for example, along interactional or attributional lines are bounded only by the creative power of the interpreter, rather than by the articulatory power of the creator.

Let us therefore examine a strategy for the interpretation of meaning which is communicational, and which uses the social process of implication and inference. My use of the terms *implication/inference* is not inconsistent with their use in formal logic but is not, on at least one level, the same. I use these terms in an *ethnographic* sense, referring to an intentional use of symbolic material in ways which are shared by a group precisely for the purpose of inferring meaning from signs and sign-events. This process—communication—that I am proposing as a dimension along which comparisons of meaning may be made between the verbal and visual modes is somewhat similar to what others have proposed as the process through which painting or art may attain meaning (Boas 1955; Gombrich 1961; Kris 1952; Panofsky 1959).

When I use any event as a symbolic event, a sign, with the intent of sharing it with others, I am using it in an implicational manner. I only use this implicational strategy, however, when I expect that others will know the rules and conventions by which I have structured my signs and will draw the inferences from them that are "proper" to the structure. When I use signs this way, I structure them, and I expect that others know and acknowledge that structure and use it in order to make inferences.

However, the evidence for the use of communicational-meaning strategies lies in the reasoning that leads to an interpretation, rather than in the accuracy or correspondence between inference and implication. It is not necessary for an interpretation to be "right" for a communication situation to exist. It is merely necessary that both parties actually share a set of conventions about communication. The

articulator and/or interpreter must *assume* an intention to communicate. The articulator must structure within a social context, and the interpreter must assume such an intention to structure.

Let us now deal with the assumption of intention that, it is my argument, is necessary for communicational meaning to exist. When a child, or an adult for that matter, fails to recognize structure, he will make interpretations through attribution. When he recognizes structure, he may know that implication/attributional strategies of interpretation are called for, or he may wish to invoke such strategies in some particular context. The reasons for this knowledge are imbedded in structural recognition, and basic to that recognition is what I have called the *assumption of intention.*

Intention is not, in this use of the term, an empirical datum or a perceptual process such as seeing color, hearing sound, or feeling heat and cold. Nor, as I have already suggested, is it verifiable by some result of an interpretation, such as making the "correct" interpretation.

Communication, and its attendant implication and inference of meaning, is a process in which one produces a set of symbolic forms or signs in some mode—in words, pictures, or sound—as well as in *some code.* The social nature of this process is imbedded in the assumption of intention. That assumption is basically that the signs people choose are coded and that the relations between signs or elements are conventional.

This assumption of intention is based upon and supported by a variety of "knowledges" arising from one's membership in a group: we tacitly know how to speak our group's language, or how people "like us" behave on the street, in classrooms, and in talking on the telephone, as well as how they write books, make movies, and prepare papers for learned journals. It is most likely that a first reason for some specific assumption of intention is that the form we choose to interpret is socially coded as being possibly, or certainly, an intentional form. We are all held socially as well as psychologically accountable for certain aspects of our behavior, particularly for our symbolic behavior, and we all know that under certain conditions and contexts other members of our group will expect us to recognize this and to behave accordingly.

Interpretation consists, in a communicational sense, of a process by which *X* (the interpreter) treats *Y* (the utterance, sign, or message) in such a way that the assumed intention is for *X* a *reason* for, rather than a *mere cause* of, his interpretation. Evidence for the assumption

of intention is not an isomorphic matching between intended state-
ment and interpretation, but rather the *reason* and *reasoning given by the
respondents.*

This conception of intention and meaning differs from many
referential, behavioral, and semiotic theories which treat meaning as,
if not divorced from, at the least unconcerned with, implication,
inference, and intention. Basically, we are arguing that a stimulus-
response theory of meaning which concerns itself with tendencies or
dispositions to behave in certain ways upon the presentation of signs
is totally inadequate for a theory of interpretation which takes it as
axiomatic that human symbolic behavior can be communicational
and is concerned seminally with meaning.

Our use of the term *intention* here is quite close to that of Grice
(1957), who says that the statement " 'A meant something by X' is
roughly equivalent to 'A uttered X with the intention of inducing a
belief by means of the recognition of this intention' " and that "not
merely must [X] have been uttered with the intention of inducing a
certain belief but also . . . the utterer must have intended an 'audi-
ence' to recognize the intention behind the utterance."

Verbal language and the grammatical structures through which
all native speakers learn to recognize linguistic form are, in general,
the closest paradigm to the structural recognitions we use to verify
our interpretations of meaning. In other contexts and modes, we may
proceed to very complex strategies, however. We may recognize po-
etic structures such as rhyme, rhythm, and meter, by using other
conventions and rules which we know (such as those of poetry or
music), and proceed from there.

If, to carry our argument further, we wish to explain why any-
one would want to invoke inference as opposed to attribution (clearly
easier, and even more fun) as a way of making meaning from pic-
tures, we should be able to show that signs of implication/inference
are present within the recognized structure of the sign-event itself.
Grice puts it quite precisely when he points out that not merely must
a meaning-event have been articulated "with the intention of induc-
ing a certain belief but also the . . . utterer must have intended an
'audience' *to recognize the intention behind the utterance."* Although this
concept of meaning has most frequently been used to describe mean-
ing in the verbal mode, Grice offers us some particularly instructive
examples from the visual realm which can serve both to clarify my
own arguments as to the assumption of intention and to act as a
bridge between these necessary preliminary concepts of communica-
tion and meaning and the following discussion of the use of the
negative in visual signs.

Compare the following two cases:

(1) I show Mr. X a photograph of Mr. Y displaying undue familiarity to Mrs. X.

(2) I draw a picture of Mr. Y behaving in this manner and show it to Mr. X.

I find that I want to deny that in (1) the photograph (or my showing it to Mr. X) meant anything at all; while I want to assert that in (2) the picture (or my drawing and showing it) meant something (that Mr. Y has been unduly familiar), or at least that I had meant by it that Mr. Y had been unduly familiar. What is the difference between the two cases? Surely that in case (1) Mr. X's recognition of my intention to make him believe that there is something between Mr. Y and Mrs. X is (more or less) irrelevant to the production of this effect by the photograph. Mr. X would be led by the photograph at least to suspect Mrs. X even if instead of showing it to him I had left it in his room by accident; and I (the photograph shower) would not be unaware of this. But *it will make a difference to the effect of my picture* on Mr. X whether or not he takes me to be intending to inform him (make him believe something) about Mrs. X, and not to be just doodling or trying to produce a work of art. [Grice 1957:382–83]

It seems to me correct to say that "it will make a difference to the effect of my picture on Mr. X whether or not he takes me to be intending to inform him. . . ." Grice, however, follows this phrase with what I believe to be a completely misleading final clause: ". . . and not to be just doodling or trying to produce a work of art." Clearly he must mean that a doodle and a work of art are in some way not used for, or are incapable of, carrying signs of intention and meaning. I think that here Grice falls into a habit of thought that has seemed to prevail largely unexamined in both linguistics and the philosophy of language, and assumes that the linguistic mode is capable of meaning and that things called "art" (doodles) either verbal, visual, or musical, are not capable of carrying meaning.

It is clearly beyond the scope of this paper to enter into even a brief review of this academic, or philosophical, sad state of affairs. Some sense of the context within which my own thinking has developed might, however, prove clarifying. I am thinking of concepts about language identified with early logical positivism which not only argued that nonlinguistic expressive modes were inherently meaningless but added to the bag of meaningless activities "poetry" and "art" as well.[3] Much discussion of language in that period was concerned with concepts of Truth and Falsity and with the ways (truth tables) that language made statements that could be character-

3. It was Carnap who urged that unverifiable statements be thought of as merely expressive and not be confused with meaningful statements.

ized as True or False or with the ways in which we can characterize the referents of language as True or False. I am also thinking of that stream of research in linguistics stemming from Bloomfield through Zellig Harris which made such an effort to define language without using the concept of communication or meaning at all.

Art critics, historians, and aestheticians, in particular, were so powerfully influenced by these notions about language that they developed elaborate rationales about what pictures were for, if (as they came to believe) they were in fact meaningless. It was in large part, I believe, in response to suppositions of meaninglessness that modern aestheticians developed theories of pictures as expression, emotion, semblances or structures of emotion, and so on. "Pictures" as a class—differentiated from something labeled "art"—were almost never studied or thought about by art historians, critics, and philosophers of art. Just as the study of language by linguists rarely concerned itself with such things as "poetry" or "literature," so in the visual realm we studied "painting" rather than pictures, "architecture" rather than buildings, and "sculpture" rather than statues. It seems to me that if we are to begin a study of how pictures mean, we must study pictures rather than painting, movies rather than cinema, drawing (on paper as well as walls, by children as well as by adults) rather than graphics, and visual structures rather than composition or design.

It is probably true that the resemblance or correspondence with "reality," and therefore the *recognition* of "representational" or "referential" pictorial signs, occurs on a basic biological level, and occurs earlier developmentally than the recognition of word signs. It would, of course, be quite tempting to argue that pictorial events are iconic in relation to the real while verbal events are symbolic and arbitrary, and that since recognition is easier with pictures, and assumptions of existence are more reasonable with pictures, that therefore attribution naturally follows. Professor Gombrich (1962) has forever spoiled this temptation for us through his analysis of the conventional nature of pictorial "realism." Gombrich shows that it is difficult to take the position that what we call "representational" drawing is in fact representational *because* that's the way the eye sees. What we are concerned with here is an interaction between convention and correspondence. In the case of words, the knowledge of convention seems more important than the ability to recognize correspondence. In the case of pictures, *on the earliest recognition level,* a knowledge of the rules of correspondence seems more important.

As soon as we move beyond this early recognition stage, how-

ever, and begin to deal with communicational meaning and its at-
tendant recognition of order and structure, these differences that
might seem to exist between pictures and words become trivial. As
long as we stay on an attributional-meaning level, questions of repre-
sentation, correspondence, and biological similarity of operation
become the most important dimensions of comparison, and the dif-
ference between the two modes assumes major proportions. When
we move to the symbolically complex levels (as opposed to the bio-
logically complex), these questions seem less important. Methods of
recognizing order and structure in both words and pictures seem to
be similar cognitive processes. The way we perceive such things as
order and structure are, it seems to me, "meta" operations that the
human mind imposes upon both the symbolic and the "real" uni-
verse. It is my position (which I shall not argue here)[4] contrary to, for
example, Rudolph Arnheim, that the world does not present itself to
us directly; that in the process of becoming human we *learn* to recog-
nize the existence of objects, persons, and events that we encounter,
and to determine the strategies by which we articulate, interpret, and
assign meaning with and to them.

Communicational meaning, involving the recognition of order
and structure, is, I believe, similar for words and for pictures. Al-
though it builds on the physical and biological correspondences
between symbolic modes, it is a meta-recognition, a cognition
applicable to all modes as mental operations, rather than as judg-
ments of physical or biological correspondence. I am suggesting that
the recognitions I talk about here are applicable to mathematical,
musical, logical, verbal, and pictorial modes and that the conventions
attendant on communicational meaning (metaphor, rhythm, rhyme,
similarity, repetition, analogy, and so on) may also be found in all
modes.

Not only do we tend to believe that most pictures represent the
world closely (are similar to it), but words in our culture have lexicon
definitions that limit the attributions one can "reasonably" make;
pictures do not.

Parents and grade school teachers socialize our children into the
belief that pictures have few rules for either qualitative judgment or
the interpretation of meaning. It is a rare father who would watch his
son swing at a ball in a Little League baseball game ten consecutive
times without hitting it, and shout, "That's a good boy, Joey. You're
doing great." Yet the same father, upon Joey's presentation of an 8
× 10-inch piece of paper filled with variously colored shapes, will

4. See chapter 4, above.

say, "Say, that's wonderful. What is it—an elephant? How nice." Joey might reply proudly, "No, it's not an elephant, it's a picture of me and Mommy playing baseball, and I hit a home run." "Oh," says the proud father, "that's right. That's great, Joey. Ask Mommy to hang it up."

Not only is the above somewhat bizarre-sounding conversation not unusual for parents and children, it is not unusual *among poets and painters* either. They also recognize the distinction between the two strategies for the interpretation of meaning and often take sides in a prescriptive dispute, demanding that their "audience" employ either one strategy or the other. Although Paul Valery is hardly a typical proponent of the proud father, a child's drawing, or a sandlot baseball game, it might help to clarify my point about the similarity of words and pictures in terms of communicational meaning to quote Picasso arguing with Valery on the distinction I am proposing.

> Valery used to say, "I write half the poem. The reader writes the other half." That's all right for him, maybe, but I don't want there to be three or four thousand possibilities of interpreting my canvas. *I want there to be only one* and in that one to some extent the possibility of recognizing nature, even distorted nature which is, after all, a kind of struggle between my interior life and the external world as it exists for most people. . . .
>
> Otherwise a painting is just an old grab bag for everyone to reach into and *pull out what he himself has put in.* I want my paintings to be able to defend themselves, to resist the invader, just as though there were razor blades on all the surfaces so no one could touch them without cutting his hands. A painting isn't a market basket or a woman's handbag, full of combs, hairpins, lipstick, old love letters and keys to the garage. [*New York Times,* 9 April 1973]

Note that one can substitute *poem, novel, symphony, dance,* or any other symbolic form for the word *painting* above. No artistic implication should, as Picasso sees it, become a grab bag for everyone to reach into and "pull out what he himself has put in."

On an attributional-meaning level, however, the listener may indeed be able to do as Valery hopes; write half, three-fourths, seven-eighths, or any and all proportions of any work. He may, if we do not constrain attribution by personality and culture, put anything into a work and happily extract anything out of it. On a communicational level, on the other hand, the reader (again within some constraints of form, content, and so forth) does not write any part of the poem, any more than the viewer paints the picture or makes the film. The reader (viewer), if he can participate in a communications event, recognizes the work's structure, assumes an intention to mean on the

part of the creator, and proceeds to his extremely complex job of making inferences from the implications he can recognize.

What is it, then, that pictures cannot do that words can do? Not only are words able to deal with negatives, but some linguists (for example, Sapir 1921) have speculated that the ability of words to deal with what is *not* is one of the central functions of language. Pictures, I shall argue, cannot deal with what is not. That is, they cannot represent, portray, symbolize, say, mean, or indicate things equivalent to what verbal utterances of the type "This is not a . . ." or "It is not the case that . . ." can do.

On a trivial level, we can construct picture symbols or signs with negative meanings that resemble language, as do some parts of Egyptian wall paintings or other hieroglyphic forms; "languages" for traffic signs and advertising have been developed which have wide usage across verbal language groups. A red crossbar over any image means "forbidden," or "do not," so that a crossbar across an image of a car means "no cars," and so on. These uses in posters, traffic signs, and even price tags are not *pictorial* uses but rather *linguistic* uses of visual forms which become sign elements in a special language. They differ from what Gombrich (1961) calls a schema for picturing. In that sense, we are talking about *ways of picturing,* ways of structuring the universe through visual symbolic forms. In the former, trivial, sense we are talking about *specific pictures* or visual forms to which we assign some particular lexical meaning or function. The crossbar becomes a stimulus sign to which birds, dogs, and other animals, as well as man, can be conditioned to respond.

In some sense, also, every positive or existential statement carries along with it the statement that it is not any other. The statement "this is a cow" or "I am a man" carries within it the conventional understanding that "this is not something that is other than a cow or other than a man," or, more exactly, "this is not a noncow" or "not a nonman." So also does a picture of a cow or of a man carry along with it the knowledge or understanding (in this culture at least) that it is not a picture of something else. Again, I believe that this aspect of pictorial negation is trivial.

However, on a value level, what is pictured is often valued precisely for what it negates by *leaving out*—so that in modern art it is possible to be *non*representational, either by being *non*objective or by being an abstract expressionist. In music, I suspect that certain notes are expected in certain codes. In earlier periods, depicting vulgar images was a rejection, and in that sense a negation, of other

conventions and prescriptive rules. We therefore can, by means of our rules of picturing, accept as negations the *absence* of such social concepts as representation, illustration, sentiment, imitation, contrivance, vulgarity, nobility, dynamism, and so forth.[5]

I have introduced the value level not because I wish to make a point of evaluation, but to make a point about "meta" levels of interpretation. When we make judgments about what a picture-maker did not do, as well as upon what he did do, we make a judgment based upon our knowledge of choices that the picture-maker had available to him, both as psychological individual and as a member of a society performing a social act. We do not, however, make these judgments based solely upon what is in the picture itself. For example: in looking at *The Raft of the Medusa*, we "know" that Gericault could not picture "I am *not* at home in my comfortable easy chair." He could paint the picture he did and expect us to recognize that, but *everything else* is not happening on the *Raft of the Medusa*. A picture-maker cannot specify, out of all the things that his picture does *not* show, which he means to say are not the case. There is no pictorial means that a painter has of indicating that a color, a shape, or an object is not something, or anything, else. All that pictures can show is what *is*—on the picture surface.

It is for that reason that it seems reasonable to argue that True-False criteria cannot be applied to pictures and that, further, pictures cannot be said to "make" propositions. We say of verbal statements that they are "not true" or are "false," or even are "full of baloney." We rarely if ever, in ethnographic fact, talk that way of pictures.

Let us then first examine what we do say of pictures on a continuum of correspondence to something called "reality." On one end of this continuum, we have the motion picture/television image, a supposed correspondence to reality, in color, with motion and sound. At the other end we have the picture of the abstract expressionist or perhaps even that of the conceptual artist who uses only words and produces no picture at all. In between, we have paintings in a variety of styles and conventions, such as caricatures, cartoon strips, or the sort of abstractions produced by Picasso and Braque that imply some correspondence with the "real" world, but portray that correspondence in nonrepresentational ways, or in less representational ways than do photographs or movies.

Let us also examine how people actually talk about hand-produced, as opposed to machine-made, pictures. At one end of the continuum of hand-produced pictures—the abstract, nonrepresenta-

5. For an interesting discussion of this issue, see Gombrich (1963a).

tional spectrum—a viewer not versed in conventions of abstraction might say that such pictures are "silly," "make no sense," "are not understandable," and so on. Our unsophisticated viewer will almost never say that a Picasso is false or that a Phillip Guston (in his abstract-expressionist period) is false. Hand-produced pictures, a viewer "knows," are somehow supposed to correspond to some concept he has about reality. If pictures do not correspond or are not judged similar enough to this "reality," the picture-maker is judged to be inept, a child to be humored, a "modern" artist to whom attention need not be paid, or some other form of incompetent or deviant. Rarely, however, is such a person considered to be a liar. Rarely is he understood to be deliberately trying to lie to the viewer. Unlike words, pictures may be thought to show it the way it is, but pictures are rarely thought of as telling lies in the way that words do.

The cliché has it that pictures cannot lie, and this is, even today, a largely acceptable statement, albeit with confusing counterexamples which lead to all sorts of angry responses that I shall deal with below.

In the case of Pollock, the unsophisticated viewer makes judgments of both deviance and incompetence, often saying, "He's crazy!" and, "Why, he can't even draw a face!"

In machine-made pictures—photography and film—we have supposed a value-free picture producer. It (the machine) tells neither truth nor falsehood but, again, tells it "like it *is.*" The machine is to be trusted to produce an image that corresponds to that portion of the world to which it is pointed. What happens when you see a photograph of a familiar face and you fail to identify the subject of the photograph? Contrary to how you would act if it were a painted portrait, you do not doubt either your ability to identify the face nor the honesty of the *photo-taker* who said that this was a photograph of someone you know. You blame "reality," *"the photographer,"* or the machine and the process. In the first case (let us say it was a photograph of your wife) you might say, "She doesn't look like herself these days," or "From that angle (in that light), she just doesn't look like herself." If you blame the picture-taker, you might assign some of the same reasons as his fault: "You should know better than to take a picture of Mary from that angle." The comment, "It's so underexposed that you can barely see anything" is another way that the picture-taker receives the blame when instant recognition does not occur. In the last case, when the process is at fault, you may get comments ranging from "What can you expect from a dumb machine!" to "You have to spend so much time fiddling that you have no chance to think about the person you're taking a picture of." In

some studies of home moviemaking and exhibition, as well as snap-shot albums and commentary about them, Chalfen (1975) found that most commonly, negative evaluations blamed the mechanical aspects of picture-making, rather than the human. If a photograph was over- or under-exposed, "that stupid exposure meter" was to blame, and if the heads of people or other important parts of the picture are cut off, "that stupid viewing system" or "these lousy cameras" were to blame.

All of this is based, of course, on an assumption of intention to portray and depict a scene that corresponds to that which the camera was pointed at. If we assume another intention, we have a choice of an intention to produce "art," or a deliberate attempt to produce a product that will fool us. I have already discussed, in the section on Grice, the possibility that art and "doodles" are equivalent in relation to some concepts of meaning. But what about an intention to trick or fool us—an intention to show it the way it isn't—and to make us think that is the way it is?

If we ask people what a "false photograph" is, almost everyone immediately asks, "You mean a fake?" A photograph that doesn't correspond (in the accepted way) to reality is not a lie, because we tacitly "know" that the medium has no conventionalized procedure for stating lies. The only way a photograph can be understood not to correspond to reality is when we change something in a *hidden,* secret, and hence tricky, manner. If I superimpose a picture of the honest senator who swears he didn't know the gangster upon a scene of the gangster having dinner with his cronies, so that it appears that the senator is toasting the gangster, I have produced not a lie but a fake. The attributions one might make from such a photograph would be empirically false, but the picture would in all respects correspond to what it would look like if the senator had been there. If I paint a picture of one woman (Mrs. A) and present it to a viewer as a picture of another (Mrs. B), it is not the picture that lies, but the picture presenter.

A movie of a boy with green hair is also not seen as a lie, and barely as a fake; it is mostly admired as a clever manipulation. It falls into the realm of fantasy, rather than fake, but is not judged by criteria of truth or falsity. *In a very deep sense, I am suggesting that the real world is symbolically inviolate.* If noncorresponding messages about it are made verbally, they are either mistakes, lies, or false statements. If noncorresponding pictures are produced, they are "fakes" or "tricks." The real world *is,* and is in a sense that supersedes symbolic manipulation. We would rather change our concept of the "real" to match our images or myths, if need be, but in any event we rarely allow a

conflict between a pictorial symbol and "reality" to go on for long.

If we are faced with a conflict between that which a picture shows and that which we know cannot be the case, we do not shout, "Lie!" but instead say firmly, "It cannot be so." The case of the so-called "impossible figures" of Penrose and others offer us an almost perfect paradigm for how we treat noncorresponding pictures (figure 7-1). They are in fact "impossible." Gregory (1970) has confounded the issue further. Almost all impossible figures are drawings. Gregory has provided us with a *photograph* that purports to be the figure in figure 7-1. When this photograph is shown to a class of high school students who have listened to a lecture on perception, we find two responses: one is anger, and the other is a happy demand for an explanation of "how that trick photo was done."

The angry response is a common one; it is not the anger of someone who has been lied to, but the anger of someone who has been tricked. It is an anger that I call *media rage.* It occurs with greater and greater frequency as artists in all modes of symbolic activity— painting, moviemaking, television, novel writing, and news reporting —are trying more and more to explore the distinctions between the real world and their symbolic world. In a movie such as *W. R.: Mysteries of the Organism,* Makavejev, the Yugoslavian master, uses old documentary films, current documentary films, and old as well as current reenactments of public and private events. He has photographs of Stalin and photographs of actors playing Stalin intermixed and so juxtaposed with current acted and documentary footage that it is

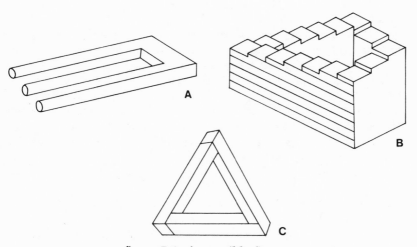

figure 7-1 impossible figures

almost impossible to tell which is which. Many members of the audience, particularly in socialist countries where such experimentation is relatively new, become quite angry.

In America, the film *Medium Cool*, which mixed acted and documentary footage in ways never before attempted, created genuine rage on the part of many audiences. They felt that this film went beyond trickery. Mixing actors and the riots at the 1968 Democratic Convention in Chicago in a way designed to make an acted plot seem real, or to make reality seem like acting, was not "right." The schemata of movie representation demands clear separation between that which is to be thought of as acted or unacted. We want to be able to say that an acted film was almost real enough for us to believe, but we want a performance, not confusion. We must be able at all times to "know" the difference.

Again, in films such as *Medium Cool*, the audience's response is not that the film is, or tells, a lie, or that the film is false. The response of many people is that the images on the screen are impossible. What they see before them cannot be. The feeling of "cannot" is so strong that many people move without thinking from "cannot" to "should not." And thus, it seems to me, their anger. I have seen the work of Escher responded to in the same way. If one cannot take pleasure in the manipulation and the creation of a structure that *cannot be*, one tends toward nonacceptance of the medium, or genre, itself as legitimate, and thus may become angry.[6]

Pictures, as we understand them in this culture, depict, or picture, what is. They are, in a visual mode, somewhat similar to the verb "to be" in its existential, not veridical, sense. Pictures, however, cannot depict conditionals, counterfactuals, negatives, or past-future tenses. Neither can they make passive transformations, ask questions, or do a host of things that a verbal language is designed to do. Pictures depict the present even when they depict fantasies such as fairy godmothers, myths, unicorns, and gods. When a picture depicts the star Venus, its context (day or night) might help us to label it the "morning star" or the "evening star," but the classical problem of the referential meaning of morning stars is not involved when we deal with pictures. Instead we may wish to ask how the context of the picture affects our labeling of that particular star. That is: how dark or how blue must the sky be for the star to be "morning" or "evening"?

Since pictures do not have the formal capability of expressing

6. See Chukovsky (1963), who points out a similar response: the anger of adults at children's fantasy verse.

propositions of negation, it follows that pictures cannot be treated as meaningful on a dimension of truth and falsity. If pictures cannot depict the proposition that something is not so, or is not the case, it would hardly be reasonable to suggest that pictures are designed to depict only those things that *are* the case.

What then do pictures depict? It seems that all we can say is that *what* they depict *is*. *They depict events for whose existence they are the sole evidence.* Pictures in and of themselves are not propositions that make true or false statements, that we can make truth tables about, or that we can paraphrase in the same medium. Pictures, it must be remembered, are not representations or correspondences, with or of, reality. Rather, they constitute a "reality" of their own.

But if pictures are not propositions, and not even representations, and if pictures cannot be dealt with on True-False dimensions, how then are we to deal with them? What is the "logic" by which meaning is interpreted from pictures? Leaving aside attributional strategies, from which, as we have seen, any meaning may be made, how do we understand the logic by which implications are made and inferences drawn? By removing the propositional property from pictures, I seem to have removed the possibility of grammar or syntax as we know it.

Truth tables can only be constructed for sentences. What are sentences in pictures? Logical syntax requires precisely defined connectives such as "and," "either . . . or," "if . . . then." Is there anything like that for pictures? I am suggesting that the basic difference between words and pictures lies in the fact that our use of speech is based upon a convention that requires a clearly defined syntax which allows us to articulate propositions about truth or falsity, while our use of pictures, on the other hand, is based upon conventions which, while linguistic in nature, have no clearly defined syntax, no ability to articulate propositions (and therefore no ability to depict negation), and no ability to make "meta" statements about lower-level statements of the picture system. A picture cannot comment on itself. A picture cannot depict "This picture is not the case," or "This picture is not true."

Before continuing, I must digress, or at least stop for a moment, to consider the argument that although pictures cannot deal with negation, they can deal with something called truth. Let me briefly mention some of the arguments that lead me to feel that the subject is indeed a digression, although much attention has been paid to this issue (Price 1949; Urban 1939; Reid 1964; Casey 1970).

The theory that there is truth in pictures usually rests on the argument of correspondence, and correspondence usually means ei-

ther similarity or correctness, or both. The notion of similarity rests to a large extent on the iconic-digital distinction between pictures and speech. Even linguists, in recent years, have given up their certainty about the arbitrariness of linguistic symbols (Friedrich 1974). Semioticians, art historians, anthropologists, and psychologists have also come to realize that a "copy" theory of pictures is simplistic, misleading, and probably just plain wrongheaded. A look at Chinese painting or another look at figure 7-1 should make the weakness of the copy, or similarity, theory of picture-making obvious. Truth is not to be found in that direction.

Second, similarity is not, and cannot be, necessary to correspondence.[7] A conventionalized code (the Morse code) can make dots and dashes correspond to letters of the alphabet, although their degree of likeness to letters is very small and their degree of similarity to the sounds of speech is almost negligible. Thirdly, similarity is an almost impossible criterion of correspondence. Similarity, or verisimilitude, asks that we match one thing (the picture) against another. How close a match makes a match? Clearly only a picturing convention or schema can tell us whether the picture is similar to something in reality.

If we take correctness as our criterion for correspondence, we fall into a set of problems that confuse, rather than clarify, the issue. Here we usually mean scientific correctness, or accuracy. As a matter of speech, we refer to "accuracy" colloquially as "scientific truth." Science carries high status and is the closest approximation we have to a method of determining something called empirical truth. But in order to be correct, we must have a measure, a standard. We must have something to measure against. "Reality" is too vague. Do we compare to a standard of our eyes—what we see—or to our cognitive capacities—what we know? In either case, we are again confronted with conventions, rules, and schemata. If we pass that problem, we find ourselves back to the problem of nonrepresentational pictures and what they correspond to. Truth, as it concerns pictures, is indeed a digression.

Pictures and speech are different precisely because pictures are not a language in the verbal sense. While words mean, primarily or basically, because of lexicon and syntax, pictures have no lexicon nor syntax in the formal grammarian's sense. And yet I am suggesting that we can interpret meaning from pictures. It is clear, however, that

7. I have relied heavily on the excellent review of this concept that appears in Casey (1970). His final conclusions, it should be noted, differ markedly from mine.

if pictures have no grammar in the strict linguistic sense, they have something like it: they have form, structure, convention, and rules. It is clear that even though a theory of correspondence is not sufficient to deal with truth in pictures, pictures must nonetheless correspond to something. Even the most un- or non-representational painting must refer to something, or it would make no sense at all. Although attributional strategies are convenient for the unskilled, no picture-maker likes to think his picture is totally up for grabs.

Earlier I suggested that the strategies we employ to interpret meaning from pictures—that is, *how* pictures mean—are largely responsible for *what* pictures mean. I suggested that if we use attributional strategies, pictures can mean almost anything. The limits placed upon our interpretation in attributing meaning are dependent mainly upon our individual psychological, social, and cultural histories. These histories interact with the sociocultural limitations we place upon what may be interpreted from pictures in specified contexts.

If, on the other hand, we use communicational strategies, a particular set of meanings can be developed for pictures, as well as for that which we have often defined as "art." In general, what we imply and infer through pictures are, first, an existential awareness of particular objects, persons, and events that are ordered, patterned, sequenced, and structured so as to imply meaning by the use of specific conventions, codes, schemata, and structures. And second, in what Larry Gross (1973) has termed the *communication of competence,* pictures, more than speech, and perhaps like some of the special modes or codes such as poetry, the sonata, or the story, communicate the competence and skill with which their structures have been manipulated according to a variety of rules, conventions, and contexts.

I have briefly outlined earlier why I think the notion of matching to the real world is insufficient to explain how pictures mean. Now I can say that I don't believe this is what one matches pictures to at all. Correspondence, if it makes any sense as a concept, is not correspondence to "reality," but rather correspondence to conventions, rules, forms, and structures for structuring the world around us. What we use as a standard for correspondence is our knowledge of *how people make pictures*—pictorial structures—how they made them in the past, how they make them now, and how they will make them for various purposes in various contexts. We do not use as our standard of correspondence *how the world is made.*

Our notions of correspondence, of similarity, and of correctness in the meaning of pictures are evidenced more in statements such as "That's a movie?!" "That's no mural!" and "I don't even call that a

picture!" rather than by statements such as "That's not true," "That's a false picture," or "That picture means that it is not about a sunset." What we mean when we say "That's not a movie" is that the articulated symbolic event before us does not correspond to our conventionalized knowledge of the way signs in movies are manipulated in our society. In effect, pictures are a mode that best communicates a dialogue with the "real" world that Picasso called "a proposition to the viewer in the form of traditional painting violated." "I want," he continued, "to give my work a form that has some connection with the visible world, even if only to wage war on that world" (*New York Times,* 9 April 1973). That dialogue in the form of traditional painting violated is similar to what some painters have meant when they said that painting was about painting, and what Malraux meant when he said that painters did not copy nature: painters copied other painters. Pictures, in this sense, picture conventions, forms, structures, and so forth. Pictures are a way that we structure the world around us. They are not a picture of it.

Although pictures do not have a grammar by which to structure how the world is, they are clearly not without forms, genres, styles, conventions, rules, and systems of usage. The concept of the "language of pictures," the "grammar of art," the "syntax of the cinema" must be understood as a metaphor, at best. In another paper (chapter 1) I have discussed the problems of describing a film grammar and have shown that certain concepts that make sense in speech or verbal usage are simply not used in motion pictures. Notions of "grammaticality," "native speaker," "paraphrase," and grammatical or syntactic transformation, while powerful enough to be forced into applicability in relation to almost all symbolic usage, actually make very little explanatory sense when applied to pictures. We can always say of pictures that grammaticality refers to that set of rules that allows even an unsophisticated viewer to "know" that a drawing is unacceptable because the perspective is "not right." We can stretch the concept of grammar to say that the recognition of "impossible figures" demands a native speaker's knowledge of the grammar of visual representation. To some extent, of course, an ability to interpret perspective is necessary in order to infer meaning from a perspective drawing, but it seems to me to be a distortion, or at least not very helpful, to refer to such conventions as perspective as a language or grammar of pictures.

It seems to me rather that pictures operate both within the framework of language knowledge *within us,* and outside the framework of language *in itself.* That is, the pictorial mode (from drawing to motion pictures) does not have a rigorous set of rules employing

a lexicon, a grammar, an ability to construct paraphrases, or an ability to produce translations within its own formal devices. But we, the viewers, do have a *faculté de langage* in general, about all symbolic materials, so that in motion pictures, for example, where sequence and time become parameters to be manipulated, we can instantly bring to bear linguistic rules for implication and inference. In other research (Worth and Adair 1972) I have shown that people who are native speakers of Navajo will frequently use Navajo syntactic rules as justification for the structuring of films that they themselves have photographed and edited.

Metz (1970) has shown quite convincingly that the acceptability of film content most often depends on its adherence to film convention rather than on its adherence to "reality." For example, a shopgirl is depicted in films in a certain way. Everyone "knows" that real shopgirls do not look or act that way. If a real shopgirl were to be cast in a film, we might recognize her correspondence to life, but would reject her because of noncorrespondence to film. What we call "true to life" must be a stereotype if it is to be recognized, and therefore becomes the least, rather than the most, valued as "art."

What is communicated by pictures, then, is the way picture-makers structure their dialogue with the world. What is meant by pictures, when we use a communicational strategy of interpretation, is how we should put the pieces together. First, as in figure 5-2 (see chapter 5), we recognize some object, person, or event in movies. It may be a "tree," or a "man." In a painting, it may be a representational object, or a color, shape, or juxtaposition of elements. We can, and many people often do, stop right there. They start attributing—putting onto and into the picture. Others, however, are able to go further, both in the articulatory as well as the interpretive process. They recognize and can articulate structure, assume purposeful manipulation and, therefore, social behavior, and treat that manipulation as a set of instructions by which meaning may be inferred.

When people are speaking, participants are able to be speakers as well as listeners. In picture-making, as in reading novels, "dialogue" or "discussion" does not exist. What we appreciate is the manipulations that the picture-maker or writer performs on his materials and our ability to recognize and to understand the conventions, rules, styles, and usages within which his particular dialogue with the world has been carried out and in which we may share.

To sum up then, I have tried, in this paper, to begin an exploration into how and what pictures mean—by themselves, as particular modes of symbolic event, and in comparison to the verbal modes. I have described a method for discussing what symbolic events mean

through the use of a communicational as well as an interactional strategy for the interpretation of meaning. In comparing speech and pictures, I have argued that on the communicational level, the major differences lie in the fact that pictures provide for the articulation of existential rather than veridical events, and that therefore pictures cannot provide us with propositions or propositional statements; that pictures do not have the formal capability of depicting negative events, and that therefore the dimension of truth or falsity is a fairly useless dimension with which to think of and about pictures. I further argued that therefore the meanings implied and inferred from pictures cannot be on a true-false continuum but rather on an exist–do-not-or-cannot-exist (impossible) continuum.

I then argued that if the way in which pictures mean is thought of as either interactional or communicational, an interactional strategy makes it possible to have any picture mean anything, while communicational meaning was primarily constituted by an interpretation of competence in the presentation of a dialogue between picture event and "reality" concerning the very act of structuring that reality.

Neither of these strategies of pictorial interpretation, it seems to me, is or can be formally concerned with truth or falsity. Speech and verbal behavior, on the other hand, may not always be concerned with truth or falsity but are formally and socially designed to be so.

A semiotic of pictures, then, must begin to describe the structures by which visual communication, in its many codes and modes, presents its own unique dialogue with the world.

eight
margaret mead and the shift from "visual anthropology" to the "anthropology of visual communication"

I would like, in this discussion, to explore a shift in how certain problems in the study of culture have come to be conceptualized.[1] These problems may best be understood by examining how one label, "visual anthropology," led to the creation of another, "the anthropology of visual communication." In order to delineate and examine some of the arguments, problems, and methods involved in this shift, it will be helpful for me to cite, and to use as my explanatory fulcrum, the work as well as the persona of Margaret Mead.

I am doing this on an occasion meant to honor her, but am aware that even that act, as so often happens with Dr. Mead, inevitably gets mixed up with a review of the history and problems in communications and anthropology. I should add that I am aware that even as we try to develop a history in this field, we also *are* in many ways that same history.

To introduce some of these issues in the history of communications study, let me quote from an informant whose comments and life history may lay the groundwork for certain of the problems I will be talking about. Some of you may still remember a television series of several years ago called "The American Family." It consisted of

1. This paper was presented at a symposium honoring the work of Margaret Mead at the annual meeting of the American Association for the Advancement of Science (1976) and published in *Studies in Visual Communication* 6:1 (1980):15–22—Ed.

twelve one-hour film presentations. One of the major participants in that visual event was Mrs. Patricia Loud, the mother of that "American" family. In a letter to some of her acquaintances which she subsequently made public, Mrs. Loud wrote:

> Margaret Mead, bless her friendly voice, has written glowingly that the series constituted some sort of breakthrough, a demonstration of a new tool for use in sociology and anthropology. Having been the object of that tool, I think I am competent to say that it won't work.

Later in her letter she continues:

> Like Kafka's prisoner, I am frightened, confused. . . . I find myself shrinking in defense, not only from critics and detractors, but from friends, sympathizers and, finally, myself. . . . The truth is starting to dawn on me that we have been ground through the big media machine and are coming out entertainment. The treatment of us as objects and things instead of people has caused us wildly anxious days and nights. But I would do it again if, in fact, I could just be sure that it did what the producer said it was supposed to do. If we failed, was it because of my family, the editing, the publicity, or because public television doesn't educate? If we failed, what role did the limitations of film and TV tape play? Can electronic media really arouse awareness and critical faculties? Did we, family and network alike, serve up great slices of ourselves—irretrievable slices—that only serve to entertain briefly, to titillate, and diminish into nothing? [Loud 1974]

Margaret Mead did not photograph, edit, or produce this visual event that Pat Loud speaks of. But in ways that I will describe, she can be understood to be a major influence in this and other attempts to show a family in the context of television. More importantly, her work over the past fifty years can help us to understand many of the questions that Pat Loud's cry of distress raised for her.

There are, it seems to me, at least three basic premises which Mrs. Loud's letter forces us to examine. First is our deeply held and largely unexamined notion that all or most photographs, and, in particular, motion pictures, are a mirror of the people, objects, and events that these media record photochemically. Second is the questionable logic of the jump we make when we say that the resultant photographic image could be, should be, and most often is something called "real," "reality," or "truth." A third concern, which is central to Pat Loud personally, and increasingly to all people studied or observed by cameras for television, whether for science, politics, or art, is the effect of being, as she puts it, "the object of that tool."

When "The American Family" was first shown on American

television in 1972, mass media critics, psychoanalysts, sociologists, and historians, as well as *Time, Newsweek,* and the *New York Times,* felt compelled to comment. Almost all—except Margaret—expressed dismay, upset, and even anger over the series. Many of these strong feelings were no doubt occasioned by the films themselves—by the way they were advertised and presented, as well as by the events depicted in them. But much of the upset was also caused, I believe, by the fact that Margaret Mead said publicly, and with approval, that this notion of depicting a family on television was a worthwhile, revolutionary, daring, and possibly fruitful step in the use of the mass media. She even compared the idea of presenting a family on television to the idea of the novel, suggesting that it might, if we learned to use it, have a similar impact upon the culture within which we live.

Interestingly enough, in October 1976 the United Church of Christ, the Public Broadcasting System, and Westinghouse Television will present a series titled "Six Families," in which the same thing that was tried in the Loud family series will now be done on a comparative basis. It seems that most of the objections of social scientists to the Loud family series were that this use of "real" people on TV was unethical, immoral, and indecent. It made, many people argued, a nation of prurient Peeping Toms out of the American people. It is, of course, "the church" which in our society can take initiative and argue that an examination of how people live, shown on TV, is not only not Peeping Tomism but the most moral kind of act for a mass medium. We will have to see whether social scientists, TV critics, and newspapers will even notice this second instance of the presentation of an American family on television.

The problem for those who heard or read what Margaret Mead said about this new use of film, whether they were academics, newspaper people, or even subjects, was that we were just beginning to understand what Bateson and Mead had said in 1942. We were just beginning to accept the idea that photographs could be taken and used seriously, as an artistic as well as a scientific event. We were not ready to acknowledge that we were beyond the point of being excited by the fact that a camera worked at all. It was, after all, understood as early as 1900 that photographs and motion pictures could be more than a record of data and that they were always less than what we saw with our eyes. Let us look at how it started.

The first set of photographs called motion pictures was made by Eadweard Muybridge in 1877, as scientific evidence of a very serious kind. He invented a process for showing things in motion in order to settle a bet for Governor Leland Stanford of California about

whether horses had all four feet off the ground when they ran at a gallop. Our popular myth about cinema and truth started here. If the motion picture camera showed it—everyone seemed to, and wanted to, believe—it had to be so. Edison in the United States and Lumière in Europe invented more sophisticated machines for taking motion pictures, and, interestingly enough, the first films made with those primitive motion picture cameras between 1895 and 1900 had much of the spirit of what is still called ethnographic filming. They presented what the early filmmakers advertised as "the world as it really was." Lumière's first film showed French workers in the Peugeot auto factory outside Paris lining up to punch a time clock. Edison's first film showed his assistant in the act of sneezing. Both Edison and Lumière went on from there to depict other "real" and "documentary" scenes of people walking in the street, bathing at the beach, eating, embarking on a train, and so on.

The issue of reality in film was already being argued in 1901, not by scientists or artists but by film manufacturers. The Riley Brothers catalogue of 1900–1901 states:

The films listed here are the very best quality. They are clean and sharp and full of vigor. They are properly treated in the course of manufacture and do not leave the celluloid. None of the subjects have been "faked." All are genuine photographs taken without *pre-arrangement* and are consequently most natural.

The notion of a systematically made ethnographic record of the geographic and physical environment of a city, in a style conforming to ideas promulgated by Collier (1967), was also being advertised and sold in 1901. The Edison catalogue for that year states:

New York in a Blizzard. Our camera is revolved from right to left and takes in Madison Square, Madison Square Garden, looks up Broadway from south to north, passes the Fifth Avenue Hotel and ends looking down Twenty-third Street.

Such a film could have been made with an ethnographic soundtrack on instructions given to modern ethnofilmmakers by archivists in the United States and several countries in Western Europe.

We have, it seems, come a long way from the days when just being able to make a picture (moving or still) of strange or familiar people in our own country or people in far-away lands doing exotic things was excuse enough for lugging a camera to the field or to our living rooms. In those earlier times, from 1895 to about 1920, the

term *visual anthropology* had not yet been coined. People just took pictures, most often to "prove" that the people and places they were lecturing about or studying actually existed. In some cases, they took pictures so that when they returned to their own homes they could study, in greater detail and with more time, what these people and things looked like. Archaeologists quite early (around 1900) began to use this new miracle machine. They found the camera not only quicker than making copy drawings of the artifacts they uncovered, but more accurate—truer to life, or to artifact. I believe that it was from the use to which archaeologists put photographs that cultural anthropology developed its first, and still extremely important, conceptual paradigm about the use of pictures: that the purpose of taking pictures in the field is to show the "truth" about whatever it was the picture purported to be of: an arrowhead, a potsherd, a house, a person, a dance, a ceremony, or any other behavior that people could perform, and cameras record, in the same spatial frame. The subtle shift that took place when we expanded on the role of photography in anthropology and archaeology, from the use of a photograph of an arrowhead or a potsherd as evidence of existence to the use of a photograph of people as evidence of human behavior, is a particularly important and unexamined aspect of the history of social science, and especially of the history of anthropology.

A conceptual difficulty that we now face results from the fact that the avowals of truth in photography made in the 1901 film catalogues now seem self-evident to us. In fact, a major problem in thinking about the use of photography in social science today is not that photographs are not true, but that that is not the purpose we use them for. One of the clearest expressions of this dilemma, and one that shaped much of my own thinking about the uses of photography in social science, can be found in the appendix to *Growth and Culture* (1951), by Mead and MacGregor, based on the photographic work of Bateson and Mead in Bali. Mead writes:

Anthropological field work is based upon the assumption that human behavior is systematic . . . that in such research the principal tool is consciousness of pattern [and] that the anthropologist brings to this work a training in the expectation of form.

Mead then explains how the photographs taken in Bali were used. Of some 25,000 still pictures taken by Bateson, 4,000 were chosen, from which MacGregor, Mead, and the Gesell group could find a set of patterns derived from a study of photographs—not from the photographs themselves—which could then be compared with pat-

terns found in the study of American children. It is important to emphasize Mead's subtle but powerful distinction: the patterns of behavior in this case were derived from the study and analysis of the photographs, not from the photographs as a magic mirror of pattern. Mead states quite clearly: "These photographs are designed not to *prove,* but to *illustrate. . . ."*

In effect, what Mead has been trying to teach us is what one of her teachers, Ruth Benedict, taught her: "patterns of culture" are what we are presenting when we do anthropology; and taking photographs, or looking, or taking notes are tools for articulating and stating the patterns that we, as anthropologists, wish to show to others. It is that old lesson about culture which we seem not to understand as it affects our use of the photograph. Somehow, our myth system about photographs helps us to forget that the photograph is not the pattern. Somehow we tend to think of a photograph not as something we use—as evidence, to illustrate pattern, to inform ourselves, or to make statements with—but as something we call "truth" or "reality."

One should distinguish between the photograph as a record *about* culture and the photograph as a record *of* culture. One should also distinguish between using a medium and studying how a medium is used. In terms of the camera, the distinction I want to emphasize is that between the scientists' use of the camera as a tool to collect data about culture, and studying how the camera is used by members of a culture. This distinction is, I feel, central to understanding the work done with this medium of communication in the last eighty years. On one level, the photograph is an aide-mémoire to the scientist, equal to his pencil, notebook, or typewriter. It is not—as we now know, from recent work by Chalfen (1975), Ruby (1975), and others— merely a bunch of snapshots or home movies made by an anthropologist. In the hands of well-trained observers, it has become a tool for recording, not the truth of what is *out there,* but the truth of what is *in there,* in the anthropologist's mind, as a trained observer puts observations of "out there" on record. Photography, as a record about culture, spans the distance from the casual snapshot, which reminds one of what a house or an informant looked like, to the systematic work of a Mead, a Bateson, or a Birdwhistell. And here I must emphasize that it is not their photography that is important, but their analysis of it. The reason their photographs and films are records is that they were taken in ways which allowed them to be analyzed so as to illustrate patterns observed by scientists who knew what they were looking for.

Let us now turn to the second level of analysis: the analysis of

photographs and films as records of culture—as objects and events which can be studied in the context of the culture within which they were used. The photographs and films analyzed in this way are understood to be parts of culture in their own right, just as conversations, novels, plays, and other symbolic behavior have been understood to be. Here I am talking about looking at how someone takes a photograph or puts together an advertisement, as well as how he makes a movie. One is concerned at this level, for example, with finding patterns of moviemaking used by anthropologists, physicists, and Hollywood entrepreneurs, by college students, by "artists," by people using 8-mm. cameras in our own culture, as well as by Navajo Indians or members of any other group who are making photographs or movies for purposes of their own.

Here one looks for patterns dealing with, for example, what can be photographed and what cannot, what content can be displayed, was actually displayed, and how that display was organized and structured. Was it arranged according to how these people tell stories? To how they speak, or to the very language and grammar that they use? Recent work by one of my students, Earl Higgins, seems to indicate that even among the congenitally deaf, the "grammar" and related patterns of their sign language influence how speakers of American Sign Language structure films that they make.

Here again, although Margaret Mead was not the first to think of examining photography and films in this way, she articulated the ideas and related them to an understanding of culture in a larger and systematic way. Mead, in *The Study of Culture at a Distance* (Mead and Metraux 1953, based on work done in the 1940s), pulls together the work of a larger group of people who were using symbolic events produced by members of a culture to find patterns of that culture.

"Films," she wrote, "being group products, have proved to be more immediately useful for the analysis of culture than have individual literary works." In this book she included the first set of systematic analyses of films by a group concerned with looking for cultural forms and the patterns evidenced in them. This work provided a cornerstone on which almost all the content analysis of our current mass media rests.[2] The development of the Cultural Indicators program (Gerbner 1972; Gerbner and Gross 1976) and the ongoing analysis of mass media, and particularly of TV content, are the fruits, it seems to me, of one direction developed from the notion that

2. For a more detailed exposition of the relation of content analysis to the analysis of culture through pictures, see introduction to Erving Goffman's "Gender Advertisements" in *Studies in the Anthropology of Visual Communication* (Worth 1976: 65–68).

the photograph, in still or motion picture form, can be a record of culture in its own right, to be studied for its own patterns within specific cultural contexts.

The term *visual anthropology*, coined after World War II, became associated with conceptualizations keyed to using cameras to make records about culture. Visual anthropology did not connote the study of how cameras, and pictures in general, were used within the context of a culture. The term did not seem to connote studies that led us to ask what we could learn about a culture by studying what the members of a society made pictures of, how they made them, and in what contexts they made and looked at them.

The idea of modes of symbolic communication designed to articulate a variety of symbolic worlds is not new to social science. Cassirer, Whorf, and many others discussed the idea that symbols and symbol systems, language, myth, stories, and conversation, as well as poems, sonatas, plays, films, murals, and novels, create a multiplicity of worlds.

Nelson Goodman addressed himself to this line of speculation at a meeting commemorating the one-hundredth anniversary of Cassirer's birth. He asks a set of questions that I would like to use to discuss some of the current issues we face in an ethnography of visual communication. He asks, "In just what sense are there many worlds? What distinguishes genuine from spurious worlds? What are worlds made of? How are they made, and what roles do symbols play in their making?" (1975:57). I think that it is only recently that we have been able to apply these questions to an endeavor we call anthropology, to a mode I call pictorial-visual, and to a concept that has come to be called communication. It was Margaret Mead who helped, not only by her work but by her teaching and her encouragement of the work of others, to integrate those three concepts: anthropology, communication, and the visual-pictorial mode.

When in 1963 (Worth 1964) I began to point out that films and photographs made by such diverse groups as students in college, people in their homes, or mental patients in hospitals could be looked at as ways in which these different people structured *their* worlds, rather than as "true images" of *the* world, I thought I was merely bringing a truism about drawing and painting up to date. Most people who talked knowledgeably about pictures in 1963 accepted the fact that Picasso drew the way he did because he meant to structure his pictures that way, not because he could not draw like Norman Rockwell or even the way he himself drew in other periods. True, Roman Jakobson in 1950 pointed out that most people wanted pictures to look like a Norman Rockwell—what we now call photo-

graphic or snapshot realism—and were disturbed by abstract painting. Jakobson ascribed this both to the fact that most people were ignorant about the conventions of painting and to the strength of conventions about pictures—when they were known. He, himself, it seems, tended to believe that the "natural" way to know pictures was to know what they represented; that to draw abstractly, or in non-representational or non-Western patterns, was somehow to act unnaturally. Interestingly, it was the early Russian filmmakers and film theorists—Eisenstein, Dovzhenko, and Pudovkin—who, following the Russian formalist linguistic theories, first pointed out that films structured reality just as speech did; that patterns of images, like patterns of sounds, were worthy of study. But so strong was the myth of photographic reality that even a Roman Jakobson could feel that representation was the natural way to make pictures.

For many leading social scientists today, as well as for our students, visual anthropology means taking photographs, photo records, movies, ethnographic movies, and film footage—all for research. These labels carry a descending aura of science about them. Film footage, unorganized but uncut, is considered the most scientific, and therefore the truest evidence, because it captures "real behavior," presumably untouched by human eye or brain—a pure record. An ethnographic movie or a documentary movie is the least scientific, not only touched, but sometimes, it seems, tainted by human consciousness and often damaged as a scientific document by something called "art." As recently as last year, the chairman of the Department of Sociology at Columbia University wrote in the *New York Times,* in shock, that a documentary film about the Yerkes Primate Laboratory expressed the filmmaker's biased view of the subject, still naively stating that he expects something called a neutral, unbiased, objective view in a film shown on television. The director of the laboratory, who had given permission to the filmmaker to make a movie to be shown on television, expressed anger that the film did not portray the "truth" about the laboratory. He, too, evinced shocked dismay that the filmmaker presented his own personal view of what he observed in the laboratory—that the act of making a movie allowed such a "distortion."

There is no point, however, in taking a position that if film is not "objective truth," there is no use to film. Many ethnologists have provided us with stills and motion pictures which they and others have used to articulate some of the most important statements about culture made in recent years. I am arguing that there is great value in visually recorded data about behavior and culture, so long as we know what it is that we recorded, so long as we are aware of how

and by what rules we chose our subject matter, and so long as we are aware of, and make explicit, how we organized the various units of film from which we will do our analysis.

Let us return to Cassirer and Goodman's concept that symbolic events produce different works and different worlds. Faced with such a concept, and, most specifically, with the fact that pieces of film, no matter how made, are patterned constructions, structured, at best, by a trained mind, the truth-seeker through film becomes confused, dogmatic, and angry. It is hard enough for some people to believe that an analysis is a construction, a structuring of reality. Most of us simply do not want to face the fact that what we loosely call primary photographic data is also a structured event. A photograph, just like any picture, is constrained both by who made it and how it is made, as well as by what it is a picture of. It should be obvious that just as pictures are not simple mirrors of what is out there, neither are they artifacts which have no relation whatsoever to what they are pictures of. The ethnographic photographer is free to take a picture of anything his system allows him to photograph, but he is also constrained by the fact that he must point the camera at some objects in the world "out there." These things out there also constrain what the picture will be like. While "out there" does not determine what the photograph will look like, it is obviously not irrelevant. In one sense, we want as many different worlds as possible, and in another, the fact that symbols and signs can best be used to construct different worlds poses almost insoluble scientific problems. In order to distinguish genuine from spurious worlds, we slip into the belief that cameras record reality, that reality is true, and that film recordings are therefore "truth."

This fantasy about symbols suffers from the error of imposing logiclike or logical sounding rules upon a domain that is governed by a set of rules that may not be like those of logic. For example, one basic convention of logic states that a true conclusion cannot be drawn from a false premise. Researchers who want to use film as a record of behavior want it to be the case that from a true premise— a picture or photograph—one cannot draw a false conclusion; that is, that from "true" films one cannot get "false" data. One introductory lecture in logic should be enough to make any student see that this is not the case. Unfortunately, false conclusions can be drawn from anything, and getting the "truth" on film, even if it were possible, will not guarantee the subsequent analysis or the conclusions drawn from it.

Suppose we agree that pictures and films can be used as illustrations of pattern—of how films themselves are structured, as well as

of how people and their behavior in films are structured. Suppose we agree that symbolic events produce symbolic worlds, and that these worlds are not (for the moment) to be thought of as either true or false, but rather as communicative articulations. Suppose we think of a film, whether it be footage without editing or footage after editing, as the way the maker of the film structures the world that he or she presents to us. Our job as viewers, then, is first to determine what he means by the film he shows us. A mere recording, without conscious selection, emphasis, and instruction by the filmmaker, is more often confusing than illuminating. The viewer of such a recording "knows" that an inanimate camera did not expose the film and decide what to shoot and how to shoot it. If the film does not instruct us how to interpret it, or if it is not constructed in a way that allows us to use conventional techniques for interpretation in that medium, we most often ignore the film or treat it as an annoyance. Ray Birdwhistell, with whom I have watched too few films, has often said to me, "I can't stand watching most so-called ethnographic movies. The man who made it won't tell me what he's doing. I'd rather look at behavior as it occurs and not have to spend all my time trying to guess how, when, and for what reasons a filmmaker made a movie of it."

Seven years ago, again led by Margaret Mead, a group of researchers interested in both records about culture and records of culture met and decided that our concerns could best be clarified by founding a new organization, with its own journal. Margaret Mead helped us to set up the Society for the Anthropology of Visual Communication (as part of the American Anthropology Association) and the National Anthropological Film Center at the Smithsonian Institution.

The kinds of problems that our members study include all the ones that I have mentioned (for there are indeed still not enough systematic records about the cultures of the world that can be used to illustrate patterns of culture), as well as the newer ones I will be talking about in a moment.

In developing a history of the shift from visual anthropology to the anthropology of visual communication, and in trying to understand Margaret Mead's role in this development, it is most important to understand that the study of culture is not accomplished by pitting symbolic worlds against one another. Those of us who are involved in using photographs and films as new technologies through which we can record cultural artifacts and events, and those of us who are involved in studying how pictures are put together to make statements about this world, are equally concerned with learning how this

particular symbol form, the picture, can be of use in the study of culture. We include scholars such as Richard Sorenson (1976) and Jay Ruby (1975, 1976), who are struggling to delineate theories of the photograph as evidence, as well as those who are following up on the work that John Adair and I (Worth and Adair 1972) did when we gave movie cameras to Navajo Indians to see how their patterns of structuring differed from or resembled ours. Most recently, *Studies in the Anthropology of Visual Communication* devoted a complete issue to a study by Erving Goffman of values and social attitudes about gender that can be derived from an analysis of some 500 advertising photographs (Goffman 1976).

Some of us are arguing that it is as silly to ask whether a film is true or false as it is to ask whether a grammar is true or false, or whether a performance of a Bach sonata or a Beatles song is true or false. The confusion about the use of pictures, in social science particularly, arises out of the fact that although symbol systems are designed to articulate many worlds, our way of thinking about such systems allows us, even compels us in certain contexts, to ask, "Are you trying to tell us that all symbolic worlds are equally true, equally correct, equally right in their portrayal of the 'real world'?"

One can indeed ask if a particular grammar is a useful description of how people talk. One can ask whether that sonata was written by Bach or whether that was a Beatles song. If the notion of a grammar is understood to be an articulation, a statement about how people talk, one can ask in what ways it corresponds to how people do talk. But this requires that we conceive of a grammar, a performance, or a film as a statement or a description of and about something. It requires that we understand that the grammar or the film is *not a copy of the world out there but someone's statement about the world.*

Acknowledging this, some of our younger colleagues are beginning to study such things as how home movies are made as a social event, as well as what they mean as a semantic event. We are looking, as Chalfen (1975) has done, into how home movies and photograph albums are displayed and exhibited, to whom, and for what social purposes. Ruby has begun to study the patterns apparent in the photographs that most anthropologists make in the field. Here he finds that in most cases they are indistinguishable from those made by journalists. That while anthropologists' written ethnographies do in fact differ from journalists' reports or travelers' letters home, their photographs do not differ from the kind that journalists take. For the most part, anthropologists and (as Howard Becker [1974] has shown) sociologists are professional scientists—only when they are employing words. When it comes to the visual mode of articulation and

data-gathering, most produce snapshots, documentary films, good (or bad) home movies, or "artistic" works. It is forty years since Bateson and Mead took their photographs in Bali, and, sad to say, in that forty-year period there have not been many social scientists who have been trained in what they developed.

The framework of the anthropology of visual communication suggests that symbolic worlds are patterned and amenable to being studied in a larger framework than pictures. Primarily, this framework helps us to look at pictures as that aspect of culture called communication. It suggests that we treat pictures as statements, articulated by artists, informants, scientists, housewives, and even movie and TV producers. We can ask what the articulator meant, and then we can ask whether our interpretation of what was meant is good, bad, beautiful, ugly, and so on. But by asking whether our interpretation of what was meant is true, we are, I am afraid, merely asking whether we guessed right. What we should be trying to understand is how, and why, and in what context, a particular articulator structured his particular statement about the world.

Treating film (the camera and celluloid) as a copy of the world, rather than as materials with which to make statements about the world, forces us into the impossible position of asking whether performance is true. Understanding that photographs and films are statements, rather than copies or reflections, enables us to look explicitly, as some of us are now doing, at the various ways we have developed of picturing the world.[3]

The parameters along which we deal with statements are many. Anthropology is in some sense a set of questions about human behavior. Ethnography is in some sense a method by which certain kinds of questions can be answered. By considering pictures and all behavior in the visual mode as possible communication acts, and by understanding that these acts can produce only statements or assertions about the world, rather than copies of it, we are enabled to consider the kinds of anthropology we want to do about the visual pictorial forms that we can and do use. In this kind of anthropology, we want to consider both how the photograph and the film can be used as evidence by the scientist and how people actually have used them, as evidence, as documents, as entertainment, and as art.

It is only within this framework that we are able to return to Pat Loud's questions with which I opened this discussion. Margaret Mead actually did influence that "show," just as she did influence this paper. Craig Gilbert, the producer of "The American Family,"

3. For a specific study of how advertisements picture the world, see Goffman 1976.

was previously the producer of another show, "Margaret Mead's New Guinea Journal." Gilbert spend a great deal of time talking with Dr. Mead about films and about culture, while he accompanied her on her return trip to some of the places she had studied in the past. He learned from her that one American family, well observed, might reveal or, in her words, "illustrate" a pattern about American families. The patterns that he observed and the way they are structured are his, and his cameramen's and editors'. The idea of trying to present them on film was learned from Dr. Mead.

Pat Loud said it "didn't work," that when she saw the film of her family, she felt herself "shrinking in defense." She felt that she had been "ground through the media machine" and "treated as an object." Then she said she would do it again if it did what the producer said it would do. Craig Gilbert had told her that by showing one family he could show a pattern that might be true of many American families.

We know now that it was not the editing that prevented the programs from "working." We have tried to reedit some of that footage. We have invited Mrs. Loud to do it herself. It seems that it cannot be done so that the film does not look as if it were produced as a drama or a soap opera for TV. Because it is on TV. And TV does not present the truth any more than film does, or than film editors do. It presents, we now know, a structured version of what someone saw, presented in a context—television—of drama, soap opera, sporting events, "news," and commercials. We have learned how to interpret what we see on TV. If we were to study that footage in other ways and not show it on television, we might find patterns that would illustrate other structures, other worlds.

Learning how to study something as complex as a twelve-hour film put together from 200 hours of film based on 400 hours of observation is part of the study we are now calling the anthropology of visual communication.

There are now heated controversies about whether Mrs. Loud and her family were fooled, whether (leaving television aside) sociologists and anthropologists have the right to photograph real people for their studies. Again, in 1936, and reported as early as the second page of *Growth and Culture,* Dr. Mead faced this question. She wrote, "I have used real names throughout. The people knew we were studying and photographing their children; indeed, they often helped set the stage for an afternoon's photography. Very cautiously, but quite definitely, they gave us permission to live among them and there is no need to blur their contribution by disguise or subterfuge." Adair and I followed this advice in our own work among the Navajo,

first getting their permission and then acknowledging their great contribution. They were in their own films, and they wanted to be seen. We can tell what would have happened had the press and assembled academics called them primitive, selfish, cruel. As we have described in our book about this project, they themselves did not think of their films as the truth about Navajos. Their films were true about, as one of them put it, "how you tell a story." Those of us interested in the anthropology of visual communication are trying to find ways to study how people can and do depict mankind, themselves, and others in all their diversity.

In 1967, I returned from the field with 12,000 feet, 480,000 single frames, of exposed film, and seven movies made by Navajo Indians. I was looking for patterns, but I was overwhelmed (as so many researchers are when they return from the field) by the masses of observations and possible data I had collected. The patterns were far from clear in my mind. I was tired. Dr. Mead asked me to show some of the films and talk about my research to her class. I did. The next day after breakfast, she quietly set up the projector, pulled up her typewriter, and asked me to start going over the footage with her. I had worked with this material for over a year. Margaret Mead began to teach me how to find patterns in it. When I finally said something like, "I know that, why do we have to keep going over it?" she replied somewhat tartly, "Sol, you begin with intuition, but you can't rest your case upon it. You must build upon it and make clear to others the patterns that seem clear to you."

This paper is my continued attempt to follow that advice. Doing the anthropology of visual communication is an attempt by a large group of students of communication and anthropology to find methods and theories by which they too can make clear the patterns that they discover and create.

an american community's socialization to pictures: an ethnography of visual communication (a preproposal)

with jay ruby

Within the last several hundred years, our search for understanding of the context and environment in which we live has moved from studies of our physical world to studies of the biological and social contexts within which we function. It has now become apparent that we live and function within the context of a fourth major environment—the symbolic. This environment is composed of the symbolic modes, media, codes, and structures within which we communicate, create cultures, and become socialized. The most pervasive of these modes, and the one least understood, is the visual-pictorial.

The visual symbolic environment—our vidistic universe—can be thought of as encompassing three possibly related domains. First is the world of "popular culture"—the mass media and mass pictorial communication in general. Here we include such things as movies, television, advertising photography and television commercials, comic books, snapshots, home movies, graduation portraits, and even the new home erotica TV tape machines that are supplied by a growing number of "honeymoon hotels."

Second is the world of "high culture" and "art." Here we include paintings, sculpture and graphics in museums, as well as the works in galleries and lobbies of public buildings; art education, from nursery school to the Ph.D., available from universities, civic organizations, and on television. We include under this "art" label some of the works that in other contexts are called "movies" and "TV." When

included in this second category, "movies" become "the cinema" or "the art of the film," "television" becomes "video art," and "snap-shots" become "photographs."

The third domain of our visual environment takes in our personal use of visual-symbolic forms: our clothes, house furnishings, and the various ways we use the visual mode in our personal or professional presentation of self. This includes how we dress to teach, to sell, and to buy, as well as to marry or divorce. It includes our private as well as our public ways of decorating and presenting ourselves. It includes the look of our houses, offices, and workshops, as well as our gardens and our walls—the "urban design" or "public design" of our cities and roadways.

We suggested earlier that these three domains of our vidistic universe might possibly be related. There is, however, very little evidence to support this view. In fact, although the vidistic world is becoming more and more pervasive and influential in the formation and stabilization of culture—the dire predictions about the television generation that won't be able to read are only one example—our knowledge of the visual domains around us is sparse indeed.

For most of Western history, and most specifically for the past several hundred years, our visual world has been examined largely by looking at only one of the domains we have outlined—that of "high culture" and "art." Not only have we concentrated on examining the "masterpieces" of art, but these have been analyzed and interpreted through the eyes and minds of the critic, the professor, and the connoisseur. The world of the arts has in general been a world of elite artifacts studied by elites.

It is the purpose of this project to begin a study of our vidistic universe from a broader, and, as we shall try to show, more fruitful perspective, using a variety of methods coming from both the humanities and the social sciences heretofore not applied to the world of culture and its art contexts and products. We are arguing that before one can understand "painting" one must understand "pictures," before one can understand "architecture" and "sculpture" one must understand "houses" and "statues." Questions about cinema, the art of the film and video, need prior understanding of movies and the tube. In a similar manner, past studies of the visual mode tended to concentrate upon interpretations advanced by critics and specialists, rather than on studies describing the methods and strategies by which the "ordinary person," the user or spectator, learned how to make and actually made meaning out of his visual environment.

What we therefore propose is a study of a vidistic environment

as it occurs in a small American community in central Pennsylvania. We have chosen this particular community because it appears to be culturally homogeneous and stable. Such homogeneity and stability allow us to deal with the relation of their culture to their vidistic environment in a straightforward manner. The method we wish to employ in this study is one we have termed *ethnographic semiotics:* the study of how real people make meaning of specific aspects of their vidistic environment. Up to the present proposed research, studies of the visual-symbolic aspects of American or Western urban cultures have used as their units of analysis the content of specific symbolic forms, either of specific programs, films, graphic arts, urban design, or the content of specific time segments or taxonomic groupings— Saturday morning children's programs, situation comedies, documentary films, exploration films, and so on. What we are proposing is to use as our unit of analysis not the product but the *context—the community and the community members'* interaction with visual-symbolic events. It is our contention that the three domains of vidistic life must be studied as one unit within the context not only of each other but of the community in which they function.

Step 1 in our research will be the development of a macro-descriptive ethnographic account of the community, starting with standard demographic descriptions but developing and concentrating on specific descriptions of television viewing and movie use—in schools, theaters, and libraries, as well as the new TV "home box office" recently available to this community. We will survey the uses of snapshots and home movies, as well as portrait and wedding photographs made by professionals and amateurs. As part of this macro-description, we will survey the "art activities" of the county's schools and art teachers, including the arts and crafts stores and craft activities in the community, as well as the work of local artists and craftsmen. As a final stage of step 1, we will produce a visual inventory, using a variety of visual media, which will record the look of the community, its houses, people, store windows, and home interiors. This visual inventory will be used as an elicitation device for further studies related to how vidistic meaning is learned and understood in this community.

Step 2 will concentrate on an intensive qualitative participant observation effort in three institutions. We will examine a sample of (1) families, (2) schools, and (3) commercial establishments within the contexts of our three domains: popular culture, art, and visual presentation of self. In this in-depth study of three institutions across three domains, we are concerned to find out how, for example, the uses of snapshots articulate with attitudes and uses of "art," and how

studying art in school relates to the kind of movies one looks at or the way one talks about film and TV. The school will be examined as a system of socialization toward symbolic use in general, fostering certain attitudes toward art, television, advertising, and so on.

Step 3 will introduce participant intervention and community participation. From preliminary work in the county, we have discovered that the second most desired change (after "more jobs") was for more adult education. We plan, with the cooperation of community agencies, to set up two classes in visual communication—one for teenagers and one for retired individuals. We will teach them how to use a visual medium through which they can present their pictures and their structuring of their world to their peers, or to whomever they choose. The choice of medium—from closed-circuit TV to still photographs—will be left to the community group. The method of teaching and observation will be similar to that used by Worth and Adair in their research with the Navajo, with black and white teenagers, and with adults (Worth and Adair 1972). The purpose of step 3 is to see if teaching the use of a visual symbolic mode and medium to members of a community will have observable consequences in how they deal with other aspects of their visual environment in the future. Will they interpret movies and TV differently? Will they demand different portraits or different decorations for themselves or their homes? Will they allow or suggest different values about their vidistic world to their friends or their children?

Step 4 will be an analysis and synthesis of the picture of an American community's picturing. By comparing the quantitative and qualitative data in steps 1, 2, and 3, it will be possible to generate an in-depth description of this community in terms of its various visual codes. We will attempt during the analysis period to learn whether the various domains and institutions of the vidistic universe under study relate to each other. We will attempt to articulate the ways in which human beings create, manipulate, and assign meaning to and through visual modes, media, and codes. The final project of the research will be to correlate and integrate the nine cells of our vidistic network of visual domains and institutions in a qualitative and quantitative description of how the various visual aspects of our environment relate to, and form a structural context for, each other.

Adair, John, and Worth, Sol. 1967. The Navajo as filmmaker: a brief report of research in the cross-cultural aspects of film communication. *American Anthropologist* 69:76–78.

Amelio, Ralph J. 1971. *Film in the classroom.* Cincinnati: Standard Publishing.

Arnheim, Rudolf. 1957. *Film as art.* Berkeley: University of California Press.

———. 1966. The myth of the bleating lamb. In *Toward a psychology of art.* Berkeley: University of California Press.

———. 1969. *Visual thinking.* Berkeley: University of California Press.

Barthes, Roland. 1953. *Le degré zéro de l'ecriture.* Paris: Editions du Seuil.

Bazin, André. 1967. *What is cinema?* Berkeley: University of California Press.

Becker, Howard. 1974. Photography and sociology. *Studies in the Anthropology of Visual Communication* 1:3–26.

Berlyne, Daniel. 1960. *Conflict, arousal and curiosity.* New York: McGraw-Hill.

Bettetini, Gianfranco. 1972. *The language and technique of the film.* The Hague: Mouton.

Birdwhistell, Ray. 1971. *Kinesics and context.* Philadelphia: University of Pennsylvania Press.

Bloomfield, Leonard. 1964. Literature and illiterate speech. In *Language in culture and society,* ed. Dell Hymes, pp. 391–96. New York: Harper and Row.

Boas, Franz. 1955. *Primitive art.* New York: Dover.

Bouman, Jan C. N.d. *Bibliographie sur la filmologie.* Stockholm: Institut de Psychologie, Université de Stockholm.

Carpenter, Edmund. 1971. Television meets the stone age. *TV Guide* 19(3): 14–16.

Casey, Edward S. 1970. Truth in art. *Man and World* 3(4).

Chalfen, Richard. 1969. It is the case that anyone can take a picture of anyone or anything, at any time, any place, for any purpose—but doesn't. A socio-cinematic investigation. Unpublished manuscript, Annenberg School of Communications, University of Pennsylvania.

———. 1974. Film as visual communication: A sociovidistic study in filmmaking. Ph.D. dissertation, University of Pennsylvania.

———. 1975. Cinema naivete: a study of home moviemaking as visual communication. *Studies in the Anthropology of Visual Communication* 2:87–103.

———. 1979. Obituary of Sol Worth. *American Anthropologist* 81:91–93.

Chomsky, Noam. 1957. *Aspects of the theory of syntax.* Cambridge, Mass.: MIT Press.

———. 1965. *Syntactic structures.* The Hague: Mouton.

———. 1968. *Language and mind.* New York: Harcourt, Brace and World.

Chukovsky, Kornei. 1963. *From two to five.* Trans. and ed. Miriam Morton. Berkeley: University of California Press.

Collier, John, Jr. 1967. *Visual anthropology.* New York: Holt, Rinehart, and Winston.

Donaldson, Margaret. 1971. Preconditions of inference. In *Nebraska symposium on motivation,* ed. J. K. Cole, pp. 81–106. Lincoln, Neb.: University of Nebraska Press.

Eisenstein, Sergei. 1933. *The film sense.* London: Faber and Faber.

———. 1949. *Film form.* New York: Harcourt, Brace and World.

———. 1963. *Film form/film sense.* Reprinted. New York: Meridian.

Ekman, Paul, and Friesen, Wallace. 1969. The repertoire of nonverbal behavior-categories. *Semiotica* 1:49–98.

Friedrich, Paul. 1974. The lexical symbol and its non-arbitrariness. In *Festschrift in honor of Carl F. Voegelin,* ed. O. Werner.

Gerbner, George. 1972. Communication and social environment. *Scientific American* 227:153–60.

———, and Gross, Larry. 1976. Living with television: the violence profile. *Journal of Communication* 26:173–99.

Gessner, Robert. 1968. In *The moving image,* App. A. New York: E. P. Dutton.

Goffman, Erving. 1976. Gender advertisements. *Studies in the Anthropology of Visual Communication* 3:69–154.

Gombrich, E. H. 1951. Meditations on a hobby horse, or the roots of artistic form. In Gombrich 1963a:1–11.

———. 1961. *Art and illusion.* New York: Pantheon.

———. 1963a. *Meditations on a hobby horse.* New York: Phaidon.

———. 1963b. Visual metaphors of value in art. In Gombrich 1963a:12–29.

Goodman, Nelson. 1968. *Languages of art.* Indianapolis: Bobbs-Merrill.

———. 1975. Words, works, worlds. *Erkenntnis* 9:57–73.

Gregory, R. L. 1970. *The intelligent eye.* New York: McGraw-Hill.

Grice, H. P. 1957. Meaning. *The Philosophical Review* 66:3.

Gross, Larry. 1973. Art as the communication of competence. *Social Science Information* 12:115–41.

———. 1974. Modes of communication and the acquisition of symbolic competence. In *Media and symbols: the forms of expression, communication, and education,* seventy-third yearbook of the National Society for the Study of Education, ed. D. R. Olson, pp. 56–80. Chicago: University of Chicago Press.

Guback, Thomas. 1969. *International film industry.* Bloomington: Indiana University Press.

Hall, Edward. 1968. Proxemics. *Current Anthropology* 19:83–108.

Harlan, Thomas A. 1972. Viewing behavior and interpretive strategies of a photographic narrative as a function of variation in story title and subject age. Master's thesis, Annenberg School of Communications, University of Pennsylvania.

Harris, Zellig. 1960. *Structural linguistics.* Chicago: University of Chicago Press.

Heider, Fritz. 1958. *The psychology of interpersonal relations.* New York: John Wiley and Sons.

Hoban, Charles F., Jr. 1971. *The state of the art of instructional films.* Stanford, Calif.: ERIC Clearinghouse on Media and Technology.

———, and van Ormer, Edward B. 1972. *Instructional film research, 1918–1950.* New York: Arno Press.

Hochberg, Julian E. 1966. In the mind's eye. Address given at the annual meeting of the American Psychological Association, New York. Mimeographed.

Hodgkinson, A. W. 1964. *Screen education.* New York: UNESCO.

Hymes, Dell. 1967. Why linguistics needs the sociologist. *Social Research* 34:632–47.

———, ed. 1972. *Reinventing anthropology.* New York: Pantheon.

———, Cazden, C. B., and John, V. P., eds. 1972. *The functions of language in the classroom.* New York: Teachers College Press.

Jarvie, Ian C. 1970. *Movies and society.* New York: Basic Books.

Jonas, Hans. 1971. Review of Arnheim's *Visual thinking. Journal of Aesthetics and Art Criticism* 30:111–17.

Kael, Pauline. 1965. Is there a cure for film criticism? In *I lost it at the movies.* Boston: Little, Brown.

Kelley, Harold. 1967. Attribution theory in social psychology. In *Nebraska symposium on motivation,* ed. D. Levine, pp. 192–240. Lincoln, Neb.: University of Nebraska Press.

Kracauer, Siegfried. 1960. *Theory of film.* New York: Oxford University Press.

Kris, Ernst. 1952. *Psychoanalytic explorations in art.* New York: International University Press. (Reprint ed., New York: Schocken, 1964.)

Kuhn, Thomas S. 1962. *The structure of scientific revolution.* Chicago: University of Chicago Press.

Labov, William. 1966. *The social stratification of English in New York City.* Washington, D.C.: Center for Applied Linguistics.

Lettvin, Jerome Y. 1976. On seeing sidelong. *The Sciences,* July/August:10–20.
Lévi-Strauss, Claude. 1963. *Structural anthropology.* New York: Basic Books.
Lindstrom, Miriam. 1962. *Children's art.* Berkeley: University of California Press.
Lomax, Alan. 1970. *Folk song style and culture.* Washington, D.C.: American Association for the Advancement of Science.
Loud, Pat, and Johnson, Nora. 1974. *A woman's story.* New York: Bantam Books.
McKeachie, Wilbert J. 1967. Higher education. In *The new media and education.* New York: Doubleday.
McNeil, David. 1966. Developmental linguistics. In *The genesis of language,* ed. F. Smith and G. A. Miller. Cambridge, Mass.: MIT Press.
Malinowski, Bronislaw. 1922. *Argonauts of the Western Pacific.* New York: E. P. Dutton & Co.
Mead, Margaret. 1977. The contribution of Sol Worth to anthropology. *Studies in the Anthropology of Visual Communication* 4:67.
————, and MacGregor, Frances C. 1951. *Growth and culture: a photographic study of Balinese children.* New York: Putnam Press.
————, and Metraux, Rhoda, eds. 1953. *The study of culture at a distance.* Chicago: University of Chicago Press.
Messaris, S. Paul. 1972. Attribution and inference in the interpretation of filmed behavior. Master's thesis, Annenberg School of Communications, University of Pennsylvania.
————, and Gross, Larry. 1977. Interpretations of a photographic narrative by viewers in four age groups. *Studies in the Anthropology of Visual Communication* 4:99–111.
————, and Pallenik, Michael. 1977. Attribution and inference in the interpretation of candid and staged film events. *Studies in the Anthropology of Visual Communication* 4:51–58.
Metz, Christian. 1964. Cinema, langue ou langage. *Communications.* Also in Metz 1974.
————. 1968a. *Essais sur la significance du cinema.* Paris: Editions Klinchsieck.
————. 1968b. Le dire et le dit au cinema: vers le declin d'un vraisemblable? *Communications* 11:22–33. Also in Metz 1974.
————. 1970. Images et pedagogie. *Communications* 15:162–68.
————. 1974. *Film language.* London: Oxford University Press.
Morris, Charles. 1946. *Signs, language and behavior.* New York: Prentice Hall. (Reprint ed., New York: Braziller, 1955.)
————. 1964. *Signification and significance.* Cambridge, Mass.: MIT Press.
Murphy, James P. 1973. Attributional and inferential strategies in the interpretation of visual communications: a developmental study. Ph.D. dissertation, University of Pennsylvania.
Neisser, Ulric. 1967. *Cognitive psychology.* New York: Appleton-Century-Crofts.
Olson, David R. 1970. *Cognitive development.* New York: Academic Press.
Pallenik, Michael J. 1973. The use of attributional and inferential strategies in the interpretation of "staged" and "candid" events. Master's thesis,

Annenberg School of Communications, University of Pennsylvania.
Panofsky, Erwin. 1959. On intentions. In *Problems in aesthetics,* ed. Morris Weitz. New York: Macmillan.
Pasolini, Pier P. 1965. The cinema of poetry. *Cahiers du cinema* 171:35–43.
———. 1966. Il cinema di poesia. In *Uccellacci e uccellini.* Milan: Garzanti.
———. 1967. La scenaggratura come struttura che vuol essere altra struttura. In *Uccellini e uccellini.* Milan: Garzanti.
Perkins, David. 1974. Caricature and recognition. *Studies in the Anthropology of Visual Communication* 2:1–24.
Peters, J. M. 1961. *Teaching about film.* New York: UNESCO.
Piaget, Jean. 1970a. *Structuralism.* New York: Basic Books.
———. 1970b. *Science of education and the psychology of the child.* New York: Grossman.
Price, Kingsley B. 1949. Is there artistic truth? *Journal of Philosophy* 46:285–91.
Pudovkin, V. I. 1949. *Film technique and film acting.* New York: Lear.
Reid, Louis A. 1964. Art, truth, and reality. *British Journal of Aesthetics* 4: 323–31.
Rokeach, Milton. 1960. *The open and closed mind: investigations into the nature of belief systems and personality systems.* New York: Basic Books.
Ruby, Jay. 1971. Toward an anthropological cinema. *Film Comment* 7:35–40.
———. 1975. Is an ethnographic film a filmic ethnography? *Studies in the Anthropology of Visual Communication* 2:104–11.
———. 1976. Anthropology and film: the social science implications of regarding film as communication. *Quarterly Review of Film Studies* 1:436–45.
Salomon, Gavriel, et al. 1972. Educational effects of "Sesame Street" on Israeli children. Mimeographed. Jerusalem: Hebrew University.
Sapir, Edward. 1921. *Language.* New York: Harcourt, Brace and World.
Sebeok, Thomas A.; Hayes, A. S.; and Bateson, M. C., eds., 1964. *Approaches to semiotics.* The Hague: Mouton.
Smith, F., and Miller, G. A., eds. 1966. *The genesis of language.* Cambridge, Mass.: MIT Press.
Sofue, Takao. 1971. Letter to *Current Anthropology* 12:145.
Sorenson, E. Richard. 1976. *The edge of the forest: land, childhood and change in a New Guinea proto-agricultural society.* Washington, D.C.: Smithsonian Institution Press.
Spottiswoode, Raymond. 1935. *The grammar of the film.* Los Angeles: University of California Press.
Stankiewicz, Edward. 1964. Discussion session on linguistics. Sebeok et al. 1964: 265–76.
Sturtevant, E. H. 1947. *An introduction to linguistic science.* New Haven: Yale University Press.
Tannenbaum, Percy H., and Greenberg, Bradley S. 1968. Mass communication. *Annual Review of Psychology* 19:351–86.
Urban, Wilbur M. 1939. *Language and reality.* London: Allen and Unwin.
Weakland, John H. 1966. Themes in Chinese communist films. *American Anthropologist* 68:477–84.
Weitz, Morris. 1959. *Problems of aesthetics.* New York: Macmillan.

Whorf, Benjamin Lee. 1956. In *Language, thought and reality,* ed. J. Carroll. Cambridge, Mass.: MIT Press.

Wick, Thomas M. 1973. Attributional and inferential interpretive strategies and variation in their application to written communications as a function of training and format. Master's thesis, Annenberg School of Communications, University of Pennsylvania.

Wolfenstein, Martha. 1953. Movie analysis in the study of culture. In Mead and Metraux 1953.

Wolfflin, Heinrich. 1950. *Principles of art history.* New York: Dover.

Wollen, Peter, and Lovell, Terry. 1967. Cinema and semiology. In *Papers of the British Film Institute Education Department Seminar.* Mimeographed.

Worth, Sol. 1963. The film workshop. *Film Comment* 1:54–58.

———. 1964. Public administration and the documentary film. *Perspectives in Administration (Journal of the Municipal Association for Management and Administration, City of New York)* 1:19–25.

———. 1965. Film communication: a study of the reactions to some student films. *Screen Education* July/August: 3–19.

———. 1966. Film as a non-art: an approach to the study of film. *The American Scholar* 35:322–34. (Reprinted in *Perspectives on the study of film,* ed. J. S. Katz, pp. 180–99. Boston: Little, Brown, 1971.)

———. 1968. Cognitive aspects of sequence in visual communication. *Audio Visual Communication Review* 16:1–25.

———. 1969. The development of a semiotic of film. *Semiotica* 1:282–321.

———. 1972a. Toward the development of a semiotic of ethnographic film. *PIEF Newsletter* 3:8–12.

———. 1972b. Toward an anthropological politics of symbolic forms. In Hymes 1972.

———. 1974a. The uses of film in education and communication. In *Media and symbols: the forms of expression, communication, and education,* seventy-third yearbook of the National Society for the Study of Education, ed. D. R. Olson, pp. 271–302. Chicago: University of Chicago Press.

———. 1974b. Seeing metaphor as caricature. *New Literary History* 6:195–209.

———. 1975. Pictures can't say ain't. *Versus* 12:85–108.

———. 1976. Editor's introduction to Erving Goffman's *Gender advertisements: Studies in the Anthropology of Visual Communication* 3:65–68.

———. 1978. Man is not a bird. *Semiotica* 23:5–28.

———. 1980. Margaret Mead and the shift from "visual anthropology" to "the anthropology of visual communication." Address presented at a symposium honoring Margaret Mead, American Association for the Advancement of Science, 1976. *Studies in Visual Communication* 6:15–22.

———, and Adair, John. 1970. Navajo filmmakers. *American Anthropologist* 72:9–34.

———, and Adair, John. 1972. *Through Navajo eyes: an exploration in film communication and anthropology.* Bloomington: Indiana University Press.

———, and Gross, Larry. 1974. Symbolic strategies. *Journal of Communication* 24:27–39.

Youngblood, Gene. 1970. *Expanded cinema.* New York: E. P. Dutton.

index

accountability, 138, 147, 167

Adair, John, 5–6, 21, 22, 52, 64, 72, 93, 101, 122, 125, 126, 159, 183, 196, 198–99. *See also* Navajo Filmmakers Project

ambiguous meaning situation, 26–27, 135

Amelio, Ralph J., 112, 117–18, 121–22

"American Family, The," 185–87, 197–98

American Film Institute, 112

American Indians, 152. *See also* Navajo Filmmakers Project

American Sign Language, 191

anthropology, 78, 92, 197; ethical problems in, 7, 17–19, 94–95, 97–106; use of film in, 4–7, 16, 18, 29, 75, 78, 83–84, 92, 94, 95, 96, 97, 101, 102, 104–5, 120, 189–90, 191 (*see also* anthropology of visual communication; ethnographic film; visual anthropology); use of photographs in, 16, 34, 194, 196; use of television in, 102; and visual images, 180

anthropology of visual communication, 6, 34, 185, 195, 197, 198, 199. *See also* ethnography of film/visual communication; visual anthropology

Antonioni, Michelangelo, 10, 46, 48

archaeology, use of camera by, 189

Arnheim, Rudolph, 19–20, 23, 29, 51–52, 111, 112–14, 116, 118, 124, 129, 149, 160, 171

art, 27, 29; as communication, 32; nonrepresentational, 173, 174, 175, 181, 193; representational, 170. *See also* conventions, pictorial; film, as art; pictures

articulation, 137, 138, 139, 141, 146, 147, 165, 166, 167, 183

assumption of existence, 145, 163

assumption of intention, 30, 32, 145, 146–47, 163, 165, 167–68, 172–73, 176

attribution, 26, 28, 29, 32, 124, 128, 135, 137, 139, 141, 142, 144, 145, 146, 153, 164, 165, 166, 167, 168, 171, 172, 179, 181, 183

attributional meaning, 165, 166, 171, 172, 179, 181. *See also* attribution

Barthes, Roland, 69

Bateson, Gregory, 16, 34, 187, 189–90

Bazin, André, 15, 37, 55, 56, 70

Beardsley, Monroe, 159
Becker, Howard, 196
belief-disbelief system, 41–42, 50
Bell Telephone Company, 91
Benedict, Ruth, 190
Bergmann, Gustave, 164
Berlyne, Daniel, 23, 51
Bernstein, Basil, 72
Bettetini, Gianfranco, 111
biodocumentary, 3–7, 18, 21, 22; contrasted with documentary films, 5; defined, 3; as research tool, 4–6; viewers' reaction to, 2–4, 21, 22
Birdwhistell, Ray, 79, 88, 190, 195
Birth of a Nation, 120n
Bloomfield, Leonard, 82, 170
Boas, Franz, 113, 166
Bouman, Jan C., 39
Braque, Georges, 174
British Film Institute Seminar, 56
Bundy, McGeorge, 91

cable television, 91–92, 99, 130, 131; and Mt. Sinai project, 93. *See also* television
cademe, 13, 52–53, 54, 57, 58, 62, 63, 64, 66, 70, 73; defined, 13, 52–53; in Navajo films, 64, 65
camera, motion picture, invention of, 86, 88
camera shot. *See* cademe
caricature, 30, 31, 155, 156–57, 161, 174
Carnap, Rudolf, 169
Carpenter, Edmund, 98
Casey, Edward S., 179, 180n
Cassirer, Ernst, 192, 194
censorship, 19, 103, 104
Chalfen, Richard, 5, 22, 80, 125, 176, 190, 196
Chomsky, Noam, 14, 15, 56–57, 60n, 66, 67, 71, 89, 113, 158, 159, 160
Chronicle of a Summer, 89
Chukovsky, Kornei, 178n
"collision of ideas," 51, 68, 159–60, 161
Columbia Broadcasting System (CBS), 105
communication, 165, 166; as social process, 26, 119, 137, 165; as symbolic behavior, 4. *See also* film, as communication
communicational inference. *See* inference

communicational meaning, 162–66, 171, 172, 181, 184; defined, 165
communicational meaning situation, 136
communication of competence, 33, 181
communications theory model of film communication, 7, 8, 29, 119
competence in symbolic modes, acquisition of. *See* development of communicative and interpretive competence
com-sign, 42
contiguity, 14n, 28, 31, 140, 141, 143; defined, 140
control of information and symbolic forms, 19, 90–92, 99, 103–4, 106, 132
conventions, 20, 21, 26, 135, 138, 147, 160, 161, 165, 166–67, 171; film, 3–4, 20, 21, 28, 29, 30, 116–17, 119, 120n, 153, 157, 165, 171, 183; language, 168, 171, 179; pictorial, 32, 33, 171, 174, 175, 179, 181–82, 193
Cultural Indicators program, 191
culture: diversity of, 105, 106; influence of, on filmmaking, 13, 14–15, 72, 79, 82, 93, 100, 101, 120, 125, 128, 131 (*see also* Navajo Filmmakers Project)

Derrida, Jacques, 149
development of communicative and interpretive competence, 27–29, 123, 124, 128–29, 138–46
documentary films. *See* biodocumentary; ethnographic film
Documentary Film Workshop, 2, 10
documentary movement, 89
Donaldson, Margaret, 144, 145
Dovzhenko, Alexander, 193
dramatic scene as basic film unit, 12, 50

early films, 62, 87–88, 187–88
edeme, 13, 15, 52–53, 54, 58, 59, 60, 63, 64, 66, 68, 69, 70, 72, 73; defined, 13, 52–53; in Navajo films, 64
Edge, David, 151
Edison, Thomas, 86, 88, 188
editing, 6, 7, 12, 13, 29, 50–51, 58–59, 63, 66, 78, 100, 119, 121, 122, 126–28, 142, 160, 183, 186, 195, 198. *See also* edeme
editing shot. *See* edeme
education: ethical issues in, 19, 97, 131–32; as form of acculturation, 118–19;

as process of communication, 122. *See also* teaching

educational television, 104. *See also* "Sesame Street"; television

Eisenstein, Sergei, 12, 15, 30, 37, 51, 52, 55, 68, 70, 111, 151, 152, 159–60, 193

Ekman, Paul, 79

Escher, M. C., 156, 178

ethical issues: and anthropology, 7, 17–19, 94–95, 97–106; and communication technology, 18; and education, 19, 97, 131–32

ethnographic film, 17, 74–84, 88, 89, 95, 100, 102, 104, 188–89, 193, 195; defined, 74–75, 77

ethnographic semiotics, 34–35, 202

ethnography, 5, 34–35, 94, 196, 197. *See also* ethnographic film

ethnography of communication, 16, 22, 77, 96, 106

ethnography of film/visual communication, 22n, 104, 192, 200–203. *See also* anthropology of visual communication; vidistics

existential meaning situations, 135, 137

feeling-concern, 8, 9, 10, 11, 20, 21, 42, 43, 44, 46, 49, 50, 59, 62; defined, 40–41

Feldman, Shel, 14

film: as art, 11, 37, 38, 39, 51, 52, 81, 89, 109, 110, 112–14, 116, 123; as communication, 4, 7–9, 11–14, 20, 37, 38, 40–41, 43, 44, 45, 47, 109, 118–20, 123–24, 132, 197; in education, 19–20, 108–33 (*see also* teaching); ethnographic (*see* ethnographic film); as language, 7, 11–14, 15, 37, 38, 39, 40, 53, 55–73, 81, 83, 109, 126, 129, 152, 153, 162, 182, 183, 193 (*see also* language, and film); objectivity of, 7, 16, 29, 77–78, 87, 88, 89, 104, 115, 116, 175, 186, 188–90, 193–95; as phenomenon of culture, 6, 16, 34, 77, 79–80, 81, 82, 84, 104–5, 191–92, 195, 197; as record of culture, 6, 16, 77–78, 79, 81, 82, 84, 89, 104–5, 120, 192, 193, 195–96, 197; as research tool, 4–6, 16, 18, 34; technology of, 16, 50, 53, 63, 68, 83, 86–88, 89, 90, 93, 98, 126; truth/false-

hood of, 162, 176–78, 186, 194–95, 196, 197, 199. *See also* anthropology, use of film in; biodocumentary; communications theory model; conventions, film; culture, influence of, on filmmaking; early films; ethnographic film; filmmaker; films; home movies; mirror-image model; Navajo Filmmakers Project; psychological model; teaching

"film literacy," 112, 121–22, 123, 130

filmmaker: cultural bias of, 7; role of, in communication process, 8–10, 11, 12, 13, 16, 20, 21–22, 29, 38, 39, 40, 42, 43, 44, 46, 49, 53, 54, 57, 59, 62–64, 70, 72, 73, 81, 119, 120, 124, 126. *See also* films; Navajo Filmmakers Project

film montage, 157, 160

films: by adolescents, 80–81, 82, 92–93, 100, 125, 128, 132; by anthropologists (*see* anthropology, use of film in); by blacks, 81, 82, 93, 100, 125, 128, 132; by Chicanos, 81; by children, 125; by Navajos (*see* Navajo Filmmakers Project); by students, 1–3, 7, 21, 80–81, 93, 125, 191, 192; by whites, 100, 125, 132

"film teachers," 111–12, 117–18

film theorists, 111, 114–17

Ford Foundation, 91

Freud, Sigmund, 86, 158–59, 160

Friendly, Fred, 91

Friesen, Wallace, 79

Fuller, Buckminster, 111, 114–15, 117, 133, 149

Gerbner, George, 80, 191

Gericault, Jean, 174

Gessner, Robert, 39

Gestalt psychology, 20, 51

Gilbert, Craig, 197–98

Godard, Jean-Luc, 68, 69, 89, 111

Goffman, Erving, 160, 191n, 196, 197n

Gombrich, Ernst, 57, 113, 114, 120, 122, 150, 155, 170, 173

Goodman, Nelson, 113, 114, 158, 192, 194

grammar, 56–57, 60, 61–62, 66–67, 68, 71, 150, 162, 168; of film, 7, 13–14, 15, 58–59, 60–61, 67, 68, 69, 71, 81, 83, 162, 182; of pictures, 61, 162, 179,

181, 182; of symbolic behavior, 123, 160, 161
grammaticality. *See* grammar
Greenberg, Bradley S., 39
Gregory, R. L., 177
Grice, H. P., 32, 146, 168, 169, 176
Griffith, D. W., 120n
Gross, Larry, 23–24, 33, 120n, 121, 122, 123, 128, 138, 143, 163n, 181, 191
Guback, Thomas, 80
Guston, Phillip, 175

Hall, Edward, 79
Harlan, Thomas, 142
Harris, Zellig, 56, 170
Heider, Fritz, 26
Heider, Karl, 17
Higgins, Earl, 191
Hoban, Charles, 108, 110
Hochberg, Julian E., 70
Hockett, C., 56
Hodgkinson, A. W., 121
holophrastic: film, 62; utterance, 61–62
home movies, 34, 80, 90, 92, 176, 190, 192, 196
Hughes, Howard, 91, 105
Hymes, Debora Worth, 154n
Hymes, Dell, 15n, 16, 18, 22, 76, 82, 113, 160

image-events, 8, 9, 10, 11, 12, 13, 20, 22, 41, 42, 43, 44, 45, 49, 50, 51, 53, 54, 59, 62, 75, 123, 126; in Navajo films, 126. *See also* videme
imagemaker, role of, in communication process, 16, 21, 22, 23. *See also* filmmaker
implication, 7, 21, 26, 28, 29, 30, 31, 33, 82, 119, 120, 124, 126, 129, 137, 138, 141, 144–45, 146, 153, 164–65, 166, 167, 168, 172–73, 179, 181, 183, 184; defined, 120n; in ethnographic film, 81–82
"impossible figures," 177, 182
inference, 7, 21, 26, 28, 29, 30, 31, 32, 33, 82, 119, 120, 124, 126, 128–29, 135, 137, 138, 141, 144–45, 146, 147, 153, 164–65, 166, 167, 168, 173, 179, 181, 183, 184; and cultural difference, 129; defined, 120n; in ethnographic film, 81–82

intention. *See* assumption of intention
interactional meaning, 162, 163–64, 165, 166, 184
interpreter, role of, in communication process, 23. *See also* viewer
interpretive strategy, 24–27, 30, 137, 141–42, 152, 153, 162–63, 164–65, 166, 172, 179, 181, 183, 184; development of, in children, 142–45. *See also* attribution; attributional meaning; interactional meaning

Jakobson, Roman, 192–93
Jarvie, Ian C., 159
Jonas, Hans, 114

Kael, Pauline, 37
Kelley, Harold, 26
kinesics, 88
Kloos, W. E., 103n
Kluckhohn, Clyde, 107
Kracauer, Siegfried, 52
Kris, Ernst, 9, 44, 113, 122, 166
Kuhn, Thomas, 113, 151

Labov, William, 113
language, 18, 60, 72–73, 81, 95, 96, 105, 122, 123, 125, 152, 158, 168; definitions of, 56–57; and film, compared, 7, 13, 60, 96, 112–14, 122, 123, 126, 129, 151; and film, contrasted, 1, 31–33, 57–59, 60–61, 66–68, 75, 93, 112–14, 115, 118, 129, 182; influence of, on film, 6, 22, 82, 83, 93, 113–14, 120, 125, 126, 127, 183, 191; Navajo, 6, 22, 125, 127, 183, 191; and negation, 173; pictorial, 173; and pictures, 1, 31–33, 156, 158, 162–63, 170–72, 173–74, 178–84; and truth/falsehood, 156, 169–70, 174, 175, 176–77. *See also* film, as language; "film literacy"
language community, 56, 72, 73; of film, 72, 73, 81. *See also* native speaker
"language of film." *See* film, as language
Levine, David, 157
Lévi-Strauss, Claude, 56, 89, 113, 149, 157
lexicon, 53, 57, 58, 61–62, 69, 71, 75, 151, 171, 180; of film, 15, 57, 58, 63, 68, 71, 75; of pictures, 180; of symbolic modes, 123

linguistics, 11, 12, 14–15, 37, 89, 96, 169, 170, 180. *See also* film, as language
Lomax, Alan, 79
Loud family. *See* "American Family, The"
Loud, Patricia, 186, 197–98
Lovell, Terry, 56
Lumière, Louis Jean and Auguste, 88, 188

MacGregor, Frances C., 189–90
McLuhan, Marshall, 96–97, 111, 117, 149
McNeil, David, 61, 62
Makavejev, Dusan, 151, 152, 177–78
Malinowski, Bronislaw, 5, 94
Malraux, André, 182
Mead, George Herbert, 160
Mead, Margaret, 6, 16, 17, 34, 35, 40, 78, 80, 89, 185–99
Medium Cool, 178
Méliès, Georges, 89
Menomini, 82
Messaris, S. Paul, 142, 143
metaphor: as caricature, 155–61; in film, 30–31, 151–52, 157, 160; portrait as, 154–55; verbal, 30–31, 129, 148–61; visual, 150, 151, 152, 155
Metraux, Rhoda, 80, 191
Metz, Christian, 37, 55–56, 111, 183
Miller, G. A., 53, 61
mirror-image model of film communication process, 9–11, 20–21, 42, 43–44
models of film communication process. *See* communications theory model; mirror-image model; psychological model
modifier-object relationship, 65–66
Morin, Edgar, 89
Morris, Charles, 14, 38, 39, 42, 58, 61, 164
Morse code, 180
Mt. Sinai Hospital cable television project, 93
Murphy, James P., 142, 143
Muybridge, Eadweard, 88, 187

National Association of Media Educators, 112n
native speaker, 56, 57, 66–67, 71, 97, 131, 153–54, 168; of film, 15, 31, 67,

153–54, 182; of pictures, 31, 153–54, 182. *See also* language community
natural events, 25–27, 29, 32, 134–37, 141, 142, 144, 146, 163, 164; defined, 25; as symbolic, 137
Navajo Filmmakers Project, 4–6, 12, 14, 16, 18–19, 21, 22, 52, 64, 65, 66, 72, 78, 81, 82, 93, 100, 101, 125, 126–28, 132, 183, 191, 196, 198–99
negation and pictures, 32–33, 156, 168, 173–74, 178–79, 184
nonsign-events, 24, 25, 136

objectivity. *See* film, objectivity of; photographs, objectivity of; television, objectivity of
Olson, David R., 122
order, 14n, 141; defined, 140
Osgood, Charles, 14

Pallenik, Michael J., 142
Panofsky, Erwin, 166
Pasolini, Pier P., 37, 55–56, 68, 111
pattern, 14n, 28; defined, 140–41
Pavlov, Ivan P., 51, 70, 164
Peirce, C. S., 14, 87, 154
Perkins, David, 157
Peters, J. M., 121
photographs: objectivity of, 16, 33, 175, 186; as phenomena of culture, 34, 190, 191–92, 197; as records of culture, 16, 34, 190, 191–92, 197; truth/falsehood of, 175–76, 186. *See also* anthropology, use of photographs in; snapshots
Piaget, Jean, 108–9, 121, 126, 133
Picasso, Pablo, 172, 174, 175, 182, 192
pictures, 31–33, 162–84; as communication acts, 197; and language, 31–33, 170–72, 173, 178, 179, 180–81, 183–84; and negation, 32–33, 156, 168, 173–74, 178–79, 184; as symbolic events, 32; truth/falsehood of, 33, 163, 170, 174–75, 177, 178–80, 181–82, 184, 197. *See also* art; caricature; photographs
Pollock, Jackson, 175
Porter, Edwin S., 12, 50, 63
portrait as metaphor, 154–55. *See also* pictures
pragmatics, 58

Price, Kingsley B., 179
psychological model of film communication process, 4, 8, 9, 10, 14, 15, 37, 40, 44, 111
Pudovkin, V. I., 37, 51, 52, 111, 193

radio, 86, 89, 90; technological limitations of, 92
Red Desert, 10, 46, 48
reflexivity, 5
Reich, Wilhelm, 151
Reid, Louis A., 179
Ricoeur, Paul, 149, 151, 155, 156, 157, 159
Riley Brothers, 188
Rockwell, Norman, 192
Rokeach, Milton, 41, 42, 50
Rouch, Jean, 89
Ruby, Jay, 17, 35, 190, 196

Salomon, Gavriel, 133
Sapir, Edward, 56, 76, 113, 160, 173
Saussure, F. de, 14, 39, 56, 67, 89
Schensul, Stephen L., 98n
Schlauch, Margaret, 105
Sebeok, Thomas A., 39
semantics, 58; of film, 13, 58, 65, 81
semiotics, 14–15, 38, 56, 58, 74, 152–53, 168, 180; of ethnographic film, 34–35, 74–84, 202; of film, 36–73, 151; of metaphor, 152, 160; of pictures, 163, 184
sender-receiver isomorphism. See mirror-image model
sequence, 13–14, 28, 30–31, 60, 64, 66, 68, 70, 73, 125, 140, 160, 183; defined, 13, 59, 141; in Navajo films, 65
"Sesame Street," 99, 117, 121, 132, 133
"shot" as basic film unit, 12, 51, 159. See also videme
sign. See image-event; semiotics
sign-event, 25, 27, 28, 33, 136, 137, 139, 140, 141, 164; recognition of, 139
"Six Families," 187
Smith, F., 53, 61
snapshots, 34, 190, 196. See also photographs
sociolinguistics, 15, 96. See also linguistics
sociovidistics, 22
Sofue, Takao, 103n
Sorenson, E. Richard, 196

Sparshott, Francis E., 31, 148n, 149, 151, 154, 155
speech. See language
Spottiswoode, Raymond, 13
Stalin, Joseph, 105
Stanford, Leland, 88, 187
Stankiewicz, Edward, 55
stimulus-response theory of meaning, 164, 168
story-organism, 8, 9, 10, 11, 20, 43, 44, 46, 49, 59; defined, 41–42
Strike, 30, 151
structuralism, 12, 56
student films. See films, by students
Sturtevant, E. H., 56
style, 39, 40, 68, 69, 70, 138, 165
symbolic events, 23, 26–27, 29, 32, 134–36, 137, 142, 146, 163, 164, 165; defined, 26
syntactics, 58
syntax, 152, 162, 180; of film, 13, 14, 15, 40, 64, 81, 83, 152, 153, 162; of Navajo film, 65; of pictures, 162, 179, 180; of symbolic modes, 123

Tannenbaum, Percy H., 39
teaching: about film, 120–21, 123, 124, 125, 129, 130–31, 132, 133; filmmaking, 1–2, 4, 10, 93, 97, 101, 123, 125, 129, 130–32, 133 (see also Navajo Filmmakers Project); through film, 19–20, 109–11, 117–19, 120–21, 123, 129, 130, 132, 133
Teatteri, 1–2
television, 36, 86, 89–90, 91–92, 94, 115–16, 117, 130, 131, 151, 162, 185–87, 191, 193, 197–98; and anthropological fieldwork, 102; and cultural change, 98n, 99, 105–6; objectivity of, 115–16, 174; technology of, 89–90, 91–92, 99; truth/falsehood of, 177, 198. See also cable television
Tillich, Paul, 41
Todorov, Tzvetan, 149, 151
Truffaut, François, 89

UNESCO, 112
Urban, Wilbur M., 179

Valery, Paul, 172
verifiability, 169–70

216 index

videme, 12, 53, 54, 57, 58, 59; defined, 12, 53. *See also* image-event
vidistics, 11–12, 14, 96, 104, 131; defined, 96n
"vidistic universe," 200–203
viewers: cultural differences among, 129; and "language" of films, 61, 67, 81; reactions of, to films, 2–4, 10, 11, 21, 22, 46–49, 177–78; reactions of, to pictures, 175, 177; role of, in communication process, 2–4, 7, 9–10, 11, 12, 14, 16, 20–22, 27, 29–30, 32, 38, 40, 42, 43, 44, 49, 51, 54, 70, 72–73, 81, 82, 116, 119, 120, 124, 172–73, 183
visual anthropology, 6, 16, 17, 34, 185, 189, 192, 193, 195. *See also* anthropology of visual communication
visual images. *See* caricatures; film; pictures

visual primacy, 19–20, 111, 112–14, 115, 116, 118, 122, 133, 149
Vorkapitch, Slavko, 52

Weakland, John H., 79–80
White-Thunder, 82
Whorf, Benjamin Lee, 6, 75, 83, 113, 114, 160, 192
Whorfian hypothesis. *See* Whorf, Benjamin Lee
Wick, Thomas M., 142
Williams, Carroll, 17
Wittgenstein, Ludwig, 56
Wolfenstein, Martha, 79–80
Wolfflin, Heinrich, 113
Wollen, Peter, 56
W.R.: Mysteries of the Organism, 151–52, 177–78

Youngblood, Gene, 20, 29, 111, 114–17, 118, 133

university of pennsylvania publications in
conduct and communication

erving goffman and dell hymes, general editors

erving goffman, *Strategic Interaction*

ray l. birdwhistell, *Kinesics and Context: Essays on Body Motion Communication*

william labov, *Language in the Inner City: Studies in the Black English Vernacular*

william labov, *Sociolinguistic Patterns*

dell hymes, *Foundations in Sociolinguistics: An Ethnographic Approach*

barbara kirshenblatt-gimblett, editor, *Speech Play: Research and Resources for the Study of Linguistic Creativity*

gillian sankoff, *The Social Life of Language*

erving goffman, *Forms of Talk*

sol worth, *Studying Visual Communication,* edited by larry gross